Culture Works

Culture Works

Space, Value, and Mobility across the Neoliberal Americas

Arlene Dávila

NEW YORK UNIVERSITY PRESS
New York and London

NEW YORK UNIVERSITY PRESS
New York and London
www.nyupress.org

References to Internet Websites (URLs) were accurate at the time of writing.
Neither the author nor New York University Press is responsible for URLs
that may have expired or changed since the manuscript was prepared.

Library of Congress Cataloging-in-Publication Data

Dávila, Arlene M.
Culture works : space, value, and mobility across the neoliberal
Americas / Arlene Davila.
p. cm.
Includes bibliographical references and index.
ISBN 978-0-8147-4429-1 (cl : alk. paper) — ISBN 978-0-8147-4430-7
(pb : alk. paper) — ISBN 978-0-8147-4431-4 (ebook) — ISBN
978-0-8147-4432-1 (ebook)
1. Latin America — Cultural policy. 2. Latin America — Civilization.
3. Arts — Americas. 4. Cultural industries — Americas. 5.
Neoliberalism — Americas. 6. Latin Americans — Economic conditions. 7.
Latin Americans — Social conditions. I. Title.
F1408.3.D37 2012
980 — dc23
2011043845

New York University Press books are printed on acid-free paper,
and their binding materials are chosen for strength and durability.
We strive to use environmentally responsible suppliers and materials
to the greatest extent possible in publishing our books.

Manufactured in the United States of America

Contents

Acknowledgments

The main ideas for this book grew out of my regular graduate seminar on culture and consumption, and I thank the students who have participated in this course throughout the years, especially Johana Londoño and Jan Padios, for the inspiring exchanges that led to the overall conceptualization of this book. Each chapter, however, has its own trajectory and its respective number of collaborators, all of whom deserve my deepest appreciation. Marisol LeBrón, Louis-Philippe Michel Romer, Victor Torres-Vélez, Elizabeth Chin, and Maureen O'Dougherty provided useful comments to chapter 1. Foremost, thanks are due to Jocelyn Géliga Vargas, who prompted me to write this chapter through her generous invitation to provide a keynote at the Caribbean Cultural Studies Association conference in Mayagüez, Puerto Rico. I also thank the organizers of the conference, where I presented this work as well, and the editors of the volume, *Blowing Up the Brand: Critical Perspectives on Promotional Culture*, where an earlier version of this chapter was previously published. Chapter 2 was made possible by the many artisans who welcomed me back to the Puerto Rican folk art circuit after a decade's absence. Learning about their trajectory as cultural workers throughout a challenging economic decade was inspiring and enlightening of the love and passion that fuel artisans' continued participation in this sector. Finally, thanks are due to my sister María de los Angeles Dávila and my niece Diego Gabriel Dávila for their generous hospitality during my stays in Puerto Rico and to my parents, Diego Dávila and Laura Feliciano, for their consistent support throughout the years and for their company while I finished the manuscript during the last month of my teaching leave.

I could not have written chapters 3 to 5 without the active collaboration of my inspiring friend, the genius art historian and curator Yasmin Ramirez. Her knowledge and commitment to uncovering the hidden stories of the Nuyorican experience have always been an inspiration to my work. Thanks are also due to Randy Martin and Andrew Ross for inviting

me to present some of this work at the Cultural Studies Association conference and to Paul DiMaggio and Patricia Fernández-Kelly for the invitation to speak at Princeton's Cultural Policy Workshop. Finally, my longtime colleague Karen Davalos provided important insights and contacts for chapters 4 and 5. It was also an honor to have had the help of Miguel Luciano, who was a great supporter of the entire book even before his work became central to one of the chapters.

The chapters set in Buenos Aires were foremost assisted by Alejandro Grimson, who was a generous colleague and mentor during my stay there. He introduced me to three very talented research assistants: Laura Benas, Juan Felipe Castaño Quintero, and Ana Fabarón, who made my stay more productive and enjoyable than I could have ever imagined. Thanks are also due to Maria Carozzi for her nuanced introduction to the performance and politics of tango dancing, to urban anthropologist Maria Carman for her help and introduction to key scholars working on issues of cultural policy and creative industries, and to Judith Stacey, my tanguera colleague, who read and commented on these chapters. Yet it is to my milonguero friends to whom I am most indebted, especially to the generous and brilliant tanguera Viviana Parra and to the immigration lawyer Christian Rubilar, who shared my interest in the expat community and read and commented on this work. My conceptualization of expats' role in the global economy was also assisted by my discussions with Judith Freidenberg and Cotten Seiler, and with my longtime friend, the talented geographer Beverley Mullings, whose work with Jamaican expats provided a helpful comparative perspective. My New York City tanguero friends also offered much help and support, especially Linda and Jim Gucciardo, whose phone kept me connected during my fieldwork. Two travel research awards from NYU's Center for Latin American Studies, supported by grants from the Dean of the Social Sciences, provided travel support.

Colleagues and friends at NYU were also central to this work, especially David Privler and Marty Correia, who assisted with the illustrations and the preparation of the manuscript. Neil Brenner, Fred Myers, Jonathan Rosa, Yarimar Bonilla, Junot Díaz, Maritza Stanchich, Daniel Nieves, Marisol LeBrón, Carlos Vazquez, Johana Londoño, and Jan Padios helped me maintain a joyous approach to my scholarship and helped renew my inspiration when I felt I was running out of ideas, especially in simplifying the complexities of my book's title. Junot: I simply do not know what I would do without you.

I am lucky to have the wonderful editorial team of New York University Press. Eric Zinner was supportive of this idea since it was a mere outline of chapters; Ciara McLaughlin and Despina Papazoglou Gimbel provided the detailed assistance to turn these pages into a final product. Randy Martin, George Yúdice, and a third very knowledgeable anonymous reviewer were invaluable to my elaboration of the larger integrative conceptual themes of this work, and I thank them for their careful reading. Finally, my deepest gratitude goes to Linda Alcoff, Marcela Clavijo, Orlando Gil, and Brenda Alejandro, who provided encouragement and support at different stages of this project with their confidence and unabated faith in my work; and most of all, to all the artists and cultural workers in Puerto Rico, Buenos Aires, and New York who collaborated in this project and are identified by name, and who are the primary motivation for this work. This book is dedicated to all of you, *trabajadores de la cultura*, for the work you do and the *gozo* you impart throughout the world.

Introduction

Culture is on the rise. In most contemporary cities, there is not a project or policy without a "cultural" component, as discussion intensifies over the role culture plays in urban development projects. Tourism and shopping and entertainment based-developments are growing, while cultural workers and "creative classes," including architects, entertainers, artists, and opinion makers, are increasingly recognized to be central to the economic vitality of modern cities.[1] In this context, cultural initiatives take center stage, though not all manifestations of culture and creative workers benefit equally from this cultural turn. It is the work that culture is increasingly asked to do in neoliberalism, and the debates that ensue from the reduction and instrumentalization of culture into economic policies, projects, and frameworks, with which this book is concerned.

Specifically, the rise of neoliberal and privatizing governmental reforms are well known to have fueled disparities and struggles over cultural equity, representation, and citizenship throughout U.S. and Latin American cities. Skewed to middle-class and upwardly mobile sectors, representations of "culture" favored in urban investment projects exclude many cultural workers from access to economic investment while altogether bypassing many urban residents as consumers and beneficiaries of these initiatives.[2] At stake are issues of space, in regard to who and what should be at the center or at the margin of cultural initiatives, and questions of value around what representations are considered more or less valuable or worthy of promotion—all of which reverberate on people's social and physical mobility.

In this book, I aim to expose and challenge the taken-for-granted assumptions around questions of *space*, *value*, and *mobility* that are sustained by neoliberal treatments of culture, by exploring some of the hierarchies of cultural work and workers that these treatments engender. I draw from ethnographic research, carried out in Puerto Rico,

Latino/a New York, and Buenos Aires to highlight dynamics that under-lie different instances when culture is put to work, whether as anchor of urban development, tourism, or other creative economies that sustain neoliberal reforms throughout many cities across the Americas. The case studies place different emphasis on issues of space, questions of value, and the mobility of peoples because these elements are more salient in the cases chosen for this study, not because they are mutually exclusive to these locations. My goal is that readers will appreciate how similar dynamics of space, value, and mobility are brought to bear in each location, inspiring particular cultural politics with repercussions that are both geographically and historically specific but that are ulti-mately global in scope.

I argue that the contradictions that come about in representations and definitions of culture cannot be understood unless we take account of the different kinds of work that culture is increasingly asked to do, as well as of the constraints faced by those who seek livelihoods in the realm of cultural production. The work that culture is asked to do in neoliberal contexts ranges from producing "added value" to shopping malls to representing "authentic" views of national identity, to promot-ing tourism, to even becoming a decoy solution to massive unemploy-ment. These uses point to the growing "expediency" of culture and its use as resource for local, national, and global projects, while demand-ing more careful ethnographic examinations of culture-based devel-opments, of the dynamics that accompany culture's instrumentaliza-tion, and of the cultural policies that are launched therein (Comaroff and Comaroff 2009; Carman 2006; Yúdice 2003). I further argue that the work of culture cannot be fully ascertained without foregrounding larger dynamics of political economy and how they may be affecting creative workers and industries within particular locations, or with-out accounting for the hierarchies of evaluation that invariably pervade most institutionalized cultural endeavors.

The book's title reflects on some of the different work that culture does and is additionally inspired by a critical view of the new guiding principle of the National Endowment for the Arts: "Art Works," a declarative state-ment of the more expansive meanings that "work" takes whenever art, and for our purposes culture, is involved. In this motto, "work" designates the products created by cultural creatives, the actions that are brought about through arts and culture, whether it is to inspire, to represent, to brand, or to instill change; and it points to the fact that arts and culture

jobs represent real jobs that contribute to the transformation of the U.S. economy.[3] Certainly the linkage of work and culture predates these buoyant declarations. In particular, scholars of cultural policy have long linked the aesthetics of culture with the economic dimensions of work through analyses of the political economy at play in culture industries, especially in the fields of media and communication (Maxwell 2001; Lewis and Miller 2002). What is novel is the cheerful and widespread adoption of culture as an economic strategy freed from any critical caveat and its use as an anchor across a variety of culture industries. This context demands attention to the unique formulations of culture that are generated in different places, particularly to how dominant determinations of what is regarded as "most cultural" may affect how culture is deployed, and how cultural workers may position themselves and their work as they seek participation in diverse creative industries.

In particular, my analysis exposes the hierarchies that are created from the incorporation of culture into neoliberal developments in ways that push us to think through the very category of culture and the imperial legacies in which it is vested, and how these hierarchies may play out in contexts where culture is put to work. For one, trapped around notions of either heritage or particularities of space, location, and identity, on the one hand, and around universal notions of progress and civilization, on the other, the process of commercialization and commodification of culture into creative products and industries has never been free of contestation.[4] While discussions of creative and symbolic economies have tended to mix shopping malls, advertising, art, heritage tourism, museums, and performance spaces without distinguishing the different institutional structures and knowledge regimes in which culture is differentially instrumentalized in these spaces, it is highly misguided to lose sight of the differences. In part, the tendency to conglomerate different realms of cultural production into generalized analyses corresponds to the complex nature of cultural industries, where genres as varied as art, music, and fashion—be they popular, commercial, or avant-garde—can work in close interdependency with one another (Currid 2007). This approach also stems from the dominance of macro geographical analyses within studies of creative economies and their tendency to prioritize urban-planning recommendations and the fostering of clusters of creativity within particular locations (Florida 2002; Currid 2007).

Yet distinctions among different types of culture and creative economies are hugely significant when determinations of value in neoliberal

economies are concerned. When instrumentalized into a given festival, tourist initiative, museum, or any other creative industry, "culture" is objectified and almost always hierarchically ordered. The end product can be recognized to be in closer proximity to sanctioned Western-based forms of high art or music or else more or less inflected by mass media and commerce; it may be considered as more or less traditional or aligned to more elitist corporate visions or even sanctioned by any attendant nationalist ideology in place or else subjugated as the product of minorities. These differences are also hugely significant when assessing how neoliberalism impacts cultural production, given its proclivities for more mainstreamed definitions of culture that resemble high-art versions of Western-based culture or else for highly commercialized endeavors that are wrapped in culture only for the appearance of "distinctiveness."

Moreover, neoliberal economic logics often demand the transformation and proper repackaging of culture for public consumption, and a distancing from popular classes and histories through processes of appropriation, transformation, and mainstreaming. The result is racial and class-based hierarchies that are not only marked by the politics of representation, in terms of the cultural content alluded to or appealed to by different cultural industries, but also by the exclusion of racialized others from the production, circulation, and consumption of cultural products. These issues have long concerned Latin American scholars sensitized to how people's culture and traditions have been linked to a variety of development projects and are summarized in the title of one of Nestor Garcia Canclini's presentations on the topic: "Everyone Has Culture: Who Can Develop It?," which lays bare the gaps between the many bearers of culture and the increasingly selected few who can develop and profit from it (Garcia Canclini 2005, quoted in Lacarrieu 2008).

The blurriness that plagues many discussions of creative economies has also adversely affected the appreciation and analysis of some of the growing hierarchies at play among creative work and workers (McGuigan 2010). In the past decades, creative work, once regarded as the most protected and indispensable sector of the global economy, has become one of the most contingent and expendable types of work, especially in the most "developed" economies. Succumbing to privatization, flexibilization, and neoliberal restructuring, creative work has surfaced, in Andrew Ross's words, as "nice work if you can get it," in that it is highly regarded, creative, and sometimes highly remunerated but highly exclusive and selec-

tive, fleeting and volatile, and no more secure than work in low-wage ser-
vice sectors (Ross 2009). Yet owing to the dominance of Richard Florida's
work on creative classes, analyses have concentrated on the fate of highly
educated and skilled (white) workers who are located in the upscale sec-
tors of advertising and entertainment or in the academy, rather than on
the plight of the many grassroots "barrio creatives" I encountered in
New York City, Puerto Rico, and Buenos Aires. These creatives are just
as important to the health of global creative cities but are regularly dis-
counted and bypassed from most national and global considerations of
urban cultural policies, while they remain the most precariously affected
by neoliberalizing reforms.

My analysis foregrounds these types of differences in creative work and
economies through ethnographic explorations intended to purposefully
expose and challenge the dominant view of many discussions of culture
in neoliberalizing contexts, where culture is often celebrated because it is
seen as an antidote to economic imperatives, rather than understood as
a central component for neoliberalism's work. This approach also guides
my attention to the plight of local cultural workers and their inclusion or
lack thereof as both producers and consumers of these initiatives. Fore-
most, my goal is to explore the particularities of culture-based devel-
opments and how they intersect with politics around space, value, and
mobility whenever culture becomes the anchor of urban development,
tourist initiatives, and other creative economies as they play out in three
neoliberalizing contexts that are very different yet also similar in distinc-
tive ways.

There has been much discussion about what neoliberalism is, how it
functions, and whether this is a helpful category or instead reifies what it
describes as a static state, rather than as a process, or even if we may have
moved past its dominance to a post-neoliberal era and to newer economic
models (Peck, Theodore, and Brenner 2010). What remains undisputed is
that neoliberalism is characterized by a range of policies and a worldview
that promotes state deregulation and the privatization of services while
fostering individualism, entrepreneurship, market logics, and free-market
approaches in the guise of better and more efficient government. These
strategies of market-driven reorganization of the economy to promote
privatization have opened up fields for capital accumulation that differ-
ent states would have once considered off-limits, such as health, educa-
tion, cultural identities, sexuality, and natural resources, leading to social
tensions and inequalities (Comaroff and Comaroff 2001; Duggan 2004;

Harvey 2007). Neoliberalizing processes are also not arbitrary ones; they always involve particular states, as well as local, state, and global agents, policies, and institutions that can be ethnographically probed and examined. Moreover, research has shown neoliberalism to be a highly uneven and hybrid process—in a given society, some sectors may be undergoing neoliberalization, while others may not. In New York City, the privatization of government has coincided with the protection of taxes for government services, but mainly those services that assure the city's "security" and readiness for business (Brash 2010). Neoliberalism can also coincide with a rise of social democratic discourses. The rise of neoliberal multiculturalism throughout Latin America provides a good example, given that neoliberal economic reforms have paradoxically been accompanied by a rise in new ethnic politics and by the introduction to public and political life of formerly marginalized political actors, such as indigenous communities, often facilitated by the work of nongovernmental organizations and investments from private entities (DeHart 2010; Hale 2006; Yúdice 2003).

Neoliberalizing processes can also thrive in contexts where neoliberalism is no longer the dominant discursive political strategy and in countries that have adopted a more socialist and emphatically anti-neoliberal agenda, or as "exceptions" to regimes for which neoliberalism is not itself the dominant formation for governing populations (Ong 2006). Venezuela's hybrid "post-neoliberal order" is relevant here (Fernandes 2010). Despite Hugo Chávez's emphatic anti-neoliberal positions, his socialist redistributive reforms are nevertheless subject to the external constraints of global capitalism, to which Venezuela needs to adjust to remain competitive in the global oil market, while neoliberal market rationalities often pervade the administration and the politics of redistribution (ibid.). Similar dynamics are evident in Buenos Aires's economic restructuring. This understanding of neoliberalism as a global logic that can limit a state's anti-neoliberal strategies brings up questions about whether it is possible to think of post-neoliberal solutions and alternatives just yet. What it surely does is lead us to probe more critically into how neoliberalizing processes work, without discounting the politics that are always triggered. Foremost, understanding the scope of neoliberalizing processes becomes vital for assessing some of the political claims that they help to obscure and delegitimize at the everyday level. In this regard, my concern is with the cultural politics around the management and representation of culture that are promoted and sustained in neoliberalizing contexts, to

expose how the spread of similar market logics and discourse of efficacy and profit may be affecting the fate and politics of cultural workers.

This stance informs my discussion of culture and neoliberalism in three very different regional spaces across the Americas, notwithstanding their unique political and economic conditions. First is Puerto Rico, the neoliberal island colony whose dependency on the U.S. economy has rendered it even more vulnerable to the transformative policies of its Republican pro-statehood governor, Luis Fortuño, who took office in 2009. Fortuño has become a favorite of North American Republican leaders for his vehement support of neoliberal fiscal reforms and for his aggressive penchant for privatization. His policies have led to a dramatic shrinkage of the public sector and to attacks on important civil-sector institutions such as the University of Puerto Rico. They have also expedited the privatization of space through shopping mall construction and led to the growth of the island's culture-based informal sector as a refuge for the unemployed and underemployed; both of these phenomena are examined in this book.

Second, I focus on U.S. Latino/a politics around the financing for arts and culture as they play out in New York City, the "global capital" of arts and culture where culture's economic impact has long been recognized and where symbolic strategies of branding and marketing have been dominant for decades (Greenberg 2008; Brash 2010). Under the neoliberal administration of the billionaire Mayor Michael Bloomberg, the city has undergone rapid reforms to its arts/culture financing policy, embodying neoliberal principles that expose and exacerbate existing race and culture hierarchies among the diverse demographics that make up the city's cultural workers. These policies have launched debates around the evaluation of Latino/a art among community cultural groups in the city, debates that also reverberate in national discussions around the feasibility of constructing a National Museum of the American Latino and in the evaluation of Latino art and artists, as can be seen in my discussion of the work of New York–based Puerto Rican artist Miguel Luciano.

Lastly, I consider the case of Argentina under the anti-neoliberal administration of President Cristina Fernández de Kirchner, who is intent on reversing the ills caused by previous neoliberal reforms that led to the collapse of the country's economy. Yet Kirchner's policies have also been accompanied by a rise in entrepreneurial and consumption-based developments and by the continued privatization of natural resources, which have consolidated neoliberal class inequalities of the past. Most specifi-

cally, under the leadership of businessman-mayor Mauricio Macri, Buenos Aires has been consolidated as a city that is partial to first-class visitors and tourists, such as the many tango tourists and creative expats who are moving there on a more permanent basis, while it has become less accessible to local residents.

The similarities I found by looking comparatively at how the politics of culture play out in these three different spaces were uncanny and were revealing of some of the similar inequalities that follow the work of culture in neoliberalism, in regard to the politics of space, evaluation, and mobility. In all three cases, we see how the upscaling of culture is accompanied by salient racial hierarchies and social disparities, limiting which cultural workers and everyday people can access these spaces, while ranking their relative value vis-à-vis others and affecting their social and physical mobility.

Additionally, the three cases help to illuminate some of the racial, national, and colonial imperatives at play in neoliberalizing contexts, and how they help to inflect and politicize specific ethnic and national identifications across Latino/Latin America. The politics of ethnicity and race are most evident in the case of Latino/as, a racial minority within a nation-state, while the cases of Puerto Rico and Buenos Aires provide contrasting views of the politics of nationalism and of the colonial and imperial politics wrought by neoliberalizing processes. Cultural nationalism has historically provided Puerto Rico, as a colony of the United States, a central domain of local sovereignty, a space in which to counter its continued political and economic dependency on the United States. In this context, assertions of Puerto Ricanness have long been part of a common and contested political repertoire, as much for locals as for any major corporation seeking a stake on the island. In contrast, in Argentina—a country rich in resources that in 2010 celebrated its bicentennial as an independent nation-state—nationalism has been more subdued but not less present. It is especially expressed through the negation of Argentina's own political and economic marginality and by the affirmation of its racial and cultural synergy with dominant Western powers, a linkage that is affirmed through both tango and the immigration of international tourists. What I offer, then, is not a comparison in any conventional sense but, rather, three distinct cases that materialize some of the ethnic and national politics that accompany neoliberalizing processes across the Americas and a discussion of how these politics, in turn, intersect with particular politics of space, value, and mobility.

Finally, while my emphasis lies primarily on the work of culture as it plays out through particular creative industries and projects, this book is also about the challenges that culture poses to policies and frameworks that seek to reduce culture to economic logics. Here, it is imperative to remember that the objectification, commodification, and branding of culture that is becoming so essential to contemporary economies represents only one treatment of culture, not the whole of its meaning and what it can represent to people across the globe. Culture as industry is but a reductive treatment that cannot fully contain the variety of living and politicized manifestations and treatments of culture that are also on the rise and are mobilized as a challenge to its reduction on the basis of simple economic imperatives. These include cultural interventions such as the resignification of shopping malls as spaces for political protest; the many responses produced in the realm of expressive culture, ranging from the community-integrative work of Miguel Luciano to the alternative tango-dancing venues that thrive beyond Buenos Aires's tourist circuit; and the popular demands about what should make a more representative Latino/a museum or cultural institution. These and other responses generate alternative and wider definitions of value in cultural production, while affirming culture's capacity for inspiration and change.

Connecting the Politics of Space, Value, and Mobility

In regard to issues of space, geographers and urban scholars have long pointed to the central role that culture plays in the gentrification and transformation of urban landscapes. My own previous work on the gentrification of New York City's East Harlem, or "El Barrio," highlighted the role that consumption-based developments played in feeding residents' dreams and aspirations for their future and in expediting the neighborhood's gentrification. Projects were sold through culture (through appeals to Puerto Rican and Latino pride) in order to seek people's acquiescence to projects that did not actually include them, conveying a sense of inclusion that was largely illusory but very effective in bringing about change (Dávila 2004). Culture's capacity for illusion and for symbolically remaking spaces and institutions and products explains its predominance in neoliberal urban developments, reliant as they are on symbolic economies of spectacle, advertising, consumerism, architecture, heritage, and branding and on other placed-based, image-centered industries such

as tourism and real estate (Cronin and Hetherington 2008; Greenberg 2008). These symbolic industries and strategies have been shown to be highly effective, not only in culturally remaking spaces but also in symbolically "softening" the aggression of displacement and gentrification through developments wrapped in cultural offerings and choices that seem edgy, democratic, alternative, and even "authentic."

This is one of the reasons why Sharon Zukin is so adamant in trying to rescue authenticity from its current relegation to a "style" or a marketing ploy for creating the experience of origin and uniqueness against the standardization of urban places that results from gentrification (Zukin 2010). As she notes, whether it is by branding a neighborhood or through the creation of heritage projects or commercial endeavors—for instance, a specialized gourmet shop or a coffee house—most current developments appeal to authenticity to appear to provide alternatives for consumption and leisure that are distinct from standardized experiences, at the same time that the possibilities for authentic urban places are eroded for most working-class residents. The re-creation of Old San Juan architectural landscapes inside Puerto Rico's largest shopping mall, discussed in chapter 1, comes to mind here, especially when we consider the growing restriction and regulation of Old San Juan as a space of leisure and entertainment for popular classes.[5] This involves restrictions on local establishments' hours of operations and on popular congregations after "closing hours," the closing off of streets to cars and pedestrians, and the greater policing and use of surveillance technology, which increasingly cloud most popular events. But it also involves higher prices at restaurants and parking lots that assuredly deter families and large groups from visiting Old San Juan as a leisure destination. Hence, as Zukin notes, "to speak of authenticity means that we are aware of a changing technology of power that erodes one landscape of meaning and feeling and replaces it with another" (2010, 220); it is to erode the illusion that neoliberal planning is fostering democratic spaces, when it is whitewashed, upscale, and segregated developments that are being built and promoted.

Throughout U.S. cities, however, the continued relegation of space as it is lived and experienced by living communities feeds the ongoing tension between "communities" and "capital," well documented by scholars of gentrification. Zukin's distinction between vernacular and landscape spaces, or spaces of everyday life and alternatively of capital and power, and Raúl Homero Villa's discussion of the processes of barrioization and barriology are some important articulations of this tension, which at the

core is predicated on the also well-known tension between the exchange value and the use value of place (Zukin 1993; Homero Villa 2000). Accordingly, it is the exchange value of particular places for wresting rent and capital and for attracting the "right" cultural workers through the right cultural investments that is prioritized rather than the value that communities may vest in these spaces, especially in regard to a space's memories, its history, and how it enables social reproduction. In sum, we value speculation; space becomes valuable for the capital that it may attract, never for the value it already represents to residents because of the histories, meanings, and value that it may sustain or help reproduce.

But what if we were to consider the exchange value that is always generated from the use value of a particular community, and the way it benefits local residents, but also how it contributes to the economic well-being of the city at large? In other words, what if we stopped defeatingly pitting "communities" and their cultural agents and products against the so-called more efficient, institutionalized offerings of "real" culture industries, and instead reevaluated the profits and value generated by communities, as I try to do in chapter 3? Is it possible for a *bomba y plena* outlet not to be at odds with the coming of a cineplex? Politicians and urban planners tell us that the cineplex will assuredly bring money; the *bomba y plena* music space, not so much. Yet does the *bomba y plena* space not also produce value, of both the economic and the social type, when it provides after-school programs to children, the same services that have been cut off by neoliberal policies? In fact, should we not consider it valuable simply on the grounds that it provides alternatives for leisure, congregation, and enjoyment?

Determinations of what uses of space should be favored and what constitutes "eyesores" transcend debates over the allocation of space; they also affect the type of cultural entrepreneurial activities that may be allowable or banned from refurbished spaces, as with the Puerto Rican artisans who are increasingly policed and banned from accessing festivals, a subject discussed in chapter 2. Shrinkage of public space for debate and social gathering is a well-known outcome of the privatization of space, but so is a decline of opportunities for where alternative economic activities can take place. The sanitization of space is often accompanied by the extension of neoliberal privatization logics that demand culture to be ordered and orderly, as in commercially packaged or aesthetically pleasing to audiences, who are increasingly narrowly conceived only as consumers. In particular, the privatization of space is predicated on ideologies of con-

sumption that are used to sustain neoliberal uses of space, as in the view that what people/citizens are most valuable for is their consumer power and that the needs of global modern residents are best met through more shopping and consumer-lifestyle alternatives rather than through jobs, public services, or affordable housing. These issues are also evident in the growth of consumption ideologies in Puerto Rico and how they are being used to sustain the development of more shopping malls, exactly the type of developments least needed in this shopping-mall-saturated island.

These determinations, in turn, are imbued with questions of value. As culture attains more "expediency" and is used as a resource for a variety of economic and political ends, it attains closer proximity with economic spheres, becoming more and more subject to issues of evaluation and management (Yúdice 2003). One outcome of the "expediency" of culture is a decrease in its "transcendency," or the view that the evaluation of cultural spheres is either immeasurable or most purely defined on its own or else most starkly defined in direct opposition to commercial realms and the economy. Pierre Bourdieu's definition of the field of cultural production as the "economic world upside down" is one clear statement of this position, in which pure value is given to those fields that can most successfully "disavow" economic interests and motivations (Bourdieu 1993). Today, however, the neoliberalization of the varying "fields" of cultural production has shattered the pretense that any realm is inherently free from economic evaluation, leading to many heated debates, with some scholars defending the economic incommensurability of many aspects of social life (art, intimacy, body organs, heritage, etc.) and others advancing arguments around the economic logics that always determine their value, which could be easily determined if we could only develop the appropriate models for measuring it (Ertman and Williams 2005; Zelizer 2007; Velthius 2005). For instance, some economists researching the arts have advocated for broader conceptualizations of value that account for art's contributions to social cohesion and community development, as well as for more democratic assessments of value such as those coming from particular communities, not solely from grant makers or art professionals (Throsby, quoted in Ragsdale 2009; Holo and Alvarez 2009).

This awareness of the linkages between "value" and the cultural construction of systems for evaluation owes much to anthropological work, especially to Arjun Appadurai's helpful exposition of value as a social construction, residing not in particular things themselves (be it a work of art, an object, or a space) but rather in their circulation and exchange (Appa-

durai 1988). And far from what neoliberal pundits would have us believe, circulation is never a naturally determined process; it is always a political one, measured and structured by a larger economy, such as by urban and cultural policies and economic incentives favoring one or another cultural initiative or one cultural product or representation over another. Take, for instance, the policies that allow a Starbucks and a movie theater to benefit from tax incentives when they are part of a development, especially if it is being built in a "minority" neighborhood, while local institutions languish. Or else consider the cultural policies that lock most of New York City's government funding for the arts to a selected few institutions in the city, as I discuss in chapter 3.

In particular, Appadurai points us to the "tournaments of value," or debates surrounding the cultural construction and organization of hierarchies around evaluation that may be normalized in any given society. These may be specialized fields and arenas that are removed from economic routines but remain central for the disposition, exchange, and evaluation of goods (Appadurai 1988). One example of these specialized fields concerns the intensification of "lawfare"—or the legal means for assessing the value of property, such as through copyright, trademark, and intellectual cultural property—that has accompanied the rise in the commodification and circulation of culture (Comaroff and Comaroff 2009). Not that decades of cultural policies and legislation have made issues of evaluation any less slippery when matters of culture are concerned. Issues of authorship, identity, and appropriation remain as contested as ever, if not more so, launching legal specializations each time proprietary rights are extended to cultural forms (Coombe 1998). What this increase in "lawfare" has certainly involved is an extension of market logics and governmentalities to newer realms of social and cultural life, triggering debates over whether there are intangible aspects of social life that should rightfully defy economic logics.

One of the many difficulties of these frameworks seeking broader conceptualization of value is that they attempt to find universal paradigms for value that are not applicable to all contexts. For instance, issues of social identity such as race, ethnicity, gender, and class may affect the evaluation of cultural forms but are seldom accounted for as variables that can affect evaluation. Instead, market determinations are seen as free of any racialized considerations even when they are vested in racial assumptions and hierarchies that limit the equitable assessment of value. This book confronts this view by exposing the racial politics of creative economies,

and how those politics complicate facile arguments about the value that is always supposedly added when "culture" is put to work. In particular, economic frameworks are often unequipped to assess cultural aspects of evaluation that may be considered intangible, beyond narrow economic determinations. These are issues that the appreciation of Latino art and culture bring especially to the forefront, given the minority status of the Latino ethnic identity, and the debate over the feasibility of building a national Latino museum in the nation's capital also hones in on these issues. At the same time, the difficulties of assessing value in cultural matters should not deter us from striving for fairer cultural policies, institutions, and practices that may support more equitable relations between the cultural and economic realms. Vivian Zelizer's discussion about the intersection of intimate relationships and the economy becomes relevant in this regard. As she notes, it is not the mingling of these supposedly antagonistic fields that should concern us but, instead, how the mingling works, how it is shaped and sustained by "institutional supports" (such as by laws, practices, and institutions), and how these in turn may lead to greater or lesser equality for the parties involved in these relations (Zelizer 2007).

Chapters 3 to 5 also point to the need to challenge the individualization of creative work as the dominant foundation for determining creativity and value. Writing about the transformations that labor in creative sectors has undergone under neoliberalism, cultural policy writer Jim McGuigan warns about the risks of romanticizing individualism in creative work (2010). As he notes, a legacy of European romanticism in aesthetics since the nineteenth century, the view of creativity as an individual matter has become complicit with the individualization of work so promoted in neoliberalizing contexts. However, as he also reminds us, under neoliberal economies, individualization has become an institutionalized condition that is hardly ever freely chosen by creative workers. Instead, it has become a mantra that sustains expendability and job uncertainty, such as by placing all responsibilities and contingencies on individuals, while undermining collective protections in creative work.

The politics of individualization are especially concerning to artistic fields of cultural production. Dependent as these fields are on distinctions around individual talent and merit, they are especially susceptible to distinctions among artists and their artistic output that can be easily activated in support of neoliberal cultural policies that reverberate across all cultural workers.[6] In the case of Puerto Rico, these politics become a veil

for eliminating the little that remains of the government cultural infra-structure that has sustained the survival of Puerto Rican artisans, as well as a medium to disavow Latino artists' connections with communities. The types of collective and community demands voiced by cultural work-ers hence surface as a challenge to processes of aesthetic individualization and as a means for anchoring and materializing some of the larger social and political dynamics that both impinge on and are so central to creative work.

In sum, to engage with questions of value is to engage with politics. It demands that we expose the premises and biases on the basis of which decisions about what is valuable and worthy of promotion and preser-vation are regularly made. It also requires that we suspend the uncriti-cal view that only cultural workers and initiatives that are properly insti-tutionalized, packaged, and profitable are valuable, in order to assess broader definitions of value that account for the intangibles of social life, which are positively affected by cultural initiatives that may be discounted as insignificant according to the premises of neoliberal development.

Finally, directly connected to issues of space and evaluation are pro-cesses of mobility, or the movements of people and things that are assisted or encumbered by the neoliberal restructuring of space and by dominant logics of evaluation in neoliberalizing contexts. These dynamics have local manifestations—for instance, in the segregation, surveillance, and policing of space that keeps minorities and those without purchasing power at bay in a given neoliberal development, city, or location—but also global ones, with regard to who can travel and can access the nec-essary paperwork to become "global," versus others who are destined to remain undocumented or alien because of their race, class, or nationality.

Indeed, an extensive literature on transnationalism and globalization has alerted us to the uneven movements of people and things that accom-pany these processes; that transnationalism does not lead to the eradica-tion of national, ethnic, and racial boundaries but to a heightening of dif-ferences; and that it highly favors finance and capital over people, unless they are part of upscale globalizing classes and groups (Sassen 1999; Basch, Glick Schiller, and Szanton Blanc 1993; Appadurai 1996). These uneven dynamics are most evident in culture industries such as tourism, in which tourists, historically drawn from international middle classes, are consistently favored as primary targets and consumers for many developments across U.S. and Latin American cities, over and above the needs of local residents.

In this book, I use *mobility* to mark the politics involved both in tango tourism and in the expatriation of North Americans and Europeans to South America, discussed in chapters 6 and 7, but also to highlight how physical mobility can also have an impact on social mobility. While I am aware of a growing literature on mobility that seeks to anchor movement in political and economic processes that are often hidden when we summon categories of transnationalism, culture flows, or circulation,[7] I use *mobility* to foreground the bodies of people involved in space and time, in ways that are not so easily acknowledged when summoning other categories. My concern is a simple one: to expose that creative industries generate particular mobilities, that they favor certain type of mobile bodies while circumscribing the social and physical mobility of others.

My interest in mobility stems also from the growing penchant for the mobility of creative classes, who, following Richard Florida's mantra, have been so celebrated as the answer for transforming cities into magnets of entrepreneurship and creativity. These groups have become a core preoccupation of urban planners, politicians, and urban pundits, following Florida's recommendations that attracting and keeping creative classes happy through diverse and stimulating arts and cultural attractions will definitely lead to a city's growth and success. The global recession has since tempered urban planners' honeymoon with Florida, whose views have been amply criticized for their tautological foundations, for their obliviousness to racial and class inequalities, and for furthering gentrification and class polarization as well as the uncritical spread of neoliberal planning logics (Peck 2005; Whyte 2009). At the same time, the preference for mobility has not waned; neoliberalizing projects still thrive on the notion that the more fleeting and mobile the capital or the group, the more value it should be given and the more incentives created to protect it. The result is hierarchies of mobilities, such as those in which "larger scales are regarded as masculine and agentive in relation to 'smaller' scales or spaces (like community) that are coded as feminine and stagnant," which can be deployed to justify differential strategies for development (DeHart 2010, 19).[8] The preeminence of tourists as engines for urban growth is one instance of this type of evaluation, as is most evident in the discussion in chapter 6, but these hierarchies are present in practically all instances in which consumption-based developments rule logics for city planning.

I also want to consider mobility in relation to the strategies of creative classes, as a tactic for maneuvering through their growing material pre-

cariousness as well as the general downgrading of creative industries and jobs. In this regard, mobility surfaces as a strategy for attaining "flexible class" in a way similar to the way Aihwa Ong described Chinese transnationals' movement across states as part of their assertion of "flexible citizenship," which allowed them to circumvent political and economic conditions and limitations imposed by different states while they sought to align their dreams, familial aspirations, and economic rationalities (Ong 1999). Granted, these strategies of flexibility through mobility across nation-states favor those with resources and capital. However, they have larger implications for all creative workers by exposing the scarcities created by a global political economy that is not fully able to award people equally or to align their class, race, social and national identities, and aspirations evenly. Hence, just as in Ong's discussion the transnational Chinese's citizenship claims in the United States are limited by their race, we may well consider how the mobility of North American creative expats to the Global South may be indicative of similar limitations, this time in regard to the shrinking space for attaining "creative" class identities and for fulfilling upwardly mobile aspirations in the United States. In this way, mobilities surface as strategies for maneuvering and maximizing ethnic, racial, and class capitals against larger political and economic constraints and the limits those constraints increasingly place on the attainment of middle-class livelihoods and identities.

From Puerto Rico to Buenos Aires via Latino/a New York

The politics and the political economy of space are more directly explored in chapters 1 and 2, with chapter 1 focusing on shopping mall construction and retail culture and chapter 2 on the informal economy in contemporary Puerto Rico. An examination of the rapid boom in shopping mall construction in Puerto Rico explores a key reason why shopping malls may be developing rapidly in places where consumers are presumably most limited in cash, rather than in the most "developed" economies, where urban planners are struggling to imagine new uses for these "old" spaces. This chapter links ideologies of overconsumption and of Puerto Ricans as "shop 'til you drop" consumers to the real estate speculation that has turned the island into a shopping mall haven, with one of the largest concentrations of shopping malls per square mile in the world. I show that we need to think of these developments as being intrinsically

tied to global real estate speculation, which is aided by neoliberal governmental policies that make these massive developments an attractive investment in Puerto Rico, despite and because of its distressed economy and weakened consumer base. I also examine how shopping malls are becoming "Puerto Ricanized" through cultural appeals to Puerto Rican culture as an example of the symbolic branding of space that accompanies many neoliberal projects.

Likewise, the culture-based informal sector on the island, described in chapter 2, highlights a common problem that accompanies the sanitization of space for tourist consumption elsewhere in the Americas, involving heightened contestation over space when some cultural workers are deemed more sanctioned than others. Similar dynamics are experienced anywhere that unemployment pushes more and more people to earn a living through artisanal and creative work. This chapter examines how neoliberal policies have led to massive unemployment and to thousands turning to culture to make a living. I also pay attention to the politics of space involved in vendors' access to space, and to the distinctions among creative workers that ensue alongside these politics. Finally, I explore their quest to claim a legitimate space as "cultural workers" rather than "merchants"—the term preferred by many government officials imbued in the government's neoliberal turn—as an instance of the type of resistances generated by local cultural workers.

Questions of value are key to most neoliberal debates over culture and development, and in this book, these issues are represented by chapters 3, 4, and 5, focusing on Latino art and community organizations in New York City, on the New York–based Puerto Rican artist Miguel Luciano, and on the debate over the feasibility of constructing a Smithsonian National Museum of the American Latino. Chapter 3 explores the cultural policies that have historically disenfranchised community organizations and placed them at the margin of the city's creative economy, and it follows activism by black and Latino groups to reform New York City funding for the arts and to seek proper evaluation of their contributions to the city's creative economy. This chapter exposes, disturbs, and ultimately challenges the hierarchies of value that, nationwide, have become naturalized in our neoliberal creative economy, to the detriment of myriad cultural workers. The question I ask is, how can the city be so widely considered the global arts capital when the majority of its residents remain at the margin of its creative economy? And how would the city's economy be enriched or transformed if we began to account for

the hidden contributions of its cultural workers of color? I suggest that in order to fully consider these questions, we must first account for and address the prejudices that cloud our ability to formulate more expansive definitions of what should be considered as valuable in our contemporary cultural and creative economy. This task requires addressing head-on the elitism that dominates discussions of culture and globalization in the context or urban development.

Chapter 4, on the deliberation regarding the feasibility of constructing a National Museum of the American Latino, hones in on some of the issues that have had an impact on the evaluation of Latino/a art and culture as these play out at the national level against the larger context of contemporary U.S. racial/ethnic politics. It also examines responses at a public hearing debating the project, as a window into alternative and popular definitions of what would make a truly empowering and valuable cultural institution. Hierarchies of value also inform the work of local Latino artists, and chapter 5 focuses on the way one artist negotiates and subverts the dominant neoliberal postidentity frameworks that dominate mainstream artistic evaluation in order to produce work that remains culturally relevant and connected with particular communities.

Chapters 6 and 7, set in Buenos Aires, explore the mobilities, exchanges, and networks sustained and created through tango tourism and the racial and ethnic dynamics reflected in the global community of tango tourists, issues that are also central to many other cultural tourism initiatives launched throughout Latin America. Chapter 6 examines the rise of contemporary tango tourism in Buenos Aires and the city's tango economy in relation to its urban development and issues of cultural equity in its creative economy. One of my arguments is that tango tourism functions as a key space for anchoring Buenos Aires's new class dynamics and upwardly mobile aspirations as a "first-world" city, attracting first-class citizens from all over the world. In this regard, I explore tango tourism in a larger context in which Buenos Aires continues to redefine its identity as a white, European-like city, as the most stylish, developed city in Latin America. This time, however, this identity may not be constructed so much in reference to its European immigrant past but, rather, in reference to global tourists, on the one hand, and, on the other, to bordering immigrants from Bolivia, Paraguay, and Peru, who are increasingly challenging Argentina's dominant image as a white homogeneous country of Euro-descendants.

Chapter 7 connects the tango tourism economy to the growth of a transnational expat community attracted to tango but also to Buenos

Aires as one of the most affordable yet most "Western-looking" havens for displaced workers to live as first-class citizens. This chapter looks into how Buenos Aires's bohemian identity intersects with the global need for playgrounds fit for North American and European middle-class professional workers to live as "Westerners" or to pursue economic risks that are no longer as viable back home, as those economies wither. This makes creative expats' physical mobilities central to their strategies for social mobility amid declining economies, while exposing neoliberalizing processes to be centrally constituted by the connections between states that espouse it and those, like Argentina, that openly renounce its logics. I also explore expats' aspirations to move and the critical alternatives they sometimes represent to some of the dominant premises of neoliberal economies.

Altogether, the chapters provide lessons about the cultural politics of neoliberalism, exposing some of their contradictions and some areas where significant responses and alternative imaginings may be on the rise. Not only are these evident in the varied cultural strategies and interventions by cultural workers that are described in these pages, but they are also central to what remains culture's most hopeful and resilient trait: its power to evoke community and, through it, to bring about enjoyment and the possibility of change.

1

Ideologies of Consumption and the Business of Shopping Malls in Puerto Rico

Yes, Puerto Rico is in deficit, but have you seen how Plaza [las Américas] is always full?

I'll leave to New York, . . . but Puerto Rico can't really be that bad if the stores are always full!

I'll shop less. The clothing compradera [shopping sprees] are over, no more lujos [luxuries]. I'm going to buy the TV before it goes up in price.

These are three common responses to the Puerto Rican government's announcement of a series of emergency measures to address the island's current economic crisis (Muriente-Pastrana 2008). The sentiments contained in these statements include disbelief that Puerto Rico could in fact be in such bad economic shape when the shopping malls are always full, as well as evidence of two common economic coping strategies: emigration, to improve one's financial situation, and more consumption, as in "Time to go purchase that discounted TV." The view that things cannot be that bad because people are shopping is at the core of Puerto Rico's economic deficit-consumption puzzle. How can the island appear to maintain a strong retail profile when it is mired in unemployment and underemployment? Why are shopping malls full? Where is the money that drives this consumption coming from?

That Puerto Ricans like to shop is a common cliché. While I conducted research on the island, whenever I described my research on Puerto Rican

shopping culture, I was met with a similar response, often voiced with a mixture of pride and embarrassment. "Of course, shopping is our national pastime," one person said. "Puerto Rico is the country that consumes most throughout Latin America," said another, who reminded me that Puerto Rico has one of the largest shopping malls (Plaza las Américas) and the greatest number of shopping centers per square mile in the hemisphere. People were quick to recall such statistics, but no one could point me to the source for these "facts." They had become ingrained common knowledge, as Puerto Ricans described themselves as the most avid of conspicuous consumers, with impulse shoppers, *novelistas* (easily swayed by the new), and *despilfarrador* (money squandering) among the descriptions most easily summoned. In sum, consumption was seen as the greatest cause of Puerto Rico's economic ills but also as an important sign of Puerto Ricans' sense of humor and optimism—the feeling that a more prosperous day is on its way.

As a Puerto Rican anthropologist who has lived most of her life in New York, returning to the island on a repeated basis, I have grown accustomed to this dominant myth of the Puerto Rican "shop 'til you drop" consumer as well as quite skeptical of it. Despite Puerto Ricans' vehement self-characterization as the most avid of consumers, the discourse of overconsumption as constitutive of national character is common among modern and modernizing citizens around the globe. It is also increasingly central to consumers' general critique of and engagement with consumer society. Additionally, research on U.S. consumer culture has long documented the ways in which consumption by marginal groups in society, be they blacks, Latinos, or women, is often pathologized as aberrant, irrational, and out of control, in reference to an imagined rational consuming subject who is thrifty, savvy, and immune to the seductions and deceptions of the market. In other words, while consumption has long served as a primary medium for the assertion of modernity, progress, and national identity both in the United States and in many modernizing countries around the world, it has always been a contested territory in which societies debate status, merit, class, and identity around notions of proper and improper types of consumption (Cohen 2003; Miller 1995; Liechty 2002).

In particular, ever since Thorstein Veblen's late-nineteenth-century discussion of women's role in fueling conspicuous and wasteful consumption, scholars have shown how consumption by marginal groups in society is often the most policed, scrutinized, and disparaged. These groups are not only purchasing goods, but they are also seen to be compensating for status, belonging, and even identity itself (Chin 2001; Halter

2002; Veblen 1994; Zukin 2004a, 2004b). When generalizing notions of Puerto Ricans as uncontrolled ultrashoppers, Puerto Ricans may therefore be subscribing to dominant discourses often circulated about groups perceived to be less "modern" or less equipped for modernity, in not dissimilar ways to how colonized groups often blame their subjugated status on their own indolence and lack of entrepreneurship. And, one may ask, why should we not police our own overspending and that of those who are most marginal among us? Does it not make sense that these groups should be chastised for their overconsumption and, especially in times of economic crisis, be deterred from shopping in the first place?

In this chapter, I argue that we do not know enough about the consumption practices of Puerto Rican consumers, or of any consumer for that matter, to be summoning such quick generalizations about them. When we do so, we may be veiling the larger political and economic interests that shape and profit from the myth of the "shop 'til you drop" consumer. For one, subscribing uncritically to this view masks the contextually specific uses of the global discourse of overconsumption in particular locations, as well as the multiple political and economic interests that this discourse may be designed to serve. Specifically, this chapter points to how this discourse helps further the neoliberalization of space and how it may contribute to real estate speculation and to the business of shopping mall construction.

Indeed, the growing recognition of consumption as a central practice and discourse for modernity has yielded few ethnographic studies that account for consumption practices in the so-called developing world. Also unexplored are the global trends fueling a boom in shopping mall construction in places such as China, Latin America, and Russia at the very same time as the U.S. retail sector is in decline.[1] This chapter attempts to address this quandary while adding to a growing literature on Puerto Rican consumption culture (Ortíz-Negrón 2007; Dávila Santiago 2005). Laura Ortíz-Negrón's work, in particular, has documented the rise of a dominant anticonsumption discourse in Puerto Rico, most strongly represented by state institutions and the church, which posits consumption as an amoral activity that destroys local culture as well as social and family ties. In contrast to this view, local scholars have noted the numerous ways in which individual practices of consumption such as shopping and visiting the mall provide possibilities for social interaction and crucial opportunities for claiming identity (Dávila Santiago 2005; Ortíz-Negrón and Guilbe López 2005). My own work draws from and contributes to

contemporary research on shopping and consumption by anthropologists, geographers, and cultural studies scholars who have critically probed this realm of practice to expose some of the ways in which people resignify consumption and the shopping mall as a space of sociality (Miller 1998; Wilson 2002; Zukin 2004b). It is important to exercise caution when pursuing this line of inquiry, however. At times, these narratives reinforce some of the dominant local discourses on shopping that reinstate the consumer as an active agent, while losing track of the subordination that is also experienced at the mall. In other instances, they further a romanticized view of consumption and consumption sites as democratic spaces that are open to everyone, whether one comes to shop, browse, or hang out. Uncritically embracing this view hinders a full examination of the existing social inequalities that are actively reproduced in these spaces. A poignant example is the common resignification of the shopping mall as the new version of the public square, a site for an array of social activities. Such a view overlooks a number of problematic features of the mall, such as its ongoing sanitization and policing, as well as its purposeful exclusion of informal vendors, beggars, vagabonds, and the homeless, among other people who are not so easily kept at bay in the public street (O'Dougherty 2006; Ortíz-Negrón and Guilbe López 2005; Zukin 2004b).

My research draws from observations and interviews at shopping malls in the metropolitan area of Puerto Rico. I conducted the majority of my ethnographic fieldwork in Plaza Rio Hondo, a 538,442-square-foot shopping center located in Bayamón, a municipality in the metropolitan area. The mall is situated in a central hub of retail activity, surrounded by six other shopping malls within five miles of the site. Rio Hondo is anchored by Big Kmart, Best Buy, and Marshalls Mega Store and has a representative mix of stores that one would find in most shopping malls throughout the island—namely, a mix of tenants selling moderately priced and average- to low-quality women's attire, such as Click, Kress, Payless, Rave, and Infinito. The more "upscale" stores, such as Banana Republic, Ann Taylor Loft, and The Gap, are found at Plaza del Sol, the nearest shopping mall to Rio Hondo. Rio Hondo opened in 1982 and was purchased in 2005 by Developers Diversified Realty Corporation (DDR), a U.S. company that acquires, develops, leases, and manages shopping centers. DDR's corporate overview indicates that the company "owns and manages approximately 520 retail properties in 41 states, Puerto Rico and Brazil totaling approximately 127 million square feet," making it one of the world's largest managers of shopping malls (Developers Diversified Realty 2011).

My research involved observations of retail activity and interviews with shoppers throughout the mall and in the food court. I literally went shopping on a daily basis, browsing through racks of merchandise alongside other customers, which allowed me to probe them about their shopping experiences, their assessments of prices, their shopping techniques, and so forth. I also offered a ten-dollar Kmart gift card as an incentive to ten respondents who agreed to provide longer interviews about their shopping habits. These observations were complemented with research on the retail industry on the island and the way this industry is marketed to the Puerto Rican shopper.

The Welfare State Goes Shopping

By all economic measures, Puerto Rico's economic profile could not be more dire. Annual income per person on the island is less than half that of Mississippi, the poorest U.S. state. More than 48 percent of island residents live below the federally defined poverty line, while with an unemployment rate of 12 to 19 percent, a large percentage of the local population remains idle. An article in the *Economist* magazine estimates that "half the working-age men in Puerto Rico do not work" and that federal transfers "make up more than 20% of the island's personal income." The article goes on to note that federal transfers coupled with a little income from informal work surpasses the wage one would get in the open market, though with far less work ("Trouble on Welfare Island" 2006, D12).

This situation has led numerous scholars to describe Puerto Rico as the colonial welfare state par excellence. In particular, economists have noted the island's dependency for jobs on an extremely vulnerable and increasingly indebted public sector and a declining manufacturing sector, which has rendered it unable to function without federal social welfare funds and other direct forms of aid (Morrissey 2006; Grosfoguel 2003). Most pressing, the island's dependency and economic vulnerability have made it extremely susceptible to the U.S. economic recession. Indeed, Puerto Ricans have experienced the effects of the recession more severely than have people in the continental United States. For instance, while Americans were complaining of rising living costs when the consumer price index rose by 2 or 3 percent, in Puerto Rico the consumer price index was up 15 percent by 2006, with basics such as water, electricity, food, and fuel becoming more out of reach for the Puerto Rican consumer (Dougherty 2007). Additionally, the rise in fuel

costs adds to the price of most consumer products, which already carry high transportation costs to import into the island. The result has been growing inequality as the middle class increasingly shrinks, leaving behind, as one informant put it, "the rich, the poor, and the even more poor."

Tellingly, on the morning of January 9, 2009, the government of Puerto Rico declared the island to be in a state of emergency, announcing the freezing of all new government hires, the firing of over eleven thousand government workers, and a proposal for new taxes on consumption goods such as cellular calls, cigarettes, gasoline, and alcohol. Shock waves were felt throughout the island. Cries of foul play were voiced by listeners on the AM talk-radio circuit. Callers and local economists were especially outraged that consumers would face 75 percent of the proposal's impact, versus the 15 percent the government would face and the mere 10 percent directed at the private sector, the richest sector of the island, despite the recently elected government's new platform that it would not raise new taxes and would place residents' interests first (Díaz 2009, 30).

In sum, the average Puerto Rican consumer is largely overspent and in debt. This dire situation has been documented by the Center for the New Economy, a nonpartisan economic think tank, which has shown that the average resident's spending and debt far exceed what he or she generates in income, a pattern that is unsustainable in the long term. This was evident in my interviews, in which almost everyone I talked to admitted to being in debt, primarily credit card debt, and in which not a single interviewee imagined being entirely free of debt in the foreseeable future. Some spoke of managing to stay afloat through the common practice of *barajeo*, which literally refers to the shuffling of playing cards but in this context refers to the payment of credit cards and bills in an alternating fashion or paying off one credit card with another.

Despite this dire economic portrait, the retail industry continues to promote Puerto Rico as a paradise of riches, boasting about the particularities of the stretched and indebted Puerto Rican consumer. Puerto Ricans, like other Hispanic consumers, typically have large households, which facilitates the pooling of resources, such as using funds from grandma's pension and saving in rent and household costs. Economists have also accounted for the role played by the informal economy, both the drug trade and other more socially sanctioned types of informal work; the pooling of resources from remittances from relatives in the United States; and the easy availability of credit and loans, as measures to help make ends meet and keep up consumption levels (Duany 2008; Enchautegui

2008). Puerto Rico's economic situation is additionally buffered by the island's political status as a U.S. commonwealth, providing residents the safety nets of federal transfers and welfare benefits that help maintain consumption levels. Then there is the fact that the island's high population density almost guarantees good numbers for retailers, as higher population density is translatable to higher sales per square foot.

Indeed, since the 1990s, the island has undergone a retail revolution, with half the shopping centers on the island being built after that time (Gigante 2000). Spearheading this development were governmental policies aimed at deregulating the project-review policies and requirements of the island's planning office. From the 1990s onward, viability studies and other requirements were consistently bypassed for the sake of "efficiency" and the fast-tracking of projects, leading to the construction of megastores and shopping centers like never before. A representative of DDR recalled, "In the 1990s, banks would just open the door. Once you had the first project built, you had a credit line to build three more, . . . and you had development land and few barriers. You'd simply go to a hearing and there would be no opposition, and the land was yours." Not surprisingly, the retail growth was primarily led by acquisitions and investments from North American investors such as DDR, which launched the largest investments with the purchase of fifteen local malls, among them the Plaza Rio Hondo shopping center (Rivera-Galindo and Alameda 2002). DDR's statement to investors about its move to Puerto Rico confirms the "business friendly" qualities that attract retailers to the island.

> [Puerto Rico is a] densely populated island whose economy is fueled by consumerism; combined with physical barriers constraining new supply this creates a highly productive retail environment. . . . Developable land is limited due to physical barriers of mountains and floodplain; as a result the major retail trade areas are mature and very dense. . . . Other attractive factors for the DDR were malls' occupancy rates, which average over 95%; consumer spending that is more than double that of the mainland U.S.; and a business-friendly approach to investment, offering businesses faster permitting, less regulation, favorable taxes, and lower operating expenses than on the mainland. (Rosa 2006)

In other words, Puerto Rico is attractive because its physical containment, high population density, consumerist culture, and lenient regula-

tory practices make it an obvious destination for major retailers. Puerto Rico has also been systematically sold and treated as a "pet market" for retailers seeking to expand to Latin America. Maria Bird, a journalist with the Latin American division of *Shopping Centers Today*, the journal of the International Council of Shopping Centers, which is the global trade organization of shopping centers, explained to me, "Retailers have the best of two worlds in Puerto Rico. They have the high consumption and the flashiness of the Latin American consumer, who likes to buy brands and show off what they buy, with the access to the U.S. credit system and the accessibility of cheaper goods." Puerto Rico's status as a "paradise of riches" relative to other Latin American markets is also tied to the higher import tariffs faced by Latin American consumers, which directly impacts on the slow merchandise-rotation rates there. As Bird continued, "In Puerto Rico, something is always going on sale because you have new goods coming up. You can go to the mall and always find a blouse on clearance for seven dollars." Notably, people in the industry pointed very matter-of-factly to the bounty produced by the drug trade and the informal economy as a key factor behind the retail industry's success. I was told that just the trade in cocaine leaks one billion dollars to the Puerto Rican economy, with informants suggesting very straightforwardly that retailers' economic measurements are not limited to official economic statistics but rather are much attuned to any new source of wealth, wherever it comes from.

Puerto Rico's attractions to the shopping mall industry were amply praised during the meetings of the first Caribbean Conference of the International Council of Shopping Centers, which in 2011 was held Puerto Rico, especially by the sophisticated PowerPoint presentations of government officials representing the strongly neoliberal administration of Governor Luis Fortuño to an audience of shopping mall entrepreneurs from the United States and Latin America. In fact, the island's chief of staff, Marcos Rodriguez-Ema, could have been easily confused with any of the shopping mall investors there, given his overt enthusiasm for the industry and the many business-friendly government reforms he flashed to them as bait, such as promises for the faster processing of permits and tax reforms that will reduce corporate taxes from 41 percent to 25–30 percent.

Still, the retail sector has not been exempt from the economic crisis. Even the most confident business sources acknowledge that Puerto Rico's consumer spending has started a recessionary phase and that it is not

expected to expand or to grow significantly in years to come. In 2007, Puerto Rico remained among the top-ten retail markets in the United States mainly because of the sales at large retailers such as Wal-Mart, Sam's Club, Walgreens, Marshalls, Pitusa, KB Toys, and Best Buy, which are able to slash prices to keep sales competitive so they can remain strong (Ryan 2009). Yet the retail industry's practice of measuring the island's retail status on the basis of sales at *megatiendas* such as Wal-Mart is quite deceiving; the practice yields high numbers in sales for mega-stores while masking the declining rate of purchases at most other retail stores, especially the small merchants who are unable to offer compara-ble prices. In other words, megasales at Wal-Mart imply not that Puerto Rican consumption is growing at a limitless rate but that consumption is simply shifting from more expensive local venues to the cheaper dis-counted megastores, the only sector experiencing steady and rising sales.

Lastly, it is important to point out the trend in real estate specula-tion in the business of shopping mall construction. This is the business of building malls and purchasing lands with government incentives that renders shopping malls a highly profitable investment, irrespective of actual sales, which evokes the make-believe qualities in neoliberal capi-talism, in which the mere illusion of profits becomes a source of value (Comaroff and Comaroff 2001). After all, the business of shopping malls is not limited to the management of commercial establishments; instead it is intimately tied to the leasing and management of space itself, which constitutes the industry's most profitable asset. Hallways and corridors are regularly rented to companies as display space for marketing promo-tions or are turned into additional retail space through the installation of temporary stands. The DDR representative I interviewed even boasted about a new solar initiative that was currently under development as part of the company's "assets management" program. Under this program, the company would reap profits from leasing the over five million square feet of roof space above its shopping mall properties or else from producing energy that could then be sold to the local electric company (Autoridad de Energía Eléctrica).

What is more, in 2007, the Puerto Rican government sweetened the pot still further when it approved House Bill 3540, which extended pass-through tax exceptions at the corporate level to retail real estate invest-ment trusts (REITs) to stimulate investments in retail properties (Ryan and Carmona 2007). Tellingly, DDR, the company behind the largest shopping mall deal on the island, was among the first self-administered

and self-managed REITs to benefit from the new legislation. Sergio Marx-uach, policy director at the Center for the New Economy, was unwavering in his criticism of the new policy. In his view, it simply did not make sense. As he noted, "You grant tax exemptions to attract new industries or to economic sectors that require incentives for growth, but it's not like we have a scarcity of shopping centers on the island!" He was also concerned with the lack of guarantees that new shopping malls would in fact produce new jobs and growth, despite the handsome government incentives.

A 2008 survey of shopping malls by the Puerto Rican Commerce and Trade Association corroborates Marxuach's concern. Puerto Rico, which is approximately one hundred miles long and thirty-five miles wide, has 317 malls.[2] This number does not include some key projects that have been approved since the survey was taken, nor does it include others that are being currently proposed, such as the two megaprojects, each involving over five hundred thousand square feet of retail space, that have been proposed in close proximity to Plaza las Américas. And then there are the additional commercial projects that the government is actively luring as a component to some of the many private mixed-use tourism- and entertainment-driven developments that are currently in the works all throughout the island.[3]

Most important, this number was not easy to come by. One of my most surprising findings was how difficult it is to find an accurate count of how many shopping malls there are in Puerto Rico. The local planning office relies on information from the federal census, which collects the number of commercial establishments and how many are located in malls but does not document the actual number of shopping malls. The uncertainty is also fed by many development proponents, who argue that, contrary to common lore, the island is "seriously undermalled" and in dire need of more establishments (Parra-Blessing 2007). Tellingly, this argument is based on commercial proprietary studies in which loose generalizations are common. One such study recently argued that a healthy retail market demands at least ten square miles of shopping center retail space per person, while the island has twenty-four million square feet of total shopping mall retail space and four million residents, which comes to only six square feet per person—a number that, very revealingly, does not take into account retail stores outside the perimeter of the mall, such as local retailers and mom-and-pop shops (Parra-Blessing 2007).

Even Elliot Rivera, the former president of the United Retailers Associations, considered the debate over whether the island is under- or over-

malled one of the biggest local *"rompecabezas"* (jigsaw puzzles). "Puerto Rico suffers from too much propaganda and too little facts," noted Rivera.[4] What cannot be denied are the ill effects of the shopping mall bonanza among small retailers: from 1993 to 2001, a period of rapid expansion in shopping malls, there was a sharp rise in bankruptcies among small retailers, for an average of 398 bankruptcies a year (Rivera-Galindo and Alameda 2002). Yet the "Walmartization" of the island's retail sector raises concerns that extend from its effects on the survival of local merchants: there are also the pressing fears about its likely impact on the island's physical landscape—will Puerto Rico become entirely enclosed by Wal-Mart stores and shopping malls (Alvarez Curbelo 2005)?

Not surprisingly, the ongoing speculation in the business of shopping malls and the involvement of stateside investors are largely hidden from public view by marketing strategies that help to "Puerto Ricanize" investors' shopping mall ventures. A stellar example is the media and marketing campaign that DDR commissioned from Cohn Marketing, a Denver-based marketing agency, after its purchase of fifteen shopping malls. Its object was resignifying and unifying the fifteen shopping malls into a single brand: the "Isla" shopping centers, or the shopping centers "of the island." The campaign involved the launching of events and promotions, such as "Chicos con Corazón" (Kids with Big Hearts), a contest to select the children who most contribute to their communities and their *isla*; the "Mi Isla" gift card, which can be used in any of the fifteen malls; and the magazine *Isla Estilo*, promoting events and sales throughout the malls (González and Hermilla 2008). The campaign's visual imagery used an *amapola*, a popular flower on the island, and depicted local scenes and imagery, including the *coqui*—a tiny frog that is reputed to die if it leaves the island and is a premier symbol of Puerto Rican identity—along with beach shore scenes and an Old San Juan *garita*, a Spanish Colonial guard post evoking Old San Juan's historic architecture.

The extension of tax exceptions to shopping mall developers implies that we are likely to see the continuation of the retail frenzy and the proliferation of even more shopping malls throughout the island, even though the industry's growth has undoubtedly slowed since the 1990s. After all, the majority of the most coveted coastal land, accessible by the two main highways circling the island, has already been taken up by shopping centers. Will the interior land suffer a similar fate? If so, we are likely to see similar developments, copies of the many architecturally uninteresting white-boxed malls that drivers encounter along the highway. Writing on

why shopping malls tend to be so predictable in their design, Paco Underhill (2005) notes the disconnect between the real estate developers who make and invest in malls and the retailers and "merchants of style" that are meant to be housed there. Consequently, unless a mall is purposefully developed as part of a tourist or cultural "destination," its design has always been a secondary concern to the building's function and cost. Constructions have minimal architectural value and are made up of clusters of stores organized around flagship stores at a distance from one another to maximize traffic and exposure to stores. Exposure is also aided by escalators that force shoppers to move across halls to reach their destination and bathrooms that are inaccessible or hard to find. Most noteworthy, malls' design and location renders them far from the open spaces, accessible to anyone, that malls may present themselves to be. For one, they tend to be inhospitable to public transportation; one has to drive to get to the mall, and throughout the United States, hindering a mall's access to public transportation is a common measure to exclude minorities and the poor from accessing the mall (Chin 2001).

This was the case at Rio Hondo, where the attendant at the customer-service kiosk looked puzzled when I asked for the public bus routes that came closest to the mall. She did not know, and from the look on her face, I could tell that this was a question she had seldom been asked. Granted, in Puerto Rico, where there is a lack of viable and dependable public transportation, owning at least one car per household is not a luxury but a necessity to participate in public life. Nevertheless, car ownership is one of the necessities most affected by the recession, the expense most informants had either cut, reduced, or eliminated as part of their cost-cutting measures. That Puerto Rican malls are packed should therefore not be regarded as proof of the island's robust economy or of the total population's economic health but, rather, as a sampling of those who have access to transportation and money, which can be simply the same percentage of the population that regularly goes to the malls, whether to shop or not. Indeed, browsing through Rio Hondo and its sister mall, Plaza del Sol, on a Sunday afternoon, one would think that Puerto Ricans are the most upscale and best dressed people in the world. Well-dressed and well-coiffed people predominate, whether entire families, women with children, or women with other women and youth. At the mall, everyone seems to be doing well, or at least well enough to have paid the necessary "symbolic dues" to assert one's right to belong at the mall by performing the role of a potential consumer (Zukin 2004a, 2004b). In contrast, people "out of place" were very easy to spot,

as was the vendor of Christian wares I encountered on a Monday morning, within five minutes of entering Plaza las Américas. The heavyset, dark-skinned woman, dressed in sandals, a T-shirt, and a long skirt, stood out from the mostly professionally dressed visitors who enter the mall in the morning. Her outsider status was easily signaled by the overstuffed bright-yellow bags she carried—the type that need to be reinforced and have "Cash and Carry" written on them, rather than the stylish logo of a Plaza de las Américas establishment. She is often asked to leave, but she is not easily deterred. It is part of her religious mission to persevere, she tells me, adding that she has become quite savvy in avoiding the guards.

The point is that people's symbolic performances, as in dressing up and looking good to go to the mall, are not appropriately interpreted as signs of their economic health or ability to spend. Shopping, after all, is an ancillary activity and is not always the primary reason to go to the mall. Meeting friends, browsing, breaking the day's routine, and accessing free air conditioning all were mentioned as common draws to the mall. The work of Puerto Rican sociologist Laura Ortíz-Negrón (2007) is relevant here. It shows that the mall should not be considered a monocultural space. It is used for a variety of activities and events that would once have taken place downtown or in the township but have now moved to the mall. Each mall has its own character and cultural rhythms, and class and generational markers are not uncommon, as they are signaled by the types of events that are marketed and the social and cultural activities that are held at different malls.

Retailers are not unaware of the multiple activities that shoppers engage in at the mall besides shopping. These activities are, in fact, encouraged by an entire industry of shopping mall marketing and interior design intended to transform the mall from a generic white box into an enticing destination accommodating everyone's needs. In particular, Puerto Rican malls have seen the development of interior built environments and what geographer Jon Goss has termed "pseudoplaces" that encourage the "fantasized dissociation from the act of shopping" by fostering other activities and events (Goss 1993, 19). Throughout U.S. malls, similar pseudoplaces involving the commodification of space have been built that either exploit the nostalgia for an authentic community—the re-creation of Old San Juan architecture in the Plaza las Américas movie theater corridor is a perfect example of this strategy—or add attractions and displays, such as carousels, art exhibits, entertainments, plants, and sculptures, that involve the thematic imagining of space (ibid.).

Re-creation of Old San Juan architecture at Plaza las Américas
Cineplex. (Photo by the author)

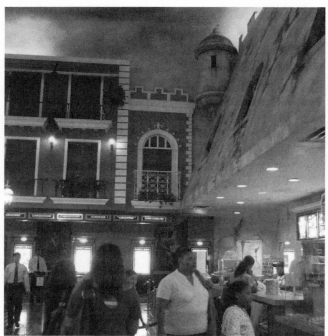

Re-creation of Old San Juan architecture at the movie concession
stand in Plaza las Américas. (Photo by the author)

Re-creation of Old San Juan architecture at a corridor in Plaza las Américas.
(Photo by the author)

Rio Hondo is lacking in pseudoplaces—there are no carousels, fountains, or special decorations to be found. But it has a well-lit twenty-thousand-square-foot food court, El Embarcadero, that serves as a draw. Retailers design food courts such as El Embarcadero to help convert "the inefficient"—in retail lingo, those who have the "lowest conversion rates" or who are least likely to buy—into prospective buyers, at least of snacks and drinks at the food court (Underhill 2005). For everyone else, however, the food court is far from a "conversion" space. Instead, it is a space up for grabs. A group of teenage girls who bought drinks but shared goodies and junk food they had bought elsewhere (such as candy that was not sold anywhere near the vicinity of the food court) and had their bounty spread out at a food court table comes quickly to mind. At the same time, people's strategies to retake the mall via other social activities beyond consumption do not imply unawareness that they are occupying a space of consumption and that their reappropriation of this space needs to be qualified in retail terms.

A well-documented group of mall users is the *caminantes*, a group of senior residents who have appropriated the mall as a safe space for exercise, as they have throughout many malls in the United States (Ortíz-Negrón and Guilbe López 2005), and it took me just one visit to discover

a group of senior citizens fitting that description in Rio Hondo's Embarcadero food court. I met the Rio Hondo Rascals, a group of retired men over sixty, who were easy to spot around the buzzing crowds of families and youth. The Rascals come every other day to the mall. One told me that he had been visiting the mall for over twenty years, since it first opened in 1982. They do not come to exercise but rather to socialize; they sit at the same table and made a point of distinguishing their group as the best group in the mall, particularly by drawing distinctions between their table and the nearby table, "*la de los Medicare*," or "the Medicare table." This name supposedly signals the poor health of the people frequenting the adjoining space, through class distinctions marked by their reliance on government insurance are likely also at play.

The Rascals are all retired from well-paid professions, by Puerto Rican standards—the post office, the Bacardi Rum Distillery, the telephone company—and they now enjoy relatively good pensions. They come to chat, to converse, to joke with one another, and sometimes to eat lunch, and they spend somewhere between two and twenty dollars each per visit; they were not certain of the exact amount because they take turns paying for one another, whether it is coffee or a full meal. My observations, however, suggest that they consume a lot less than they let on: whenever I saw them, their table was always clean and empty, without a trace of food purchases, and they seemed delighted when I offered them a complimentary round of coffee.

Yet once again, and returning to the symbolic performances that are part of people's claims to the mall, the Rascals insisted on being consuming subjects, on spending money. "There are no senior citizens' discounts here. We're like everyone else," one noted. As such, they gave evidence of being fully aware of some of the distinctions at work in determining who can access the mall as a space of leisure and who cannot, or should not. These distinctions not only included the ability to purchase items but also extended to codes of behavior. One explained, "We only allow people with good manners to sit at our table. We don't want to be called '*viejos verdes*' [dirty old men]. . . . We're professionals; we don't socialize in *plazas públicas* [public squares]. We come to the mall." For them, "good manners" means refraining from addressing women inappropriately, from being loud, and from engaging in the type of banter that in their view belongs to a *plaza pública*, not the mall.

In this way, as Sharon Zukin (2004b) tells us, the act of "dressing up" is best seen as part of consumers' self-disciplining in order to appropri-

ately participate in the not-so-public space of mass consumption. This act entails considerable stress—one must pay to look good, determine what would look good, and so forth—but also considerable joy: the joy of asserting one's upward mobility, one's status, and one's respectability and of having these qualities recognized by others. As one of my interviewees explained, "I dress up because I may bump into someone I know. . . . Seeing fashion live is different from the TV. Here, in person, you can tell if something will suit you." She went on to explain how much she loves to people-watch and to see how people dress at the mall, fully aware that while she was engaged in people-watching, she too was being put on display for others to see.

Finally, it is important to note that conducting research on shopping malls involves a self-selecting process, since it includes only those sectors of the population that are likely to participate in this realm of consumption, because they have either money to shop or else the social and cultural capital to feel comfortable and welcome to browse the mall or to use it for leisure and fun. In sum, mall-goers are undoubtedly a highly diverse population, but generalizing about the totality of the Puerto Rican population from those who go to the mall is misguided. So is drawing larger patterns about people's consumption habits from one or two purchases observed or recalled by informants, without first contextualizing them within the particular social and cultural norms in Puerto Rico.

I recall my own ethnographic research with Hispanic consumers in the United States and how it directly contradicted dominant images circulated about them by Hispanic marketers. Marketers described them as the most brand loyal, most traditional, and least likely to try new brands, while my informants revealed that it was price and availability that mostly guided their shopping selections (Dávila 2001). Similarly, Elizabeth Chin's ethnography on black kids and consumer culture in New Haven, Connecticut, showed that while these kids are regularly stereotyped as poor yet conspicuous consumers—willing to die or kill for a pair of brand-new sneakers—the kids she worked with were tempted but did not succumb to logos and brands; they simply could not afford them. Instead, Chin found that they made rational and calculating choices in their purchases and spent money (given to them by Chin as part of the ethnography) on practical items or gifts for the family (Chin 2001). My observations with Puerto Rican shoppers showed similar contradictions between the discourse and the practice of consumption. It is to these dynamics that I now turn.

Going Shopping: "Nada de eso de que tengo calor y estoy aburrida" *(Never because I'm hot or bored)*

Despite the intense desires of retailers and shopping mall investors and the dominant folklore, Puerto Ricans are not a homogeneous mass of consumers. Even within a single mall such as Rio Hondo, which is considered a more modest and accessible mall, there were visible distinctions among customers, as well as evidence that impulse and leisure shopping characterized only a selected group of visitors to the mall. Customers entering Kmart, primarily mothers accompanied by their children and families or shopping alone buying "*lo necesario*" (the necessities), differed from the more upscale shoppers, oftentimes the pairs of women friends, who limited their visit to Marshalls, a store known as more upscale because of its discounted designer ware. Many young women flocked to the sales racks. They restricted their browsing to sale items displayed in store entrances, refraining from entering stores altogether. Others carried shopping supplements as a guide to find the best sales. These are the type of glossy and colorful flyers, or "shoppers" as they are locally called, from Wal-Mart, Kmart, and other establishments that in the United States would be limited to weekend newspaper editions but here are a regular complement to local papers.

In particular, the women whose husbands' working hours had been reduced or eliminated altogether took pains to clarify that they were at the mall to buy only "*lo necesario*," as opposed to "*la compradera*," or the freestyle shopping that they attributed to others, never to themselves. Elsa, a twenty-six-year-old mother of two who works at home and whose husband's hours at work had been cut, described having to return all the clothes and materials she had purchased for her kids; they were no longer going to a private school, as there was no money for school dues or uniforms. She used the Kmart card I gave her strictly for her kids' back-to-school purchases. In this way, again and again, shoppers gave signs of being calculating rather than compulsive shoppers. There was the fitting-room chatter about whether one had checked prices at Click or Rave before purchasing the item at Kress, as well as the many women who walked into stores carrying shoppers and coupons. At times, especially before lunchtime, the stores seemed desolate. In this regard, I should note that I conducted the bulk of my fieldwork during January, in what is regarded as a commercial *tiempo muerto*, or dead time, when people are

outspent after the holidays. Puerto Rican consumption is fueled largely by holidays, and this too brings attention to the social aspects of consumption and to the seasonal patterns of gift giving and reciprocity that serve to spur, but also to deter, shopping throughout the year.

People recalled the last "*gusto*," or treat, they gave themselves with joy and glee: the eighty-dollar Chanel perfume bought at Sears that a retired woman bought herself or the two pairs of shoes with rhinestones, $49.99 each, bought by a nurse working at a government medical clinic in Barrio Obrero, a well-known working-class neighborhood. These were the first shoes this woman had purchased, rather than inherited from her sister, in years. There was also the single mother who bought herself a pair of shoes when she learned they were half price, after purchasing the pair of shoes she had come to buy for her daughter. She was excited about this special offer because she shared her daughter's shoe size, and, between them, they now had two new pairs of shoes. Far from impulse shoppers, these customers represent women who buy treats for themselves with great calculation and who recall their shopping adventures at the mall with relish, because while visiting the mall may be a common occurrence, shopping for something for themselves was considered a special treat.

Even young working women, who emerged as the most frequent and enthusiastic shoppers, gave signs of thriftiness and calculation. Claudia, a twenty-four-year-old university student I met at the women's clothing store Rave, was purchasing two shirts on sale at eight dollars each. She works at a retail store and lives with her parents, a common measure to pool resources and cut costs among young people on the island. Her parents pay most of her living expenses, leaving a car payment as her biggest expense. She goes to Rio Hondo for lunch and browses the clothing stores almost daily, frequently leaving with a shopping bag. She was dressed fashionably, and her makeup and hairstyle were carefully done. "We're '*gastadores compulsivos*' [compulsive spendthrifts], and I'm one of them," she noted, admitting that the bulk of her income is spent on clothing. Yet she too was also paying for the price of maintaining her "*gustos*" (treats). She skipped this year's vacation, which she regularly takes, a necessary strategy to maintain her weekly shopping trips.

This woman's response brings attention to the type of expenses that people regularly give up in order to maintain whatever consumption level they may be accustomed to. It also highlights the values and cultural meanings that we regularly impart to different ways of spending money for "leisure" (Chin 2001; Zukin 2004b; O'Dougherty 2002). Vacationing

and travel, entertainment (going to the movies, to the theater, to a concert), taking a course, and home repairs are some key leisure expenditures that are rarely frowned upon in society, even though they can incur more costs and debt than a shopping spree at the mall does. As opposed to a shopping spree, these other expenditures are regarded as constructive for self-growth or for the greater benefit of society. But the fact is, in moments of economic hardship, it is far easier and more significant to anyone's budget to give up visiting an aunt in Florida than to do without a trip to the mall. In other words, equating shopping with money squandering, without taking consideration of people's larger economic decisions and invisible calculations to stay afloat, can lead to misguided assumptions about their consumption.

I was especially impressed with the bargain-shopping skills of the average Puerto Rican woman I interviewed.[5] Often when I asked about people's latest purchase, I was met with stories of elaborate footwork and research carried out before making a purchase. Brenda, who had lost her phone and could not replace it, was thankful to her sister, who sent her to Wal-Mart to buy a phone for ten dollars and then to ATT to purchase a replacement chip for $26.99. The women I talked to were savvy shoppers and had ample references for what constitutes a real sale, such as the woman who immediately walked away from a 50-percent-off sale rack because a shirt originally priced fourteen dollars should have been priced at seven instead of ten dollars. I myself take great joy in using my bargain-shopping skills and was quite proud of the ten-dollar dress I found at Plaza del Sol, until I met Yvette in Plaza Rio Hondo. A forty-five-year-old single mother, she visits the mall four times a week, to shop and "to get rid of stress," a statement that readied me for accounts of *compradera* sprees. But she quickly surprised me with a very matter-of-fact discussion of her budget: "If there's money in the budget, I buy something small, usually less than ten dollars, but if there's no money in the budget, I don't buy or simply buy something listed in the shopper." Yvette works as an accounting clerk in the purchasing department of a pharmaceutical company and takes great pride in her savvy with numbers and budgets. Her shopping sprees, it turns out, are mainly research trips to look around; she makes a purchase only when money is available. She went on to evidence her vast insider knowledge of where the deals are: shoes for ten dollars at Wal-Mart; dresses discounted 80 percent at a "very special store" in Plaza del Sol, which she did not name, though she laughed when I guessed Group USA, where I had previously bought my ten-dollar dress.

Yvette was not the only respondent who brought up her budget and shared tips for finding the best deals. Jose, a hairstylist in his forties, was one of the few respondents who described being debt-free. He had been in debt in his youth and had learned to budget from hardship. Now he divides his monthly pay into four portions to determine well ahead how much he can spend on the movies, which is his greatest *gusto*. Jose had purchased a new car last year and was keeping up with the payments by refraining from purchasing clothes. His last purchase was Christmas gifts, toys, which he bought for his nephews. And then there's the "Kmart woman," as I call her, because she buys everything at Kmart: her husband's clothes, the family's shoes, her home decorations, and so on. Yolanda works at home, and her husband works at the post office, which is considered a steady and good job because it is a "federal" position, not a local and more vulnerable government job, by Puerto Rican standards. She goes to the mall four times a week to shop, which she loves to do to "get out of the house." In fact, she admitted purposefully pacing her purchases—buying one item today, leaving another for the next day—to ensure that she always has "an excuse to leave the house" for a shopping errand. Her errands are limited, however, to buying detergent and household supplies advertised in the Kmart shopper, which she reads faithfully. She skips most other stores, she told me, so she is not tempted to buy. She too talked about budgets and prioritizing household expenses before anything else.

Finally, my informants' most effective cost-cutting measure was simply to abstain from going to the mall altogether. This is a common practice among the most marginal groups, as documented by a study of the economic practices of unemployed women who had been fired after the closing of manufacturing plants throughout the island (Colón et al. 2008). I too came across women who told me they had stopped going to malls or who said it had been months since their last visit to a shopping mall. In turn, this cost-cutting strategy sheds light on yet another aspect of Puerto Rico's high economic deficit/consumption puzzle—namely, that going shopping is still a largely spatial practice, requiring the bulk of the Puerto Rican population, who live in suburban and rural settlements, to leave their homes and communities to go shopping.

More specifically, Puerto Rican society is organized around the automobile. Pedestrian opportunities to access stores and purchase goods are generally limited for those who do not live within the immediate vicinity of a town center, unlike in many major cities, where one need only walk a block before hitting a store. Consequently, people in need, such as

the women fired from their factory jobs, can limit consumption by eliminating the practice of "going out shopping" altogether. This means that the image of the overflowing Puerto Rican shopping mall that is so often discussed on the island needs to be tempered by the high physical density and excessive concentration of shoppers that result from the island's urban planning and its ensuing segregation of domestic and commercial spaces. This physical concentration of retail activity assures that shopping centers appear constantly packed, providing a far more skewed picture of retail than if stores were evenly distributed throughout the island's physical landscape.

The Modern Overspent Consumer: Some Local Thoughts on a Global Discourse

Where does all this deliberation about Puerto Rican consumption practices leave us? To summarize, the Puerto Ricans I interviewed described the average Puerto Rican consumer as *"comprarero y gastador"* (a compulsive shopper and wasteful), but few included themselves in this characterization or admitted partaking in a carefree shopping behavior. Perhaps this is because of the political symbolism involved in the act of shopping on an island where economic woes are at the forefront of public debate. Maureen O'Dougherty's (2002) work on consumption among Brazil's middle classes in times of high inflation is relevant here. She describes how consumption intensified as a practice of class differentiation, but not without a discourse of morality developing around the "right" ways to consume and to be a good Brazilian. For instance, using cunning to get the cheapest goods was socially accepted and encouraged, but not if it appeared to infringe on others' needs.

I believe that a similar discourse of shopping morality may be at play among my Puerto Rican informants. Admitting that one overshops is to announce out loud that one is well-to-do. But in times of economic hardship, it also implies that one may be profiting from something or someone at the cost of others, whether one is a *"riquito"* (independently wealthy) or, worse still, engaging in illicit activities such as in the drug economy or evading taxes and hiding income. At the same time, reveling in a generalized view of Puerto Ricans as conspicuous and limitless consumers is to believe that while one may not be able to shop oneself, others can and continue to do so. This position allows Puerto Ricans to protect and proj-

ect an optimistic image of the island as a modern country with high living standards, in contrast to an imagined "third world" beyond the island that truly suffers. It is to believe, in the words of the "Kmart woman" quoted earlier, that Puerto Rico is in fact a "*pueblo bendecido*," a blessed country, because "Puerto Ricans cry broke, but they always find money to make a purchase."

Unfortunately, though this strategy may prove comforting, it comes with a price. It involves reproducing the myth of Puerto Ricans as "shop 'til you drop" consumers who are impulsive and wasteful; in other words, it is a self-subjugation that further stereotypes Puerto Ricans as irrational consumers, when in fact, as I have shown, they are regularly quite calculating and smarter in their purchase than retailers would have us believe. Unfortunately, this strategy directly benefits the unabated growth of the shopping mall industry—the most direct beneficiary of the view that Puerto Ricans will always find a buck to make a purchase. In particular, shopping mall investors and real estate speculators revel in the view of the limitless consumer, which allows them to rationalize the need to build even more shopping malls while benefiting from the government's tax-free passes that help buffer their losses and investment risks, whether there are shoppers or not. In this regard, we may imagine a not-so-distant future when the shopping mall business may not even need shoppers to make a buck; the mere illusion will do. And as we have seen, Puerto Rico provides a good illusion.

At the same time, since Luis Fortuño's election and the launching of a series of privatization measures and massive layoffs, Plaza las Américas has surfaced as the main gathering point and venue for popular demonstrations against the current tide of privatizations, held by workers, students, labor unions, and concerned citizens at large. Plaza las Américas was the site for two major national strikes against privatization in 2009, as well as the site where students from the University of Puerto Rico made appeals to the larger Puerto Rican community about the administration's privatization policies, a demonstration that launched a massive student strike in 2010. Students protested the administration's tuition hikes, which would exacerbate existing inequalities, challenging the governor's position that public education was not a right but a mere "privilege" and that dissenting students were "selfish, privileged and disorderly, irresponsible and socialists" (Brusi-Gil de Lamadrid et al. 2010). Their banners at Plaza las Américas rejected the government's authoritarian position and called for "diálogo, negociación, conocimiento, educación, libertad, trans-

parencia, democracia y participación" (dialogue, negotiation, knowledge, education, liberty, transparency, democracy, and participation).

These types of demonstrations suggest that Puerto Ricans are not buying into the illusion that shopping malls are an apolitical space for the leisure and entertainment of locals and for the benefit and profit of major retail corporations. These striking performances showcased a key predicament of neoliberalism: that if there are no jobs or accessible public higher education, there cannot be shopping. Much can be said about the takeovers of the Plaza las Américas shopping mall by strikers, but to me, they represent a hopeful challenge to the uncritical celebration of an unlimited world of consumption; when the prerequisite for a consumer society disappears—a job, a salary, the type of job security that allows people to plan and make big purchases—only social strife and inequalities remain. Under these conditions, there just cannot be "business as usual," as the Fortuño administration countered publicly.

It was especially ironic to witness government representatives extend promises for tax cuts and exemptions to shopping mall investors at the Caribbean Conference of the International Council of Shopping Centers, held in San Juan, while there was an active student strike and overt popular resistance to the budget cuts and the fees imposed on students of the University of Puerto Rico, the island's premier public educational institution. Indeed, the statements by government representatives during the shopping mall convention made amply clear that they were ready to give away millions to corporations to incentivize shopping malls—exactly what the island has in excess—but not one more cent to provide the essential public education so craved by students.

These are the type of policy disjunctions that the strikes at Plaza las Américas helped to showcase, especially the linkage between consumption and the structural factors that make people's consumer lifestyle possible, while demonstrators demanded the type of conditions that enable access to sustainable livelihoods and the dreams and aspirations of our contemporary world. For now, we are reminded that notions of overconsumption, so widely circulated across modernizing societies, require critical probing for the work they do and the interests they serve in historically and culturally specific contexts. As we have seen, the retail industry accrues value through the myth of the Puerto Rican shopper as a consumer who is inclined to overshop—this supposed overconsumption is manipulated as added value to the shopping corporations, allowing them to expand and privatize more development land. Another lesson is

Students demonstrating at Plaza las Américas against the $800 tuition fee at the University of Puerto Rico. Their signs call for "dialogue, negotiation, knowledge, education, liberty, transparency, democracy, and participation." (Photo by José Orlando Sued)

"There is Money, Missing are good administrators." Students striking at Plaza las Américas. (Photo by Javier Maldonado-O'Farrill)

Striking students take over Plaza las Américas. "I can't study in a military campus"; "I don't have arms, just books." (Photo by Javier Maldonado-O'Farrill)

Supporters of the students at Plaza las Américas. (Photo by Javier Maldonado-O'Farrill)

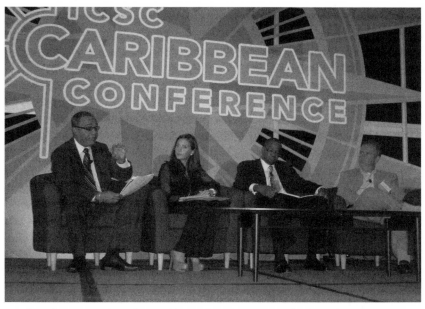

Speakers discuss trends in the Caribbean shopping center industry at the 2011 International Council of Shopping Malls Conference held in Puerto Rico. (Photo by the author)

the need to push beyond the seeming "sameness" of the mall. Far from malls' standard characterization as structures that despatialize localities and level out middle-class identities across the globe, they should be seen as territories that breed symbolic performances and visible acts of distinctions by the way they are marketed and by their use by shoppers and browsers alike. And even more hopefully, shopping malls are a key space where massive popular resistances are being launched by the growing numbers of people who cannot afford not to see beyond the illusion.

※ 2 ※

Authenticity and Space in Puerto Rico's Culture-Based Informal Economy

Thus the meaning of informality has changed markedly in the neoliberal era. In the past, it was the sector where those excluded from the modern economy found employment; in the present it has become a place for those escaping the degradation of formerly secure jobs.

—Miguel Angel Centeno and Alejandro Portes, "The Informal Economy in the Shadow of the State"

The informal economy has long served as the refuge of the unemployed and underemployed. This flexible sector—which is never isolated from the "formal economy" and encompasses a wide range of unregulated income-generating activities, from street vending to intermittent services and casual work—can provide the bulk of jobs in many countries throughout the world (Portes, Castells, and Benton 1989). This is even more the case during neoliberal reforms, when government budgets shrink and civil sector jobs disappear, and with them job security and economic stability (Itzigsohn 2006).

In Puerto Rico, which has had double-digit unemployment for decades, informality has become a way of life that straddles all sectors of the economy, from the many educated professionals who operate cash-only to hide income under the table to the smallest vendor whose income is never reported. Informality is further fueled by the local tax system, which favors foreign corporations over local businesses, a legacy of the island's modernization program in the 1950s, and by what locals describe

as "permisología" or the bureaucracy of permits, which in the colonial context of Puerto Rican society is compounded by local municipal, state, and federal laws that often contradict each other. The result is that most locally initiated activity borders on informality, especially activity initiated by the most disenfranchised people, who are least able to access permits (Davis and Rivera-Batíz 2006; Alm 2006).

In this chapter, I focus on an intriguing contradiction of neoliberalism: its praise for entrepreneurship and individual agency in economic matters at the same time that it is characterized by the growing policing and restricting of the populations that have historically been most entrepreneurial: the working poor, the unemployed, and the disenfranchised, who have long had to *inventárselas*, or "make do," to make ends meet. I explore the added constraints faced by those who seek livelihoods in the realm of grassroots cultural production, particularly in crafts and artisanal work. These are activities to which many Latin Americans workers have historically turned to make ends meet and that have been additionally constrained by the multiple types of work that culture is asked to do: whether it is to provide an upscale ambiance or entertainment or to represent a national identity or to ameliorate unemployment.

In particular, craft production has long been subject to a variety of interests involved in regulating matters of authenticity in ways that constrain workers' legitimate participation in this sector. Among these interests are nationalist elites who have long marketed folk art as an embodiment of national culture and for tourist ends, and private corporations that promote craft fairs as part of their marketing and public relations campaigns, making for a highly politically loaded field of cultural production. Indeed, the linkage of crafts, artisans, and authenticity has a long history throughout Latin America, where cultural policies regulating craft production have been a central component of cultural nationalist projects. Thus, far from what modernization pundits once augured, craft production and the "traditional" never faded away with modernization but instead have been reconstituted into new forms—transformed into folk objects or nationalist or tourist symbols and reordered around new logics of production and consumption centered on museums or the market (Garcia Canclini 1993; Nash 1993). Additionally, throughout the developing world, craft production and the turn to the "traditional" have been driven by economic need and by the same processes that render "cultural" products economically profitable. Primary among these processes are unemployment in the economic sectors that once sustained "traditional"

culture and workers, as well as the new markets created by the market-
ing of culture, which today can span transnational networks of art deal-
ers, nongovernmental organizations, and other intermediaries sustaining
international markets for people's traditions, be it in the form of world
music or ethnic art (Grimes and Milgram 2000; Nash 2000).

Consequently, it is not only nationalist elites or international dealers
who manipulate or profit from culture but increasingly also the unem-
ployed and underemployed who turn to this sector as a viable economic
choice. In an earlier work, I analyzed local debates over authenticity in
crafts production, showing how artisans' economic strategies to assert
their right to sell their products have implications for representations of
Puerto Rican culture (Dávila 1997). As these workers become involved
in commodifying their own traditions, I argued, they also engage in the
ensuing "tournaments of value" (Appadurai 1996) involved in defining
what is authentically cultural, transforming and appropriating notions of
traditional culture in their own products and self-presentation in order to
participate in this important cultural/economic sector.

After decades of cultural nationalist regulation of folk art produc-
tion, these debates continue to thrive. The involvement of new producers
and more competitive conditions in the marketing of culture continues
to feed struggles over who can be considered an authentic producer and
over what is more culturally relevant. This already political field of cul-
tural production has become more contentious because of neoliberal pol-
icies regulating urban space and cultural production. For one, the priva-
tization of space has led to the upscaling of cities and to the sanitization
and repackaging of spaces for specialized consumption, shrinking and
limiting people's access to spaces in which to market their products. This
upgrading and privatization of public space, in turn, has been accompa-
nied by a rise in the criminalization and policing of street vendors and of
any form of public economic solicitation, hindering access by grassroots
cultural workers to the most centrally located and profitable areas (Baud
and Ypeij 2009). Further politicizing this realm are market logics that
push for the professionalization and standardization of a field in which
workers require and depend on informality and flexibility to make ends
meet.

In this context, debates over authenticity no longer represent the
greatest obstacle to entry and participation in this economic field. Mat-
ters of authenticity do endure and are reproduced around discourses that
accommodate innovation, especially because what is considered more

"culturally" relevant does not always make for the most profitable product. Also, many would-be artisans have learned to navigate dominant systems of evaluation in order to become certified as "authentic" artisans. But artisans' largest obstacle for entry into this sector now stems from its general upscaling, led by government's and private entities' emphasis on entrepreneurship, standardization, and commercial viability, which in turn is exacerbated by the greater competition among artisans that has been brought about by unemployment and a lack of economic opportunities.

This push for entrepreneurship and marketing has eroded the culturally sanctioned aspects of this field of cultural production, aspects that were once dominant and tended to hamper new artisans' involvement but also served to protect artisanal events from official scrutiny and policing. As a result, artisans who once struggled against narrow formulations of authenticity that excluded them now find themselves defending the authenticity and sacredness of the folk art circuit against a neoliberal administration that sees their products primarily through dollars and cents. This growing policing and management of cultural production also involves cultural workers themselves in ways that have potentially significant repercussions, not only for future generations of cultural workers but also for the very definition of folk art and for its sale and promotion as a culturally sanctioned or alternatively as an undifferentiated commercial space.

In Puerto Rico, these debates are most immediately affected by the neoliberal policies instituted by the far-right Republican, pro-statehood governor Luis Fortuño, who took office in 2009 and whose aggressive attempts at fiscal reforms led to the laying off of over seventeen thousand government workers within his first year in office.[1] The government's privatization schemes have been accompanied by repressive anticrime measures, such as the use of the National Guard and of countersurveillance methods against university students and demonstrators, measures that represent a backtracking on the island's civil rights (Brusi-Gil de Lamadrid 2011; LeBrón 2010). In sum, the policing of the island's artisanal sector, discussed at the end of this chapter, must be contextualized against a larger climate of reform and repression that has left few spaces of contemporary Puerto Rican society untouched and that constitutes a substantial threat to the thousands of unemployed people who have taken refuge in this sector.

This chapter draws from my research with Puerto Rican artisans at the "De Plaza Pa' la de San Sebastián," a prestigious, by-invitation-only

folk art fair at Plaza las Américas, the island's largest shopping mall, as well as with artisans at three different folk art fairs during the Fiestas de San Sebastián, an important national feast that celebrated its fortieth year in 2010. These include the by-invitation-only folk art fair organized by the government's Institute of Puerto Rican Culture (ICP) and two independently organized fairs developed in response to years of pressure for additional vending space during this important and massive event. Artisans were also interviewed at the 2010 "Barranquitas National Folk Art Fair," one of the oldest and most traditional fairs, which regularly attracts a diverse group of cultural workers from all over the island. I also incorporate a comparative perspective drawn from research I conducted on the island's culture-oriented grassroots sector in 1992–1994, when I interviewed an extensive sample of artisans and government cultural officers (Dávila 1997, 1999).

Origins and Transformations of Puerto Rico's Culture-Oriented Informal Economy

Puerto Rico's informal sector is a well-known but underdocumented aspect of the economy. The few works that have touched on the subject have recognized its diversity, its extension to the middle classes, and its economic impact, which is estimated to be in the billions of dollars (Ortíz 1992; Enchautegui 2008) and to constitute upward of 23 percent of the island's gross domestic product, even though its impact remains largely undetermined (Enchautegui and Freeman 2006). Yet given the island's high rate of unemployment, it is not farfetched to consider this sector an important motor of the local economy, one that along with federal welfare subsidies is central to sustaining Puerto Rico as a "postwork society," a society where salaried work has been displaced as a central principle in people's everyday lives (López 1994).

Grassroots cultural festivals and fairs organized by local groups, municipal governments, and private corporations constitute a central component of the island's informal economic sector. These events are free and open to the public and provide an attractive venue for vendors because their reputation as "cultural activities" has historically shielded them from the greater policing that characterizes public mass events on the island, such as concerts and sports events. Within these festivals, the sale of folk art becomes a preferred and viable economic activity. Unlike

vendors of food, drinks, and other goods, artisans constitute the symbolic base that gives activities a "cultural look," and they are therefore always sought after as participants. As opposed to other vendors, who may be charged thousands of dollars to sell in the most popular grassroots events, artisans sometimes have fees waived, or they are charged just a small amount. The most prestigious artisans may even receive a small stipend from organizers for the duration of the event. Moreover, for over a decade now, annual yields from the sale of folk art in Puerto Rico are exempted from government taxes up to $6,000, a provision that gives artisans a means of disguising their financial profits if they so wish. Most significant, their sales are exempt from the 7 percent sales tax that since 2007 is charged on all sales on the island. The festival circuit continues to provide the only direct and accessible market for locally produced goods that are shunned by most retail stores, where prices are tripled to reap profits, rendering them altogether inaccessible as an outlet for locally produced products. Fairs also provide the most direct link to consumers of Puerto Rican folk arts, who are primarily local Puerto Ricans in search of a special piece or memento to collect, gift, wear as adornment, or decorate their homes. All of this makes the festival circuit an attractive retail sector for local folk artists, who increasingly include unemployed university graduates and the long-term unemployed and underemployed.

The folk art circuit has also been advanced by private corporations, which regularly sponsor fairs as part of their public relations campaigns. Shopping malls too have become important promoters. Many of them now have cultural consultants in charge of organizing folk art fairs in their venues. Folk art was a central part of Plaza las Américas' remodeling, which involved a re-creation of Old San Juan landscapes, including Spanish architecture along the "Ricardo Alegria Cultural Corridor" (a corridor named after the founder and longtime director of the Institute of Puerto Rican Culture). As the organizer of the Plaza las Américas fair explained, fairs represent "value added" to a shopping mall, a medium to attract shoppers during "*tiempo muerto*" (the slow shopping season), when there are no holidays. Shopping mall fairs, especially at the most upscale malls such as Plaza las Américas, are highly prized by artisans because, in contrast to outdoor fairs, they provide protection from bad weather, air conditioning, and a more high-scale environment for sales (especially those fairs that include free publicity and attract people interested in this medium).

Artisans' better sales conditions within the folk art circuit relative to vendors of food, alcohol, or commercial wares are nevertheless countered

by the pressure on them to become certified and recognized as "authentic" artisans. They are required to pass evaluations certifying them as such and to sell only what they produce, avoiding any merchandising, which is always more profitable. Artisans have had to maneuver through narrow and romanticized ideas of folk production. For decades, newer would-be artisans have been challenging these views, which are drawn from dominant definitions of folk art at play in many nationalist ideologies across the globe that posit folklore as the natural embodiment of a nation's essence and the artisan as its important vessel (Handler 1988). These ideas are evoked by the pun "*arte-sano*," or "sane" or "healthy art," which was used by a radio interviewer during the program aired live during a folk art fair I attended in 1993. The pun, used to introduce the interviewer's artisan guests, summarizes the dominant coordinates around folk art: that artisans and their creations are positive contributions to Puerto Rican culture and that folk art is good and "healthy and enriching" to the local culture, as are by extension its creators.

These nationalist associations have permeated the promotion of folk art, which became central to local governments' strategies for self-definition shortly after Puerto Rico became a commonwealth of the United States in 1952. This status provided the island local autonomy for the first time since U.S. occupation in 1898 and helped launch cultural policies and institutions with which to safeguard Puerto Rican identity within the commonwealth political arrangement. Most specifically, the Institute of Puerto Rican Culture was founded in 1955 and charged with the mission of promoting and regulating cultural and artistic expressions of cultural identity, with folk art being primary among them. In particular, folk art surfaced as the preferred medium to substantiate the "content" of Puerto Rico's national identity around a romanticized agrarian peasant past and the racial blending of Spanish, indigenous, and African components of society. Accordingly, the crafts most favored were those that were handmade of preindustrial products and crafts of the rural peasant, preferences directly related to Puerto Rico's dominant myth of national identity. Soon other government cultural agencies and the tourism office joined in, organizing events where folk art was similarly exalted and promoted as an expression of Puerto Rican identity.

These old-fashioned and unfeasible views of folk art production are still prevalent today. Government cultural institutions still promote the image of the elderly male, rural, white peasant who inherited the craft from his immediate family and is a patriot and a true lover and defender

of his culture. This artisan carves "*santos*" (wooden images of Christian-derived iconography), does woodwork, makes hammocks associated with the indigenous traditions, or draws images and themes from the trilogy of Puerto Rican racial identity (Spanish, indigenous, and African, hierarchically organized in that order). Most important, this view entirely ignores the economic role that crafts have historically played on the island; it is only the patriotic role of folk artists as lovers, patriots, and bearers of cultural traditions that is emphasized. The artisans I saw at the by-invitation-only fair at Plaza las Américas were a good sample of this traditional view. Most were senior artisans, having worked in their craft for fifteen or more years, all certified by the government, older in age, and working in the more "high-end" media such as woodwork. It was hard to find new and younger artisans among them, and black artisans or artisans working with overt African-inspired themes were almost entirely absent.

Local artisans, always more diverse than this preferred demographic segment, have long worked to challenge this view of the traditional folk artist. In the 1970s, the Hermandad de Artesanos was key to these contestations. The group was organized by university students intent on organizing artisans to highlight folk art's economic significance, challenging the view that the rightful artisan was the older master producer rather than new producers, such as university students and the unemployed. Among its goals was the promotion of new fairs as a way to increase available markets and the organization of artisans as a community of working artists across the island. The Hermandad was short-lived, but it was very influential in creating a workers' consciousness among artisans. Many of them still refer to themselves as belonging to a "*gremio*," or an artisanal class. The Hermandad was also successful in creating new markets in important commercial centers. It was the first to successfully take over shopping malls, spaces that were initially considered too commercial and inappropriate for cultural workers but that today are a regular and highly popular site for folk art fairs.

Government actions emphasizing folk art's economic dimensions soon followed. In 1978, the government opened a folk art office in Fomento, the government's office for economic development. As opposed to the ICP's primarily cultural mission, Fomento was charged with promoting folk art production as a sustainable economic activity, though the symbolic role of art production continued and was further promoted through the creation of standards for evaluating local artisans. These evaluations are still in place; would-be artisans seeking to sell their work are required

to pass evaluations and to obtain identification cards. These artisans are then part of a directory that facilitates their invitation and participation in government-backed fairs and that is consulted by hotels and private corporations in the organization of their own activities.

Criteria for evaluation were listed in 1986 in Law 99, which stipulates, among other things, that the folk art product be "made in Puerto Rico, that it use Puerto Rican material, and that the themes relate and reflect Puerto Rican culture, such as its history, its fauna, flora and the symbols of the traditional life of our people."[2] Needless to say, some of these regulations were contradictory or impossible to meet, such as the stipulation that products use "Puerto Rican materials" in a colonial context where most everything is manufactured elsewhere and imported and where there are state and federal regulations against the collection of prime materials from public and privately owned farmland. Moreover, in sharp contrast to romantic ideas about the older, senior master artisan, most contemporary artisans are women, young (in their thirties and forties), and urban, as evidenced by the only local study done on artisans as workers, conducted in 1992 by a former director of the government's popular arts division (Vargas 1991). Though considerably dated, this study remains the only one to explore the economic role of folk art and also confirms my observations on the makeup of folk art fair participants. The author referred to these artisans as "neo-artisans" because 51 percent were found to have been working as artisans for only the past ten years and most of them learned their craft from friends, at technical schools, or even at the university. They also took up their craft as a means of solving unemployment problems, and most of them, irrespective of their cultural motivations for taking up the craft, increasingly responded to economic pressures. In fact, as Centeno and Portes (2006) remind us in the epigraph to this chapter, this sector has become a primary refuge not only for the unemployed but also for those who have seen their formerly secure jobs degraded or suddenly jeopardized.

Juan José, a thirty-five-year-old carver, is indicative here. For fourteen years, he has held a government job; however, he had taken as a hobby etching drawings onto wood, a skill he had learned while at the university. Fearful of being laid off, he had slowly decided to turn his hobby into a vocation and was ready to do so full-time if need be. As he explained, "I don't like to work in construction, and I don't want to work in Burger King. This work allows me to do what I love to do and to work with my hands." I came across many educated, young, and unemployed or under-

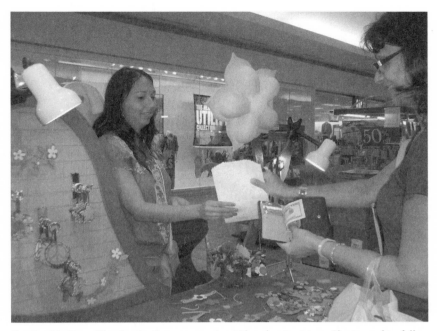

Onellys Medina selling her leather ornaments at Plaza las Américas. She turned to folk art as a university student pursuing a career in nutrition. After seven years, she has yet to find a job in her field that will provide a sustainable salary. (Photo by the author)

employed people with few prospects who, like Juan José, had turned to crafts because they provide a flexible and relatively upscale option involving the arts, an option allowing them to avoid hard labor and unskilled-sector employment. In fact, it could be argued that the artisan sector has become a key buffer to soften people's downgrading: an occupation that helps safeguard workers' "middle-class" status identities by affording them participation in a seemingly upscale sector.[3] Yet, unlike Juan, who still has his job, most would-be artisans seeking certifications have already been fired and face stiffer challenges to launch successful artisanal careers in a more competitive environment. After the controversial firings of thousands of government workers throughout 2009–2010, the government's artisanal office in charge of evaluations was bombarded by crowds seeking "certifications" to reinvent themselves as artists. The staff extended permits to most solicitors but admitted that few were likely to make it in the long run.

The government evaluation process was always quite malleable, but it has become even more so, to the point that it is almost unenforceable and, most troubling, meaningless in its ability to help artisans succeed exclusively from the sale of crafts. For one, evaluating criteria are not written but are verbally communicated to prospective artisans, leaving a lot of subjectivity to the review process. What a review process does very well is screen out people who may find it intimidating to initiate the evaluation process because of their background, education, and class or who may lack the time and transportation to arrange an evaluating visit to the government's San Juan office. Those who do make it to the evaluation process usually end up passing the test, especially if they comply with the instructions and orientations of the government staff. As a staff member explained, the register now has over twelve thousand registered artisans, a huge number for a staff of four, which cannot confirm how many of them are still active or even alive.

Adding to the malleability of the certification process is the practice of issuing certification cards undated, which makes it easier for artisans to sell products that are different from what they originally showed. Consequently, irrespective of what is shown at an evaluation, it is what sells that determines the choice of items produced: souvenirs in clay and leather, decorative pots, key chains, silkscreen T-shirts, candles, soaps, and, most of all, jewelry. These items are sometimes authenticated through decorations that develop Puerto Rican themes. Images of the three kings, Taino iconography, or the addition of nationalist phrases and poetry are common. But not always. After decades of use of this imagery, artisans also shun it as repetitive and passé. The result is that contemporary production challenges distinctions between handicrafts, kitsch, decorative fine and plastic arts, and folk art, as well as nationalist precepts about authenticity. More and more, it is jewelry and other easily manufactured goods such as candles and soap, which some people disregard as handicraft, that dominate over traditional folk arts, such as woodcarving and mask making, which require more time and training to produce and can be considerably less profitable. The importation of primary materials such as leather and clay also challenges governmental dictates that authentic crafts be made from indigenous materials. Additionally, permits extended to one artisan are commonly "stretched" to a network of family and friends, as was the case for a leatherworker I met who sustains five family members, two of whom work full-time for him selling his wares exclusively by participating in fairs.

Moreover, decades of cultural dictates have made Puerto Rican artisans extremely proficient in the discourse of "heritage" and talented in navigating criteria for obtaining permits and certifications and in presenting one's work as culturally relevant. New cultural workers have also successfully expanded definitions of what is considered appropriate in this field of cultural production. The statement voiced in 1994 by a woman who had been creating jewelry for fifteen years and relied on sales of it to supplement her part-time job could not be more relevant to the type of statements I heard voiced in 2010: "My work is folklore because it is made here and by myself, a Puerto Rican. I obtained my card doing something else, but I continued adding beads [prefabricated] because it is what I like and it sells much better. I am indeed a representative of Puerto Rican culture but one who represents a contemporary aspect and a historical moment in Puerto Rican culture and history, unemployment and the socioeconomic situation."

Many artisans obtain their licenses by presenting more standard work, as this woman did, only to substitute it later with more marketable products. Such is the case for an artisan who passed her evaluation showing leather goods inscribed with Taino iconography and now sells fashionable leather purses, which sell better. These practices have allowed for innovations and expanded products, transforming what is considered culturally relevant. Changing views toward T-shirts printed with nationalist messages or patriotic slogans are a good example. Once banned from fairs because they are considered a mass-produced item, they are now one of the most popular items. Themed T-shirts have been especially important for disseminating marginalized aspects of Puerto Rican history. Their themes include images of Afro-Caribbean heritage, salsa musicians, and contemporary figures.

Ultimately, artisans are constantly juggling pressures to keep up to standards while innovating products to keep up their sales. As we have seen, these strategies reproduce distinctions between those who can and those who cannot manipulate the discourse of authenticity because of their class and educational levels, background, and even political partisan identification. Specifically, this discourse shuns less educated vendors who may lack the ability of college-educated vendors to present their products as culturally relevant. Consider the case of Juan, who found himself unemployed and engaged to be married when he was introduced to folk art by a friend. Alerted that he needed to produce something connected to Puerto Rican culture to become certified, he began to

craft clay figurines of autochthonous birds he had been introduced to in a university-level agronomy class. On the other hand, a needlework factory worker who never made it to the university, had more difficulty in presenting her products as culturally relevant. Her handmade clowns are also hand embroidered, but she lacked an argument of what made her clowns a culturally relevant craft that reflected Puerto Rican history. She was awarded an artisanal card, but she is rarely invited to participate in fairs. Like many artisans, she "crashes" them without a permit by setting up individually and at her own risk.

Overall, contemporary debates over certification and authenticity are becoming more and more irrelevant, as government registration no longer assures artisans' invitation to fairs, which represents their primary marketing medium. Accessing markets increasingly demands that artisans market themselves, play up their contacts, and rely on their own inventiveness and entrepreneurship. As the Fomento cultural representative I spoke to explained, "We give them the cards, but we urge them to become well versed in marketing. They have to become their own public relations agent. It is up to them to compete and get invitations to fairs." In contemporary neoliberal Puerto Rican society, this essential step of accessing spaces and markets is exactly the trickiest part.

The Politics of Space and the Craft of Luxury

As we have seen, the folk art circuit has always been a relatively exclusive realm but one that, given the many gaps between artisans' economic needs and the unrealistic demands that have been placed on this sector, has always displayed considerable room for maneuvering. However, beyond artisans' certification, the business of participating in the folk art circuit presents its own challenges: it requires artisans to pay for lodging and transportation and meals while they participate in fairs that require travel and mobility, in ways that preselect those with resources. Still, as these events provide one of the few opportunities for artisans to access markets, attending them is paramount, and many do so with great sacrifice, crashing with friends or family or sleeping in cars during the event. Unfortunately, it is exactly in this realm of access and participation that hierarchies and obstacles remain most rigid.

For one, the most valued opportunities are extended to artisans by invitation only from promoters, who are charged with putting up dis-

plays that are seen not only as "authentic" but also as attractive, orderly, and "showy." In fact, more and more promoters are asked not so much to organize a fair as to "decorate" a plaza or historic building or any other primary location, in such a way that complements rather than disturbs the overall event. This guides the common practice among promoters of extending exclusive invitations to senior and more "traditional" artisans, while everyone else is required to pay fees or to juggle for participation. This practice places newer artisans and those who work in jewelry and other media regarded as more "commercial" or less "artistic" at the bottom of any space-allocation decision within the festival circuit.

These distinctions were evident at the 2010 folk art fairs during the Fiestas de San Sebastián, where selected invited artisans (about two hundred) were given free spots, assisted with the setup of their products, and placed in a beautiful historic building nearby the main plaza (a location that was also advertised in the press). There, they were protected from the weather and in close proximity to bathrooms and were provided with overnight security for their products and a free lunch. Everyone else was not so lucky. They had to coordinate their participation through independent promoters, who charged them fees for security and setup expenses, about $250 for a more centrally located area or $100 for the most crowded spots (close to the portable potties). In this space, the mood was chaotic during setup time, as most placements were assigned at the last minute.

I had been warned about Monty, the promoter of one of the "marginal" fairs. I was told that he is not a real cultural promoter but rather a "*kinkayero*" (merchandiser) and that his fairs cheapen the reputation of Puerto Rican crafts, among other accusations that made it clear that he would have interesting insights to share about the politics of space in the festival circuit. Monty is one of the few independent artisanal promoters who is not a former employee of the Institute of Puerto Rican Culture. Instead, he is an artisan whose credentials come from the street and whose primary concerns are self-admittedly not about product quality, balance, or placement but, rather, about protecting artisans and assuring them a space to sell. His constituency is the many artisans who seldom get invitations from government or private entities to participate in events and who are at the margins of most events because their work is considered less valuable or more commercial or because they work in "saturated" segments. Monty sets up these artisans in spaces that he negotiates with the formal organizers of the main event, avoiding the scattering of these artisans throughout the fair, which organizers believe "cheapens"

Erick Ortíz, trained as an engineer, turned to woodworking after being laid off from his job. He is shown here at the main fair at the Fiestas de San Sebastián in Old San Juan. (Photo by the author)

their event, while protecting artisans from becoming easy targets of the police. Monty described the fine line he walks to an eager crowd of artisans as they waited to receive their assigned vending spots: "There are people who want to eliminate this market and who don't understand its need, so we have to keep it looking nice. Please don't put up additional tents, pick up after yourself, and make sure you only sell what you make." His lecture came across as public posturing, for Monty's motto is quite well known: "I'm no god, and I can't control everything," a posture that always leaves room for maneuvering.

Monty is aware of the criticisms leveled at him by other promoters, but he ignores them in favor of the many artisans who are excluded from the festival circuit and who seemed to wholeheartedly support him. In his view, there is simply not enough space for so many people who need access to markets and cannot depend only on government- and commercially initiated events. His was the real fair, he noted, and the one most

needed, or as he colloquially put it, "It's a waste to do a JC Penney, when what you need is a Me Salvé" (a local discount store). In sum, he was questioning all the fuss involved in organizing official fairs, when all artisans needed was space.

Rules for winning an invited spot in government-sponsored fairs have always cross-cut personal relations, contacts, patronage, and other dynamics discussed elsewhere. However, the privatization of government and the diminishing funding of cultural activities has exacerbated problems of access because there are less opportunities for government-sponsored invitation events, more competition, and more demand that artisans pay and negotiate with independent promoters organizing events for private venues. All these factors have imposed additional limits to entry and have contributed to the overall elitisization of this sector, adding pressure for the development of more informal vending alternatives. The sector's exclusivity is also exacerbated by the growing professionalization and commercialization of the festival circuit and by the increasingly more

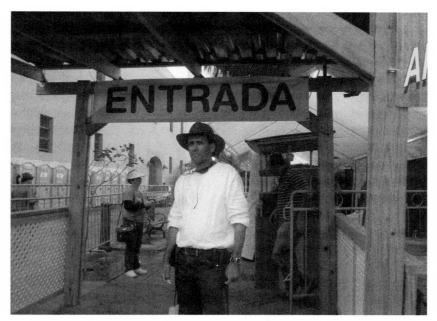

Monty, the organizer of the informal artisanal fair at the San Sebastián festival, stands in front of the fair's entrance. Notice the location of this alternative fair by the portable potties. (Photo by the author)

exclusive commercial demands and criteria constraining the work of contemporary artisanal promoters, especially by their professionalization as "consultants" and "experts" working for private organizations and venues.

In the 1990s, when I first studied this sector, government artisanal promoters were often criticized as exclusive and elitist because their determinations were constrained by old notions of authenticity. Today, however, independent promoters (including former government workers and artisans turned into professional promoters) increasingly respond to even more exclusive demands and criteria. This is especially so when they are hired by private entities, such as shopping malls, which demand not solely a fair but also a selective show that is attractive to consumers and audiences and is produced with the most stringent commercial quality controls. One cultural promoter, who studied communications and works as an artisan herself, explained: "I have to look for quality in each segment but also choose artisans who will put up the nicest display and arrangement, the most pleasing decoration, and will provide the best impression for the public." In selecting artisans for events, promoters described qualities that were not mentioned in my earlier research, revolving around artisans' self-presentation, how well they are versed in discussing their work, how well they deal with the public, and their ability to show up on time and dress neatly and in a professional manner (as opposed to in T-shirt and shorts, which were common in the festival circuit). Promoters acknowledged that these demands force them to make determinations that result in decisions that are more "elitist" that they would like.

Through these practices, the list of thousands of registered artisans has greatly shrunk. In particular, commercial demands for variety in the folk art genres that are displayed adversely affect the entry of new artisans into the festival circuit. This is the case for artisans working in the largest and most rapidly growing sector: jewelry. As one of the easiest arts to produce, jewelry is also one of the most saturated segments, with far more certified artisans working in jewelry than in any other single category. And as unemployment rolls soar, so have requests for certification by would-be artisans in jewelry. Except there is now a moratorium on jewelry certifications by Fomento's craft office, and none of the promoters I spoke to wanted to evaluate and meet more people working in the area, a dictum that greatly diminishes opportunities for the newest and neediest artisans.

Fair crashing, or the invasion of festivals through the informal setup of tables or the resale of assigned spaces from one artisan to another—a common practice to break into the circuit—has also become more difficult as

fairs become more regulated and move to more upscale spaces such as shopping malls. For one, artisans are less likely to let crashers in when they have had to pay for a space or are monitored by organizers to prevent reselling their spaces. Then, there are the pressure and transformations of the festival circuit brought about by the entry of new categories of cultural workers, who ten years ago would have never stepped foot in this sector. More and more, artists in metal, fine arts jewelry, decorations, glass and ceramics, and sculpture are becoming certified to participate in the artisan circuit, as a means for accessing markets and obtaining tax-free incentives. These artists define themselves as workers of contemporary crafts, as hybrid artisans, or as "new artisans," though others shun the category of artisan altogether, preferring to self-define around more artistic categories. Among them is a contemporary self-defined designer who had been working in copper decorations for twenty years but had only become certified as an artisan in the past four years, when big orders from interior decorators and other vendors dwindled.

Others have been straddling categories of "artisan" and "artist" for much longer, receiving a lot of notoriety as innovators in contemporary crafts. Martina, who works in painted Murano glass, is a good example of someone who has received a lot of press for her work and benefited much from her identity as a contemporary artisan. Glass is considered a prime artisanal material, and she is as versed in universal themes as in more "native"-inspired scenes, but always with a contemporary approach, such as the use of abstract geometric and organic forms. In 2006, she was featured as a "new contemporary artisan" in the book *Manos del Pueblo: Artesanias de Puerto Rico*, which was produced by MAPFRE, a private insurance company, along with Lopito, Ileana and Howie, one of the island's largest advertising agencies. She is also one of the first "artisans" to be awarded a coveted rent-free spot to sell her work in Plaza las Américas.

Martina was quick to acknowledge the professional training and background that had led to her current success. As she admitted, "It's not a matter of the quality of your work but of how many friends in media you have." She had studied in Italy and the United States, was well traveled, and had also a background in marketing that she had drawn from to market her work, which she has successfully sold to galleries and museums. In addition, her husband introduced her to the business of corporate gifting, yielding special commissions for Puerto Rican mementos to give out to his business VIPs and corporate visitors.

Another example of the new artists who are often preferred for more upscale settings is Efren Gregory, known as "Gregory," a former art

restorer who became a high-end jeweler and now works in cold forging, anticlastic, and cloisonné, using precious metals and stones. I met Gregory at the fair at Plaza las Américas. The fair's organizer, who prides herself on her curatorial expertise and selection of the best-quality artisans, was wearing one of his pieces, which she readily showed me as an example of "the fine work that Puerto Rican artisans can strive for." In fact, it is not coincidental that these new artisans are often known by a single name, as is more commonly done in artistic than in artisanal settings, where artisans are more likely to mark a familial heritage in their craft by using their last name or a nickname. Notably, these artists' certification as "artisans" is central to their commercial success; it is what distinguishes them from other fine arts artists and what makes them eligible for tax incentives and, in the case of Martina, to occupy a rent-free space. However, we should not lose sight that for these modern artisans, fairs are only one more platform for future orders, never the only opportunity for sales, as it is for the majority of artisans. In this way, promoters' preference for this more upscale type of work is likely to lead to hierarchies of evaluation while limiting most artisans' financial success.

Interestingly, the involvement of contemporary artists in the artisanal festival circuit was applauded by most everyone I spoke to. They are seen as an example of the general upscaling of crafts and of the entrepreneurship that characterizes the new breed of professional artisans; both of these developments are part of larger calls for greater recognition that artisans themselves have been making for decades. Recall here the earlier work of the Hermandad, demanding that artisans be recognized for what they are: artists and innovators, rather than as backward, ignorant, rural, and humble citizens who only work for supposedly purely patriotic reasons. The interesting point, though, is how the category of "artisan" can become so easily stretched to fine artists but not so easily to other artisans lacking in education, contacts, and cultural capital—recall the case of the needleworker and her handcrafted clowns.

In addition, the current upgrading of the artisanal class is not a possibility for artisans who lack the type of contacts and resources needed to produce at this scale or to attract consumers at the corporate level. Most problematically, promoters' preference for "upscaled" artisans is based on the success of a few and breeds competition and differentiation, rather than groupwide policies to improve opportunities for an entire "artisanal class," as was initially envisioned by groups such as the Hermandad. These earlier efforts drew on a collective vision of artisans as members of

a working class, a vision that the elitisization of this sector increasingly renders as downgrading to the work.

The fact is that artisans' longstanding calls for more market opportunities have never led to policies for opening markets or to enforceable legislation to protect local artisanal products from the exported, mass-produced "Puerto Rican souvenirs" that crowd tourist shops. Instead, they have been met with policies that promote the increased production and profitability of artisanal products. These laws seemingly provide more services and incentives to artisans to become more "productive" and "marketable" but also demand more governmental scrutiny of their work in ways that shrink artisans' freedom and ability to make and market their products. This is one of the reasons why artisans have been skeptical of changes and addendums to governmental legislation around crafts production (such as Law 166 of 1995 and Amendment 124 of 2007, among others). In particular, artisans fear that these laws represent a direct challenge to their artisanal identity. As one noted when explaining artisans' reticence about the government's promotion of collective artisanal workshops to increase production, which is part of the 166 legislation, "They forget that we're professionals. They want to downgrade us as collective workers and not as artists. . . . Our production is individual production. It is artistic and inventive, and we're very protective of our designs." In this way, artisans insist on their individual artistry as a challenge to legislation that does not take into account the particularities of the culture sector, especially artisans' need for protecting the differentiation of their individual designs. Foremost, artisans fear their downgrading into the category of independent vendors and merchants, which will eliminate the most valuable aspects of their work: the cultural value their work is seen to embody and their categorization as "artisans," which affords them a relatively easier inclusion in fairs as well as the tax breaks that barely keep them financially afloat.

The Jewelry's Hook:
Thoughts on Neoliberalism and Informal Economies

Artisans' fears about their future were brought to the forefront by the random government crackdown on artisans working in jewelry throughout 2009 and 2010. Drawing on commercial legislation requiring permits for the sale of fine and custom jewelry, the government's tax-revenue office (Hacienda) stopped randomly selected artisans working in jewelry

at different events and fined them for selling, without a permit, jewelry items that included hooks and clasps made from manufactured materials. Uninformed officers would appear unannounced, sometimes armed, threatening artisans with the confiscation of merchandise and with overblown fines that artisans told me ranged from one hundred dollars to the thousands. Rumors and fear spread quickly—recall that most artisans work with prime material that is bought, not made, by artisans. My informants wondered why it had been those in jewelry who had been targeted, when practically all of the island's artisanal work is made with some percentage of manufactured materials. They asked, why do they persecute workers in the most vulnerable segment with the largest number of new artisans, most of them recently unemployed, when they should be targeting shops that sell imported and mass-produced goods as "Puerto Rican crafts" to tourists? Most troubling were the implications and the precedents that would be set if artisans working in jewelry were forced to get a commercial permit and were disqualified altogether from being considered as "artisans." This move would represent the de facto commercialization of the largest segment of the artisanal class; if everyone is pushed to get commercial licenses, they would automatically be turned into "*kiskayeros*" (a local pejorative term for knickknack vendors), and it would be just a matter of time before other categories were affected.

Indeed, the crackdown scared many artisans from participating in events. But others rose up in opposition, and rightfully so, because it turns out that Puerto Rico's cultural legislation and the problem of "permisología" worked in their favor. The Hacienda had sent the police without fully understanding that crafts were protected from commercial permits and that any dealings from this government office should have been made not directly with the artisans but with Fomento, the government office most directly in charge of all cultural legislation around craft production.

Cheo Pavrilla, a veteran jewelry artisan for twenty-eight years and one of the artisans threatened, went on to be part of a negotiating committee between artisans and government officials. He recalled with great indignation his meeting with the Hacienda officers:

> They told me that they're doing me a favor, because with the payment of a commercial license we could sell sunglasses, watches, anything really, and amplify the products we offer. I had to explain to them what an artisan is, . . . how you don't see the *Playboy* symbol hanging in any of our work. We work within cultural parameters, and

Nilda Borrero, who specializes in ceramics, was one of the artisans who challenged the government crackdown on artisans working on jewelry. (Photo by the author)

I've been working in this for twenty-eight years. This is not a job to become rich; we do it because we love it. And if you tell me that I should sell sunglasses and imitation Louis Vuitton bags, then you are insulting me! We are not *vendedores* [commercial merchants]. And I have nothing against them. . . . But you must recognize that we are "artisans."

In sum, Cheo was defending his most valuable possession: his identity as an artisan, an identity that could not be so easily compromised by the inclusion of a metal hook. He reminded the officers that if he had wanted to become rich as a small merchant, he would not be toiling in this cultural sector for so many years. Additionally, he, like other artisans, was concerned that this crackdown was part of a larger government policy to turn artisans into "small merchants," not only to charge them more taxes but also to boost the category of the entrepreneurial self-employed in ways that would mitigate unemployment figures.

Months later, when I followed up with Cheo at the National Folk Arts Fair in the town of Barranquitas, he was happy to share that government raids had finally stopped, though for how much longer, he could not tell. For one, artisans' reliance on fairs makes them especially vulnerable as scapegoats to governmental calls to regulate the informal economy and to prosecute tax evasion and hidden income. Their visibility and dependency on fairs renders them the easiest targets for any future symbolic raid.

The kinds of threats artisans face in regard to their cultural and artistic identity have important repercussions for the future of artisanal work as either a cultural and protected realm or else as a purely commercial space that is increasingly unaffordable to local artists. As we have seen, artists have responded to these threats by insisting even more forcefully on their identity as innovators and artists, while returning to old arguments around authenticity as they seek to differentiate themselves and their products from other vendors, as well as to avoid future government raids. These strategies are concerning because they allow some artisans to shield themselves from any impending threat to the future of artisanal work on the island on the basis that their work is protected because they are supposedly "better-quality" artisans, versus an imagined bulk of others who are supposedly more commercial. The neoliberal emphasis on individuality, artistry, and entrepreneurship is thereby consolidated through these appeals, despite the government's failure to impose commercial licenses on artisans. Indeed, as of this writing, the Fomento office is going through a restructuring of the evaluation criteria to make them more competitive, and proposed measures, such as extending certification cards with expiration dates, are likely to greatly shrink the number of people gaining livelihoods as cultural workers. The politics of space also factor in these processes. Trends to encourage artisans to market themselves and to engage individually with private organizers of fairs and events work to hinder broader interests from developing among all cultural workers who are similarly in need of freer access to spaces in which to market their products.

I conclude this chapter with an acknowledgment of the many people who live and eat from culture and of the centrality of folk art production and the culture-based informal economy in light of Puerto Rico's growing unemployment. In this context, romanticized views of folk art production have long expired their usefulness and can only foster inequalities among cultural workers. It is also evident that growing regulation of

entrepreneurial activities in the realm of cultural production at the very time when the local economy is characterized by massive unemployment is not only counterproductive but also likely to fail as long as people lack jobs and a means to make a living. In fact, fining artisans because they use manufactured hooks on their jewelry, when it is practically impossible for any contemporary Puerto Rican artisan to do without processed, imported, and manufactured materials, may be as absurd as pretending that a crackdown on fairs will lead artisans to magically transform themselves into successful cultural entrepreneurs. Just as absurd are cultural policies aimed at assuring that only "rightful" artisans get incentives when the unemployed have nowhere else to go and when folk art production is forever changing and adapting, as are the people involved in it.

Finally, the middle-class background of this sector deserves some mention. Discussions of the informal economy often revolve around stereotypical discussions of people at the margins of society, either working in illicit activities or off the books, entirely unmonitored by the government (Vanketash 2006), or else located in developing contexts. We hardly associate informality with sectors that are certified and partly facilitated by the government, as is the case with many folk artists in Puerto Rico, who gain incentives through their certification but regularly operate at the margin of any government regulation in regard to reporting their income, accessing fairs, or even producing their craft, in order to make do. Nor do we immediately think of educated sectors in highly industrialized countries when we summon the category of informal worker.

The fact is that the rise of informality can be considered one of neoliberalism's most direct outcomes. New studies on informality acknowledge this development by moving away from the adversarial relationship with the state that used to characterize discussions of the informal economy as a development entirely at the margins of the state. Instead, these studies highlight how "formality breeds informality," pointing to an analysis of informality as a product of uneven state enforcement and contradictory mandates from state agencies and prompting a look at the constant negotiations and compromises between government and popular informal sectors (Cross 1998; Fernández-Kelly 2006, 3; Ulysse 2007). In these studies, informal sectors are shown to be highly political, inventive, and entrepreneurial and constantly engaged in negotiations and alliances with authorities at the local and state level to navigate changing circumstances and make a living. This begs the question of why neoliberal governments praise entrepreneurship and individual agency in economic matters at

the same time that the entrepreneurship of the unemployed and of those working in informal sectors is being most managed and restricted. This contradiction exposes the inherent unsustainability of many neoliberalizing policies. It is worth recalling the spirit of Monty's question of why there is all the fuss around turning out fancy fairs and authentic displays, when all artisans need is space to make a living. I hope to have shown that demands for space are directly linked to the scarcity of jobs and economic opportunities and that these demands will not abate until real economic options are provided to all.

3

The Battle for Cultural Equity in the Global Arts Capital of the World

> *So many of our organizations grew out of social movements, but we spend our lives trying to justify our existence, as if making art is not enough. We have been functioning outside the box forever. I'd love to see what's in the box!*
>
> —Rosalba Rolón, Artistic Director,
> Pregones Theater, New York City[1]

In today's economy, street writers, *bomba y plena* dancers, and tamale makers are not regularly considered cultural creatives. This label has become overidentified with what Robert Reich called the "symbolic analysts," people working in technology, publishing, advertising, and the arts, or else with the "creative class" in Richard Florida's work: the architects, novelists, entertainers, opinion makers, and others whose function is to "create meaningful new forms" (Florida 2002). The highly educated, white, liberal, Brooklynite independent writer comes quickly to mind. In contrast, across U.S. cities, barrio cultural creatives are easily dismissed as "ethnic" or quaint, rather than being recognized as the cultural and economic foundation of particular communities. And by "barrio creatives," I am referring to the many Puerto Rican and Latino cultural workers who are increasingly displaced and priced out of residence from New York City, especially from historically Latino strongholds such as East Harlem, a.k.a. El Barrio. Familiarity with East Harlem or New York City, however, is not required for considering the major concerns of this chapter, which

àre to expose, to disturb, and ultimately to challenge the hierarchies of value that, nationwide, have become naturalized in our neoliberal creative economy, to the detriment of myriad cultural workers.

These are the same values that underlie inequalities in urban/cultural policies and that promote the cultural and economic contributions of selected cultural workers and institutions while veiling those of the bulk of others. In particular, I am concerned with the marginalization of cultural creatives from communities of color in New York City who, while making up 65 percent of New York City residents, remain at the margin of most considerations of the city's creative economy.

Indeed, the economic impact of the arts in New York City's economic profile has long been evidenced and recognized: in 2005, the arts' economic contribution was shown to surpass $21.2 billion, with 160,300 jobs created and $904 million in taxes reaped for the city (Alliance for the Arts 2007; New York Foundation for the Arts 2001). However, within this industry, it is the economic impact originating from commercial film and television, commercial theater, art galleries, and auction houses that is most recognized. Less is known about the economic impact of nonprofit cultural organizations, and within this sector, even less is known about most culturally specific and community-based institutions or about what art historian Yasmin Ramirez has described as New York City's "creative community of color" (2010). Ramirez uses this term to distinguish these creative groups from the apolitical vision associated with the "creative class," as well as to denote groups for whom "cultural diversity [is considered a] civil right and access to arts a social good" (34). This vision stems from her work with the Cultural Equity Group, whose activism I discuss later. However, this notion can be expanded to include creative workers who are not regularly considered to be part of this category because they lack the formal training or education but who nevertheless are contributing directly to New York City's creative economy.

The question I ask is, how can the city be so widely considered "the global arts capital" when the majority of its residents remain at the margins of its creative economy? And how would the city's economy be enriched or transformed if we accounted for the hidden contributions of its cultural workers of color? I take on these questions by drawing from my longtime observation of East Harlem's Latino cultural groups, from interviews with minority cultural stakeholders, activists, and administrators, and from a look at the activism of the Cultural Equity Group, at the height of its activism throughout 2007–2008. I suggest that in order to

fully consider the state of New York City's community cultural groups, we must first account for and address the prejudices that cloud our ability to formulate more expansive definitions of what should be considered valuable in our contemporary cultural and creative economy.

The Race of Value

I start by addressing head-on the elitism that dominates discussions of culture and globalization in the context of urban development. Indeed, global cities are cultural marketplaces because of the presence of all types of expressive specialists, Ulf Hannerz long ago insisted, but these actors are not positioned equally (Hannerz 1996). Immigrants, tourists, and artists have all been accounted for as cultural agents by models of globalization, yet when policies are concerned, it is the need of the actors with the greatest "symbolic capital"—those harbored in the more institutionalized culture industries—that are prioritized and taken as the norm. When local cultural creatives are recognized, it is primarily for providing background, color, and vibe, rather than as agents who in and of themselves are worthy of investments and policy initiatives. This perspective is neatly represented in the work of the influential urban studies luminary Richard Florida, who equates diversity with cultural offerings that help entertain and tantalize (white) creative classes, never with the diverse ethnic constituencies that populate most urban centers, much less with their cultural work. These determinations consistently veil the value of creatives from communities of color, who in fact have been at the vanguard of the city's creative economy.

Indeed, that community art groups create jobs, provide services, and help reinvigorate communities has been a longstanding argument among advocates for government financing of culture and the arts. In 2009, these arguments could be heard loud and clear at public hearings after the New York State Senate proposed even more cuts to the arts. One by one, advocates described the work they do and the many social needs they fulfill on a daily basis, filling the void created by government cuts to education and myriad social services. As they noted, more cuts to the arts would translate into greater inequality among the neediest sectors. At the hearing, this point was underscored by Richard Kessler, director of the Center for Arts Education, who testified that 30 percent of the city's schools lack a single arts specialist, while pointing to the 63 percent decline in spending

on arts supplies and equipment already endured by the education system (Kessler 2009).

Celeste M. Lawson, executive director of the Arts Council in Buffalo & Erie County, for her part reminded the senators that arts groups are even more profitable than Wall Street because they provide a nine-to-one return on public investment, far above what Wall Street would perform on its best day, especially in the present downturn. In her words, "A quick survey of 21 of the organizations on the list scheduled to lose their NYSCA [New York State Council for the Arts] funding shows that they directly employ 167 people on a full-time basis, 127 on a part-time basis and contract with 1303 individuals for services representing 1695 employment opportunities. They also make available more than 150 intern placements for students seeking to fulfill graduation requirements" (Lawson 2009). In sum, arts and culture are an economically smart investment, a point underscored by the Grammy Award–winning musician Tom Chapin during his musical testimony, the sing-along song "You Can't Spell Smart without Art."

Arguments about the economic value of the arts have become commonplace among advocates for community arts, echoing the widespread use of neoliberal frameworks prioritizing profits and marketability and the economic utility of the arts. For years, these frameworks have dominated the agenda of private funders, but now they are central to governmental cultural policy at the state and federal level. Rocco Landesman, the new chairman of the National Endowment for the Arts, has even coined the slogan "Art Works" as his new guiding principle to stress the centrality of the arts to economic growth and neighborhood revitalization. Landesman's public statements openly acknowledge Florida's inspiration; he cites Florida liberally at public speeches that insist on the economic profitability of the arts, as he appeals to government to recognize that "arts jobs are real jobs" and hence worthy of federal economic investments, and even more so during recessionary times (Stolberg 2010).

Unfortunately, urgings about the economic benefits of culture circulate primarily as rhetorical arguments. In fact, arguments about the value of art and how best to measure it have become more challenging in a neoliberal context that continually reduces the arts to primarily economic determinations. According to Grantmakers in the Arts, a membership organization concerned with arts philanthropy, a consistent problem is that the arts community has been generally unable to make adequate economic arguments about the value of the arts (Markussen 2009). High-

lighting the economic output of cultural organizations disturbs and hence diminishes any value they may yield on the basis of their cultural and artistic output, lessening their "artistic" attractiveness, which is what first and foremost renders them valuable. Then there is the question of why the government, or any foundation, should support cultural organizations as engines of economic growth, as opposed to any other industry that may produce more measurable outcomes.

The crux of the problem lies in the same predicament that has long troubled the economic evaluation of intangible aspects of life, such as intimacy, care, heritage, spirituality, and art. For years, scholars have posited theses arguing for the economic incommensurability of these spaces or else for the economic logics that always determine their value and that challenge us to develop more appropriate models for measuring it. Achieving broader conceptualizations of value that take into account art's contributions to social cohesion, to fostering creativity and intercultural dialogue, however, are consistently limited by dominant standards determining what constitutes a professional art and cultural organization (nonprofit status, a payroll, a functioning board, trained staff, etc.). These distinctions often exclude many organizations that work on a more community-focused or voluntary basis, because they either are not "professionally recognized" or lack the full-time staff needed to participate in funding competitions. As a longtime arts advocate told me, "Like it or not, you can't get away from standards when you're in the arts. It's a delicate and loaded issue. But you simply can't do without it." Similarly, proposals for more democratic assessments of value that include the views generated from particular communities, not solely from grant makers or art professionals, are almost entirely excluded when these groups are not recognized, much less invited to provide feedback on funding panels.

Then there are arguments about cultural expediency, in which we are summoned to consider the multiple economic projects that culture is made to serve, whether it is education, security, or stability, as aspects that should be considered in its evaluation (Yúdice 2003). A recurrent problem here is that this framework does not account for the hierarchies of culture and race that impede our evaluation of the products and contributions of all types of cultural workers. Instead, I want to call attention to the hierarchies reproduced by dominant definitions of cultural value in discussions of the creative economy. Anthropological critiques of value are worth recalling, for they remind us that value is always culturally constructed and point us to look at the policies and institutions that sustain

dominant beliefs for imparting value. In the context of urban planning, for instance, we are pushed to consider how urban policies and economic incentives in the form of tax breaks create value, rendering evaluation a social construct that is both politically and culturally produced.

The effects of policy disparities that favor large gentrifying projects at the expense of local groups were amply evident in East Harlem, where in the span of a few years I witnessed a variety of cultural spaces, such as the former Mixta Gallery, Edwin's Café, and Calitos Café and Galeria, open to the great enthusiasm of local residents and very quickly close. In their short life span, they nurtured artists, audiences, and visitors from all throughout the city, until they simply could not handle the higher rents. The fact is that communities such as El Barrio have an abundance of cultural workers: there are the poets, the musicians, and the street writers, not to mention the cultural entrepreneurs who continue to open cultural spaces despite the challenging real estate market. Representative Charles Rangel recognized this abundance of culture workers when he established the Culture Industry Fund within the Upper Manhattan Empowerment Zone legislation, to ensure that culture-based initiatives would get a break in the midst of rapid gentrification and that Upper Manhattan would not be so whitewashed that tourists would not come its way. Except, as I document elsewhere, narrowly defined standards of what makes a worthy cultural initiative and a fundable proposal kept most local cultural initiatives at bay. Instead, it was the historic churches and larger and more established organizations such as the Apollo Theater that got Empowerment Zone funding, rather than local initiatives with the greatest need for financial help (Dávila 2004).

Granted, in our modern economy, street writers and tamale makers are not regularly considered cultural creatives. Neither are many of the local cultural entrepreneurs behind the small-scale initiatives I have been referring to, who may lack professional degrees and so-called efficient boards. Yet can we talk about a Little Mexico without street vendors? Is El Barrio still El Barrio without the music jams at Camaradas or old-timers dancing salsa at the Julia de Burgos Latino Cultural Center? I ask these questions not out of longing or nostalgia but to evoke the type of activities that on a daily basis provide the "cultural" content of El Barrio's Latino life and that my experience researching cultural workers in communities such as East Harlem has taught me people find of significance and value. Barrio cultural workers may not have proposal-writing skills. Many have difficulty voicing their role in creating jobs and in increasing

profits and revenues, which are the standard criteria for funding cultural work in the neoliberal city. But create value they do, not only because of the "economic" return they produce, whether it is by creating jobs or attracting patrons to restaurants, but also by providing the "cultural" content that shapes a neighborhood's culturally specific ethnoscape (Irazábal 2011). Distinctive ethnoscapes, in turn, are not only valuable as sources of place making but also for nurturing cultural creativity. In sum, these are the spaces where people can value, debate, contest, and communicate about their identities, which can nurture larger debates about diversity, among other contributions that are not neatly appreciated in simple economic terms (Jackson 2008).

Culturally specific and community-based institutions serve as anchors for many creatives of color, who are regularly shunned from the commercial gallery circuit. This was one of the key findings of a survey conducted by Yasmin Ramirez, an art historian and researcher at the Center for Puerto Rican Studies. The study surveyed artists who participated in the Urban Artists Initiative, the first and only citywide individual grant program for artists of color.[2] In the three years that it operated, this groundbreaking program became a forum among cultural institutions serving communities of color and artists in which to debate how issues of race affect artists of color in the current funding climate, coinciding with the activism of the Cultural Equity Group. Ramirez's survey showed that it is in education, in the nonprofit sector, and in social services, rather than in commercial sectors, that artists of color find the most employment (Ramirez 2010). Participants felt shunned from the government and private foundation circles and immediately gravitated to a program spearheaded by a consortium of community institutions with which they were familiar. The Urban Artists Initiative's reliance on intermediary community institutions with the easiest and closest access to artists of diverse constituencies was central to its success in attracting thousands of applications from its start. The program's motto, "diversity within diversity," indexed its goal of reaching and representing the new demographics of New York City with care and sophistication in order to explore the type of differences among New York City artists—around issues of immigration, class, and background—that remain unaddressed and misunderstood by public and private funders.

Indeed, the diversity of Latino art and artists is one of the biggest challenges affecting its evaluation, the fact that it includes forms such as murals and performance that are not "restricted to the wine and cheese

gallery scene" and artists from racially and nationally mixed and indige-
nous and African backgrounds, who are middle and working class, immi-
grant or here for generations, and always changing and in conversation
with the past as well as with most vanguard political and artistic trends.[3]
In sum, the "work" of representing this artwork can be vexing to main-
stream institutions, and involves social engagements that community cul-
tural institutions have been doing for decades. This work creates value
in the form of scholarship and documentation on the changing face of
Latino art and in the form of inroads into what may be the best program-
matic interventions to reach diverse constituencies. The value created by
community cultural groups is additionally extended if we account for the
work they do with immigrant communities, who are among the most dis-
enfranchised from formal institutional structures. Within these groups,
art has been shown to serve as a source of comfort, as a mode of launch-
ing political action, and as an important source of mobility through
expressive entrepreneurship (DiMaggio and Fernández-Kelly 2010).

These types of efforts at creating infrastructure and programs to
address locally identified and generated needs, however, are seldom con-
sidered as entrepreneurial or as creative in comparison to export-driven
cultural production and more commercial entrepreneurial activities
aimed at attracting outside visitors and tourists. Also obviated by this
export-driven vision is the role played by local consumption. Namely,
the daily and regular contributions of local residents who actively sus-
tain the creative economies of their particular communities as consum-
ers and active participants of cultural offerings and goods are systemically
bypassed in favor of the consumer tastes of more fickle visitors, such as
tourists (Aoyama 2009).

Another problem affecting the valuation of community art groups
stems from the attendant emphasis on proving the value of this work
through evaluations and measurements that are standardized by gov-
ernment and foundation sources. As noted by Maria-Rosario Jackson, a
senior research associate and director of the Urban Institute's Culture,
Creativity, and Communities Program, this trend has pushed community
groups to adopt defensive postures that overstate what can be accom-
plished, in ways that obstruct the appreciation of what they actually
can or cannot deliver (Jackson 2009). As she explained, the fact is that
community groups operate in daunting conditions of poverty and rac-
ism among other structural conditions that are never sufficiently rem-
edied through arts and cultural programs. Accordingly, groups' inability

to address these issues through their work should never diminish their value as spaces of social encounter and exchange. This issue was voiced as a common frustration during a series of national conversations held by the National Association of Latino Arts and Culture in 2010 as part of its twenty-year anniversary. Participants spoke of ambiguous funding guidelines, of the generally inhospitable funding climate they find, and of the distorted picture of what their organizations bring to communities that results when outcomes are measured by foundation guidelines and when their work is treated as "medicinal" to social ills (Méndez Berry 2010a, 2010b). They also objected to the strong outcome orientation of funding guidelines, so that it is the funders' goals rather than the organizations' that are prioritized and so that "at risk, disadvantaged, innovation, sustainability, cutting edge, value-added, diversity, [and] out of the box" stand as the "foundation world's most beloved buzzwords" (2010a, 6).

Another daunting problem is how, despite all the talk about the value of diverse places and creative landscapes, concerns over the survival of local cultural production are regularly considered nostalgic and misplaced by New York City's neoliberal cultural policies. In today's neoliberal economy, a community's identity of place may be rhetorically celebrated, but it is more often than not ultimately seen as a hindrance to the creation of robust cultural landscapes. This stance was communicated to a group of East Harlem Latino cultural leaders and cultural stakeholders by Mayor Michael Bloomberg himself during a breakfast meeting at Gracie Mansion shortly after his inauguration. The city has changed, he noted, so why should we not have vibrant Latino cultural organizations in all the boroughs, not simply in East Harlem? Fair enough, I remember thinking, while realizing the brilliance of gathering East Harlem cultural stakeholders in the Mayoral House, to recognize them as such and to have them rehearse arguments about the importance of protecting East Harlem's Latino identity, only to remind them of his administration's priorities. He was claiming Manhattan. Latino cultural institutions could go elsewhere, to the outer boroughs, and no identity-of-place argument would prevail.

Connection to place represents another significant impediment to the evaluation of barrio cultural creatives. Our contemporary creative economy values movement and mobility, and it is "fickle" cultural initiatives that can pack up and leave that are most valued and that are said to require incentives and to demand romancing: the chain restaurant, the Starbucks, the museum from downtown seeking a cheaper location in a gentrifying neighborhood. In contrast, cultural institutions that are

anchored in place, or whose activities revolve around their identity, are easily taken for granted. Most problematic, barrio creative work is devalued because it is regarded as instinctual to ethnic communities and lacking in any training and expertise. You are Puerto Rican; you dance *bomba y plena*. You are Mexican; you cook tamales. It is what you do; it is in your DNA. You are moved to "protect your culture" for ethnic pride or, in the eyes of many people, for ethnic chauvinism. If no higher degree is involved, if you do not come packaged with the appropriate credentials, then there is no creative work to talk about, despite the hours of training and the sacrificed income that characterizes most cultural work. This ongoing professionalization of the arts and nonprofit management sector, evidenced in the growth of university arts-administration programs, has especially affected Latino art/culture administrators, most of whom are artists and lack the type of formal business training that dominates many of these programs' outlooks, and has increasingly affected the hiring priorities of most art and cultural institutions (Méndez Berry 2010a).

Yet even more difficult is how inequities in cultural evaluation are often codified in law and cultural policy. In fact, in the current neoliberal city, these disparities are exacerbated by policies that supposedly seek to broaden participation in the city's creative economy. This is nowhere more evident than in New York City's financing policy toward the arts, to which I now turn.

Demanding Equity: New York City's Cultural Equity Group

In 2006, Mayor Bloomberg initiated a series of reforms that increased the budget for the arts, a move that was greatly celebrated, but the reforms also included an overhaul of the funding process, which proved more controversial. The new cultural policies were intended to limit the amount of politicking and lobbying involved in the distribution of government funds, especially the involvement of local-level politicians, such as city council members, through the establishment of citywide competitions that would instead emphasize "meritocracy and accountability." However, questions soon emerged about the supposedly value-free and politically neutral policies. Primary among them concerned the fate of smaller institutions, which may be well known within their immediate community but because of a lack of staff, resources, and infrastructure may fall short of proving their "worthiness" at a citywide level.

Most problematic, the policies left untouched the distribution structure that has historically sustained inequalities in the city's artistic/cultural landscape, by tying over 80 percent of the city's budget to a selected group of cultural institutions. Indeed, New York City is considered a pioneer in funding for the arts: the city instituted the first council for the arts in 1960, five years before government arts funding was adopted at the federal level, while it has long recognized the arts and culture as key economic engines. But, as I have been noting, these achievements stand on very unequal footing. For one, there are over fourteen hundred recognized nonprofit cultural and artistic groups throughout the city, which begs the question of why a mere thirty-four institutions still receive from 75 to 80 percent of the city's arts budget, even after the current funding reforms supposedly aimed to create more funding opportunities.

These selected institutions, known as the Culture Institutions Group (CIG), are supposedly "owned" by the city through a model that dates to the mid-1800s, whereby the city owns, constructs, and maintains a building while a private board operates the institution. Today, CIGs include a total of thirty-four cultural institutions throughout the boroughs, which get operating monies, their heat and water paid, and the bulk of the city's arts budget, while everyone else gets only limited programming money. No one could contest the vibrancy of these preferred institutions, which include internationally known tourist magnets such as the Metropolitan Museum of Art and the American Museum of Natural History. But what cannot be denied is that their priority funding status is in fact, as Norma Munn from the New York City Arts Coalition stated to the *Gotham Gazette*, an "accident of history" and, consequently, the subject of much criticism from the city's artistic advocacy community (Mandell 2005). The article notes the arbitrariness of including the Bronx Historical Society and the Staten Island Historical Society in the Cultural Institutions Group, while excluding the Queens Historical Society, the Brooklyn Historical Society, and the New-York Historical Society, as well as the inclusion of the Queens Museum of Art and the Museum of the Moving Image but not the Whitney Museum of American Art. At the core, Munn notes, it is "a lesson in politics," the fact that "somebody 25 years ago was smart enough in the Bronx to lobby, and somebody in Queens was not" (ibid.).

Indeed, the inequities in the city's funding structure have long been noticed—they have been an ongoing concern of the New York City Arts Coalition that Munn chairs. One of her longstanding concerns is how this funding structure divides cultural organizations and hinders their ability

to form large-scale coalitions around arts funding. When the playing field is so unequal, it is difficult to lobby for wide sectoral increases that do not address structural inequalities in regard to distribution. However, for the purposes of this chapter, I want to call attention to the demands voiced by the Cultural Equity Group, a new advocacy group of cultural institutions serving primarily black, Latino, and Asian communities that was founded in 2007 to demand fair and equitable funding. In particular, I examine what these institutions' demands may reveal about the prospects for creating equitable cultural policy in light of neoliberal policies that disavow their work and value in sustaining cultural diversity.

The group is an offshoot of a series of national conversations over arts and equity among community arts organizations that dates back to the early 1990s, some of which are captured in the book *Voices from the Battlefront: Achieving Cultural Equity* (Moreno Vega and Greene 1993). But most specifically, it grew out of a series of conversations around sustainability inspired by the thirty-year anniversary of the Franklin H. Williams Caribbean Cultural Center African Diaspora Institute, which coincided with similar anniversaries of other organizations that were products of the same civil arts activism. When the institute's director, Marta Vega, reached out to other groups to see if they wanted to join the celebration, she discovered that, as she put it, "Everyone's in the red, and there was little to celebrate." Even worse, stories of organizations ready to close their doors began to surface. Mostly, organizations were affected by changes in the funding of the arts that saw a confluence between private foundations limiting their funding to programming support and a dwindling of city and state funding support of administrative operations. Instead of a celebration, the Caribbean Cultural Center organized the "Community Grounded Cultural Arts Organizations @ 30 Years" conference hosted at New York University's Tisch School of the Arts. The conference brought about a renewed activism among local cultural groups, leading to the creation of New York City's Cultural Equity Group.

The group was founded primarily by Puerto Rican arts veterans Marta Vega of the Caribbean Cultural Center and Bill Aguado of the Bronx Council of the Arts, and it includes members from some of the established organizations that emerged out of the civil rights movement and have been in existence for thirty or more years, such as Bob Lee of the Asian American Arts Center, and newer arts administrators, such as Laurie Cumbo of the Museum of Contemporary African Diaspora Arts. All represent organizations that are primarily headed by people or color

and have a mission and programming focusing and reflecting communities of color. As an intergenerational group, they represent a variety of perspectives: older members of civil rights movements focus primarily on demanding equity in government funding, whereas heads of younger organizations are more open to broader private-public solutions. Despite these differences, however, members of the coalition position themselves as representing artistic and cultural communities that are marginalized because they represent communities of color, and they share the need to advance equality and artistic diversity and enfranchisement.

There is much that is exciting about this multiethnic artistic coalition and the activism that it has been waging, from demonstrations in front of City Hall to the organization of town hall meetings ("Equity in Cultural Funding" 2008). In particular, I want to focus on how the Cultural Equity Group's demands engage with the current neoliberal considerations that dominate the city's funding structure. Specifically, it is not the profits and revenues these institutions produce, the services they provide, the tourists they attract, or their so-called value and merit that dominate their demands for equitable funding. These issues are not in doubt by anyone involved in these institutions. Their officers' public statements are dominated by reminders of how they help stabilize communities and of the services they offer to children whose school arts programs have been purged (F. Lee 2008). As they repeatedly maintain, their organizations are multidisciplinary, and they have a purpose and mission that make them far more valuable than any other arts organizations that do "art for art's sake."

Foremost, these institutions insist that they have been producing value and creating infrastructure for entire communities, long before neoliberal policies emphasized job creation, profits, and economic measures for evaluating cultural work. In this way, their call is to be considered at the vanguard of current economic consideration of creative work. This is an important point: institutions founded by cultural creatives of color to serve constituencies of color are not against the "expedient" use of culture, as may be the case with other cultural organizations that have had the luxury to maintain an "art for art's sake" mission and may resent having to stretch their missions in economically stressed times.

Discussions of neoliberal cultural policies are often predicated on a shift in arts financing that assumes that arts/cultural institutions have had to become more culturally expedient in order to attain sustainability and remain marketable. The assumption here is that there was a time when most arts and culture institutions could afford to function for the

single purpose of art's sake—a scenario that has never fit the reality of most community cultural institutions, which born out of social struggles have always been directly invested in a variety of social missions and have long been thinking and working out of the box. Indeed, coalition members highlight the historical disinvestments in minority communities that have long pushed minority cultural organizations to multitask and stretch their services to meet added needs in the communities they serve. In sum, these are not new roles for these institutions. Hence, in their view, the city must account for the special socioeconomic needs addressed by minority organizations whose communities are mired in unemployment and lack of social resources. Or as the CEG manifesto stated, "These community institutions stabilize whole communities with far less resources, assistance, staffing, health care and opportunities than their white counterpart institutions that have the luxury of focusing on 'art for art's sake'" (Frye Burnham 2008). Statements such as these call attention to the value and services that institutions of color produce, while also underscoring their differences from mainstream institutions, which have had greater room to work relatively undisturbed from the need to place art in larger conversation with communities. In contrast, institutions of color have never operated in a vacuum, isolated from the communities where they are located, where they often serve as a social, cultural, and economic anchor. The problem, however, is that the added work and function of cultural creatives of color is consistently discounted, overlooked, and devalued.

This predicament informs CEG activism, which has also included educational workshops to educate local institutions and the public at large of the value generated by community organizations. Through workshops, such as the one at the Black, Asian, and Latino Political Caucus in Albany on February 14, 2009, CEG members encourage institutions to use the economic language of the times and to see and present themselves not only as nonprofit institutions but also as profit-generating small businesses that are central to reinvigorating communities. This involves shifting these institutions' public image to ensure that they are appropriately seen as income and job generating, not only for minority communities but, more broadly, as institutions that help build infrastructure in their surrounding communities.

However, while CEG members are adept at emphasizing the economic arguments that so dominate the advocacy for arts, they are also well aware of the limits of this line of advocacy when cultural institutions of color are concerned. In fact, it is exactly the multiservice and multi-

function aspect of many community cultural groups that has rendered them less valuable in the eyes of the mainstream artistic establishment. Aguado spoke to this issue when he described the patronizing treatment he witnessed during panels where proposals by institutions of color are reviewed: "They see us as a social service organization, but not as arts groups or as valuable assets. . . . It's all a colonial situation," he poignantly added, as he pointed to the Eurocentric frameworks and racist underpinnings at play in the city's arts establishment that so affect the evaluation of cultural organizations representing communities of color. These are the same universalistic visions of art for art's sake that have historically informed definitions of what constitutes "art," definitions that are still dominant in the world of culture and the arts (Marcus and Myers 1995; Bourdieu 1993). Accordingly, the most valuable art is that seen to be most universalistic and hence divorced from any particular social context, even when art scholars and critics have long shown the theoretical impossibility of any art form lacking a social and political context.

The point here is that cultural institutions of color pay a higher price than mainstream institutions do when they emphasize their economic and social utility and when they market themselves along lines other than arts and culture. Unlike mainstream institutions, they are already tainted by their ethnic content, and consequently, in the eyes of the artistic community, extending their missions toward "economic" ventures further diminishes their value and role to one of a "social service" institution rather than an "artistic" venture.

This explains why CEG's economic arguments are always complemented with matters of historical inequity, intended to confront head-on the city's color-blind discourse of value and merit with testaments to the ways in which community institutions have been historically devalued because of their mission, their location, and the communities they serve. Consider the comments of Marta Vega during a town hall organized by the CEG, where she reminded the audience of the historical antecedents of such inequity. She noted, "I came to the arts when there was something called the 'Ghetto Arts Program at NYSCA' [the New York State Council for the Arts]. If you don't understand the history, then you don't understand why inequity exists. So what's in a name?" In her view, the whole NYSCA should look like "Special Arts," the new name that was given to the former Ghetto Arts Program, which was founded in 1969 and was itself the outcome of civil struggles of the times, and which still serves as testament to the segregated world of New York City arts.

It is necessary to step back and consider the elitism that has historically surrounded art institutions in the United States and to recognize that concerns over diversity and attempts to reach out to diverse publics by this sector have been the result of financial exigencies and of accountability demands stemming from government involvement in the funding of this sector from the mid-1960s onward, rather than from democratizing tendencies originating from within the arts establishment (DiMaggio and Useem 1978). In the United States, support for the arts remains highly contentious, with many people arguing against government funding for the arts, even though government support for this sector has historically been minimal as well as far more decentralized in comparison to such support in European and other countries (NEA 2007). In 2007, "only about 13 percent of arts support in the U.S. came from the government, and only about 9 percent from the federal government, of which less than 1 percent came from the National Endowment for the Arts" (NEA 2007, v). These figures are quite minimal, considering the democratizing effects that the initial availability of government funding after the 1960s had in broadening art institutions and constituencies. Indeed, the growth of minority arts and cultural institutions in the late 1960s and 1970s was greatly assisted by government funding for the arts that began to be available to wider constituencies. Granted, government funding for the arts never fully addressed inequalities from the institutional art establishment; instead, it has also helped to exacerbate them, as evidenced here. In fact, from the beginning, the inclusion of minorities in the world of government arts financing was quite segregated and calculated. Chon Noriega explains: "In effect, white middle-class artists went to the National Endowment for the Arts (NEA); minority and working-class artists went to the Comprehensive Employment and Training Act (CETA). When these distinctions broke down in the early 1980s, largely due to the dismantling of CETA and similar programs, the culture wars began" (1999, 61–62).

To highlight this history of segregation, the CEG has been emphatic about the power of demographics and the fact that minorities, even when they are no longer actually in the minority, remain so at the level of arts funding. Once again, Aguado explained: "Talk about quality and value seems fair and appropriate. But what if we use demographics as the funding criteria? If the city is 65 percent minority, should not 65 percent of the money go to organizations that are and serve those communities?" He went on to point out the inadequacy of the current funding system,

which does not provide small-scale institutions funding for administrative costs, to cover health insurance, energy costs, rent, or strategic planning. Instead, the limited funding is tied to programs, which does little to assure the survival of cultural institutions in more challenging times. In Aguado's words, "This is about systemwide inequality; it is not meant for growth of capacity. How do you explain that organizations that for twenty years have served as an anchor to their communities are getting only $10,000?" In sum, the CEG highlights that the city's changing demographics demand new prerogatives: that community cultural institutions be nurtured and respected as central to the city's cultural economy.

Indeed, that the city's artistic establishment and funding structure does not reflect the city's demographics is an extreme understatement. New York City likes to boast about its record in diversifying the arts: the appointment of Mary Schimdt Campbell as the first African American chair of the New York State Council for the Arts (2007–2009) is often pointed to as an example. Yet the governor-appointed Council for the Arts during Campbell's tenure—described to me as the most diverse council since her appointment—included less than a handful of council members of color among its twenty appointees. Members of the CEG are well aware of this situation; many of them shared the same experience of being the only person of color on funding review panels whenever they are invited to serve as panelists.

At the same time, CEG activism shows that arguments around cultural equity in the current diversified, color-blind, neoliberal context cannot be reduced to a matter of advocating on behalf of "cultural institutions of color." For one, community cultural institutions are not immune from universalist standards at play in the arts, and neither are artists immune from seeking to become more attractive and legitimate within the mainstream artistic establishment. In fact, since the 1970s, when most Latino-specific museums and cultural organizations were initially founded as part of larger social movements of the times, many of these institutions have distanced themselves from particular communities, changing their programming to attract wealthier patrons and audiences. This is one of the reasons why members of the CEG coalition are also very attentive to matters of class and space, in addition to ethnicity. Once again, Yasmin Ramirez, explained: "It's not enough to say black and Latino organizations. You have to focus on the communities these organizations serve, and where they're located, and address the class dimension at the heart of why some institutions serving blacks and Latinos languish and others are

able to get monies and tap resources." This statement bring up yet another key issue that is a matter of contention: what exactly makes up an artistic institution of color?

The city's Department of Cultural Affairs (DCA) claims to support organizations of color on the basis of an institution's self-identification or claim that it serves a "community of color." But the CEG goes further to specify an organization of color by the race and ethnicity of its leaders, staff, board members, and the community it serves. In other words, for the CEG, it is not enough to claim to serve a community of color; these communities must also be wholeheartedly represented in an institution as workers, leaders, and board members (F. Lee 2008).

Indeed, at the heart of the debate over what counts as a community organization is a growing gap between the staff and administration in charge of cultural policy and community groups. The city arts administration has not been exempt from the same bureaucratizing and privatizing trends that have characterized government funding under the Bloomberg administration, in which it is primarily technocrats and staff from the private sector that dominate civil service positions (Brash 2010). During the height of CEG activism in 2007–2009, the DCA staff, for instance, included a former fundraiser for the arts and a staff member who had worked in investment banking and was a former funder. When I finally met with them, after several queries, I was greeted not with an interview but with a prepackaged lecture/presentation. The very well-dressed and professional-looking staff performed a well-rehearsed PowerPoint presentation, with vague appeals to the importance of culture "as central to people's right as an economic engine responsible for $5.8 billion in revenues." It was evident from the contrived presentation and the defensive tone with which they answered my questions about the CEG's claims that they were well aware of the group's criticisms that DCA does not fairly represent or fund minority groups. Their position is that they do and that the claims are unfounded, though the staff's defensive tone suggested otherwise. In fact, I had intended to interview officers in the major government cultural/arts programs at the state and city level to assess CEG's claims but could not find anyone who would agree to discuss openly issues of cultural equity.

Yet issues of race are not so easy to dispose of. In fact, in demanding respect for community institutions in the funding process, the CEG institutions maintain that their existence provides the only true guarantee that the city's racial and ethnic demographics are represented in what remains

a still largely Eurocentric artistic establishment. In particular, the group maintains that the arts funding system does not work for institutions of color, proposing that the city set up a different pot of money for community organizations whose work addresses issues of social justice and social rights. The proposal was presented to the New York City Council, where it was critiqued as separatist for suggesting setting up a separate system of funding. However, that was exactly the point these organizations sought to make. Their proposal was strategically meant to highlight that the city already harbors a separate system that guarantees that some major organizations receive the bulk of the city budget. As Marta Vega noted, "If you have the CIGs, why not have the CEGs too?" In fact, the name "CEG" represents a pun on the "CIG" name—the "e" in English is pronounced in the same way as the "i" in Spanish—to stress the point that if there is a separate funding system for one, then there should also be one for the other. The CEG proposal called for these separate funds to be administered by the Fund for the City of New York or by another structure that better reflects the city's composition in its panel structure. This last point was meant to critique the lack of diversity in the DCA panels and staff, which renders it unequipped to manage funding fairly and appropriately.

Unfortunately, arts activism such as that of the Cultural Equity Group faces great challenges in the neoliberal city. First, the CEG's activism coincided with the city's largest financial recession in decades, which in 2009 led to a dramatic shrinkage in the budget for the arts and hence in the terrain in which to demand fiscal equity. Additionally, CIG institutions constitute a far more powerful lobby than they were when the CIG was initially founded. They command the strongest boards, have the wealthiest donors, and host the fanciest parties. Their boards are made up of the same people who feed politicians' budgets, making the prospects for structural funding reform extremely poor. In this way, CEG demands brought up another key point: the larger inequities affecting the field of philanthropy and the class and racial dynamics at play. On this point, it is estimated that only 10 percent of all tax-deductible charitable contributions go to the poor; the bulk goes to institutions involved in lifestyle and prestige maintenance for the wealthy and powerful, such as large museums or alma maters, a pattern that critics have argued raises questions about whether they should be accurately regarded as "charitable" contributions (Reich 2007). The issues CEG raised in regard to the need for fair public funding are therefore significant to larger debates around the need to democratize philanthropy, which has been shown to consistently "short-change" com-

munities of color (Pittz and Sen 2004). The fact that inequalities in private philanthropy remain publicly unaccountable thus adds to the importance of addressing inequities in government funding for arts and culture.[4]

Another challenge to CEG activism is the dominant view that support of one major cultural institution per minority group is enough to address issues of equity. Because there is one Latino- and one black-identified institution among CIGs—El Museo del Barrio and the Studio Museum of Harlem—many people fail to grasp why blacks and Latinos would be concerned about issues of inequity of city funding and why two protected "minority" institutions are insufficiently able to represent the artistic and cultural demands of such diverse constituencies. "There's diversity within diversity," CEG members repeatedly reminded audiences during town hall meetings and other events, knowing full well that the city's artistic establishment is always quick to homogenize and just as quick to disregard their claims. Especially concerning to the group was that the black and Latino institutions selected are two of the most mainstreamed and distanced from their original grassroots mission. In this way, the group's stress on recognizing differences among "community cultural institutions" is important and strategic. It is meant to insist that it is not enough to claim to represent diverse audiences; reference to, service to, and connection to a living community remains paramount.

On Barrio Creative Work

I started this chapter by discussing tamale makers, street writers, and other uncounted cultural workers, and readers may be wondering about the relation between these cultural workers and the claims being made by established minority cultural institutions, such as the CEG members. I would answer by emphasizing two points as a way of a conclusion. First, it is community cultural institutions such as those that are part of the Cultural Equity Group that serve as conduits to disparate barrio cultural workers throughout the city: these are the institutions that know how to channel these workers, where to find them, and how to contract them for catering, programming, or entertainment and that serve as anchors to manifold cultural creatives who remain unrecognized by the city's artistic establishment.

As such, support of community cultural institutions is of paramount importance to the health of the city's creative economy; their success can

ensure the success of numerous networks of cultural workers, who are the life blood of particular communities. Calling attention to the linkages between barrio cultural workers and community artistic organizations is also a way to underscore the enormous gaps that exist in the valorization of community cultural organizations. Not unlike the way the street writers and the tamale makers lack recognition as cultural workers, local cultural institutions lag greatly behind in most considerations of the city's creative economy, being continually discounted, underfunded, and ignored as unimportant to the city's cultural and economic well-being.

Thus, I conclude with the same concerns with which I started: I bring to mind that value is always created, that it is a social invention that we can affect with the right policies, with the right priorities, and, most important, with a corrected thinking of what should be considered valuable and profitable in the world of culture and the arts. The biggest challenge remains discovering the best practices for reevaluating the economic contributions of all creatives of color without subsuming their work to only economic considerations. At the same time, the case of the Cultural Equity Group shows that attention to economic matters is essential for assessing issues of equity in the field of culture and the arts.

It has become commonplace in progressive and anti-neoliberal circles to bemoan the intrusion of economic considerations in the arts and culture, because it is seen as eroding their intrinsic value and inalienability. I hope to have shown, however, that in the present context, it is naive to position the arts and culture as irreconcilable fields to the economy; in fact, it may be downright prejudicial to many community arts groups. As we have seen, exposing the economic advantages of large-scale mainstream institutions versus the inequities that limit the success of community cultural groups may be one way to advance discussions of racism and how it operates in a field so mired in elitist appeals to universal value and merit. CEG activism reminds us that creatives of color have never been shielded by the universalist appeals that so dominate the arts field and, therefore, that discussion of the economic and other "mundane" aspects of this world may well represent a step in the right direction toward finally bursting the view that art ever existed for its own sake. It never did, and hence the arts/culture field cannot take refuge in the mendacity that it should remain free of any economic considerations. For all cultural institutions produce and reap dollars, and whatever value they create is directly related not so much to the work they produce but to the value they are given and the investments they can therefore muster.

4

The Trials of Building
a National Museum of
the American Latino

We don't want a second-class museum. Do it in the Mall.
Do it the right way or not at all.
> —audience member at New York City public hearing

"That's a strange world in which to start building a museum to cele-brate Latinos"—so said skeptically a *Washington Post* editorial chal-lenging the viability of building an "old-fashioned, balkanized museum of ethnic identity" (Kennicott 2010). In this culture critic's view, in fifty years we may not even have Latinos as we understand them today, much less the need for a building to celebrate them. The critic was disparaging the project, but when alluding to a "strange world," he could well have been speaking about the larger context in which a bipartisan bill to create a commission to study the feasibility of establishing a National Museum of the American Latino (NMAL) was signed into law by President Bush.

The bill, a bipartisan effort sponsored by Democratic Congressman Xavier Becerra of California and Republican Representative Ileana Ros-Lehtinen of Florida, took five years to pass, but when it did in May 2008, it did so with relatively strong support in both the House (291–117) and the Senate (91–4). That it passed in the midst of heated immigration debates that two years later led to the passage of Arizona's stringent xeno-phobic legislation is strange indeed but not unrepresentative of the main-stream's contradictory treatment of Latinos as threats to the integrity of American national identity or, alternatively, as model American citizens. In sum, the bill's passage was not unexpected. It represented one more

instance of what has been a historical trend: the paradoxical celebration of Latinos at the level of media, public holidays, celebrations, and rhetoric, while their policing and marginalization, sanctioned by social mores and legislation, continues (Chavez 2008). Moreover, the bill's passage represented an important political gesture to wrest "Latino" political capital for an administration that had started by courting Latinos like no administration had previously done and that, by its end, had seen the rise of a heightened nativist political climate.

The commission was given the charge of studying the feasibility of building a National Museum of the American Latino—whether a museum is actually built could be an issue for years or decades. The National Museum of the American Indian, which opened in 2004, was decades in the making, and the National Museum of African American History and Culture, which is finally scheduled to open on the Mall in 2015, traces its timeline to 1929 legislation authorizing "the construction of a National Memorial Building to serve as a museum and 'a tribute to the Negro's contributions to the achievements of America'" (Smithsonian Institution 2009). In fact, the idea of building a Latino museum dates back to the 1990s, most specifically to the now famous 1994 Latino task force report to the Smithsonian Institution documenting the institution's willful neglect toward Latinos. The report showed that the Smithsonian had historically and systemically excluded Latinos from all its programs and operations, and recommended the establishment of a center for Latino initiatives to partially remedy the institution's dismal record (Smithsonian Institution 1994). Indeed, in public statements, Henry Muñoz, the commission's chair, acknowledged the project's uncertain timeline when at different times he described the project as one that could take ten, fifteen, twenty, or thirty years or perhaps even more time to come to fruition, as if toning down people's expectations with a measure of reality. Then there are issues of whether the museum will be built on the Mall, or even in Washington, D.C., as opposed to in another state with more historical relevance for Latinos or else as a network of umbrella or satellite museums built throughout the nation. There is also the question of whether it will be part of the Smithsonian, which would assure it federal funds but could risk its independence, or else developed independently, and with what percentage of private and public funds.

These and other issues make amply clear that whether a National Museum of the American Latino is actually built and in what fashion will be determined by heavy lobbying and politicking and by the successful

mustering of millions of dollars from corporate and government sources. The figure of $500 million is the one I have heard most circulated publicly, though many people feel that over a billion dollars is more accurate. What no one denies is that the project's final outcome will be reflective of larger debates over the public value and recognition of a constituency that has been consistently berated in public life. Skeptics will need convincing that learning about and celebrating Latinos' contributions can be beneficial to all Americans. This is no small feat given the ascendancy of color-blindness, such that ethnic-specific projects are consistently dismissed as "old-fashioned." On the other hand, xenophobic fears and views of Latinos as relative newcomers and foreigners, undeserving of a place on the highly coveted Mall, will need to be silenced.

As for me, I love visiting museums and appreciate their political value. But I am not without criticism. Museums are some of the most effective nineteenth-century inventions for proving that a "given people" exists and "have a culture," because museums facilitate their "objectification," through objects and representations that can be displayed for everyone to see (Anderson 2006; Handler 1988). These are, of course, the same qualities that make museums such contested institutions, always in need of probing and scrutiny to avoid their functioning as essentializing vessels rather than as social spaces for generating social interactions, ideas, and social change (Karp and Lavine 1991). These are the type of concerns that have impelled alternative museum practices—the interactive format of the National Museum of the American Indian being a good example, and one that can potentially inform the NMAL. While this museum has been criticized for its alternative formats, its reliance on multivocal stories rather than objects, its collective curatorial practices, and its overall celebratory tone, among other criticisms, it has nevertheless been generally lauded by Native American communities and advocates for turning the museum, an instrument that has served in the colonization and cultural erasure of Native Americans, into a medium of self-affirmation and Native American cultural continuity (Jonaitis and Berlo 2008; Lonetree and Cobb 2008).

The National Museum of the American Indian, however, started with the already-existing Heye collection, which was considerably expansive. Most important, the institution was informed by a previous Native American museum movement that, emerging in the 1970s, had directly challenged the colonial and objectification frameworks of traditional museological practices and critically engaged with complex issues of authority

and power in representation, as well as of repatriation and of intellectual and cultural property rights (Pierce Erikson 2008). In contrast, Latinos, who have rarely been exhibition subjects in the mainstream museum world, lack a history of engagement with museums and are just beginning to grapple with the thorny issues at play. I am also skeptical of any politics focusing on museum representation in the current political climate, in which a lack of a national museum represents the least of Latinos' current political ills and concerns.

At the same time, I acknowledge the importance of this national endeavor and consider any argument that may be mobilized in determining whether Latinos merit such a massive undertaking on the National Mall to be extremely revealing of the politics of value surrounding Latinos' past, present, and future. Elsewhere I have argued that contemporary U.S. Latino politics are constrained by the larger neoliberal political and economic climate, in which citizens are increasingly valued for their usefulness as either consumers or political constituencies, pushing groups to prove their "worthiness" along very narrow lines (Davila 2008). Racial minorities are specially affected by these type of politics because being considered as de facto suspect citizens/subjects—as foreigners, newcomers, and not fully belonging to the U.S. national body—they are forced to fit even more narrowly within these dominant conventions. The tendency to represent Latinos as "more American than the Americans" or as holders of "conservative, traditional, and family values" or as primarily a large consumer base or as a rentable political constituency are some outcomes of this type of positioning.

What follows explores the museum project in light of the preceding reflections but also in relation to what we may learn about the politics of value and worth as these are mobilized around the project's feasibility and around the kind of institution that should be developed if and when the project is finally approved. While this is a national project whose feasibility has been debated in numerous states as well as in Puerto Rico, my discussion is limited to its debate in New York City, coupled with interviews with some of the NMAL commissioners and stakeholders of the project and analysis of its coverage in the press. Numerous queries I made to the commission to access public hearings in other cities remained unanswered, while the museum's preliminary status as a "proposed" idea also greatly limits the scope of this chapter. What follows is hence necessarily more suggestive than assertive, though, I hope, not less revealing of some of the dominant issues at stake.

"To Know Your Future, You Must Know Your Past"

The axiom that knowing about one's past is central for launching a future opens up the museum project's principal communication medium: a three-and-a-half-minute video, narrated by Eva Longoria and widely distributed on the Web and shown at all hearings. However, what history and in what fashion are important questions to pose given the dominance within Latino advocacy of safer representations that appear more marketable and acceptable to mainstream society. This stance is echoed in the NMAL commission's composition, as well as in its public communication materials. The twenty-three members, seven appointed by the president (some by George W. Bush and others by Barack Obama) and the rest selected by Republican and Democratic congressional leaders, were supposedly selected because of their expertise in Latino culture, history, museums, and nonprofit administration. However, it is not people with museum or nonprofit background who predominate in the select group but rather leaders in the fields of entertainment, media, and public relations, as well as entrepreneurs and advertising leaders, providing the board with a dominant corporate outlook. The highly photogenic Eva Longoria provides the public face of the project, while Latino political appointees were drawn primarily from some of the most politically contested (and hence potentially rewarding) states, such as Florida, which has six commissioners, and Nevada, which has four. There are no commissioners identified as originating or representing important Latino cities and states such as Chicago, New York City, or New Mexico, pointing to the primacy of political motivations in the selection of the appointees.

Yet it is the communication video that provides the clearest example of the more politically and corporate palatable vision of Latinos that the project spearheads.[1] For one, its tone revolves around the presentation of Latinos as model citizens who contribute to the strength of the United States (rather than challenge or threaten it, as we are more likely to be told by the mainstream press). In fact, the didactic promotional video could not be more prudent and cautious in making the case that this project is not solely about Latinos but, rather, is for the benefit of all Americans. Granted, Smithsonian museums on the Mall are both national and international attractions, accessed by visitors from all over the world, all of whom need to be engaged as prospective visitors and consumers. What cannot be so easily overlooked is that this larger positioning is cen-

tral to the commission's strategic stance, intended to neutralize the project's perception as a balkanizing project that is only for and by Latinos. Moreover, in the current political context, this message fits easily into the dominant color-blind and postracialist ideology of the times, characterized by the diminished currency of and space for ethnic-specific appeals and concerns. It does so by playing down the specific reference to Latinos, which may be perceived as divisive and balkanizing, while writing off a Latino-specific project as a "necessary evil" in order to bolster the strength of the United States by safely incorporating Latinos as a missing part of its history. Consider the video's narrative:

> Latinos are an integral part of the history and culture of the United States. Latinos have been present on the North American continent for more than five hundred years. The influence of Latinos is spread throughout the entire country and evident in every facet of our daily life.
>
> All people of the United States contribute to the American identity. The illumination of the Latino story in America is a recognition not only of a culture that represents one of our country's national assets, but of the complete—and compelling—history of America.
>
> For the benefit of all the cultures that make up the American identity, a national effort is underway to study the creation of a National Museum of the American Latino, in Washington, D.C., a museum that, on a national scale, will provide a focus on popular, historic and contemporary Latino contributions and creative expressions produced and originated in the United States and its territories.

In sum, the project is not presented as one that is directed solely at Latinos but, rather, one that aims to benefit "all the cultures that make up the American identity" and as a project that it is foremost about reinforcing U.S. national identity, rather than only one of its components. This message is reinforced through the visual images, which start with a short historical section showing children and women of indistinct Latino/a descent and a map identifying Florida and South Carolina as part of the Bay of Mexico but quickly jump to showing some nationally well-known contemporary "icons" as testament to Latinos' contributions. Pictures of Sonia Sotomayor, of actor/director Edward James Olmos, and of comedian George Lopez are introduced as examples of Latino influence, and highway road signs for Sacramento and Santa Ana are shown as evidence of its spread. Only two images mark Latino political activism, a picture

of United Farmworkers followed by one of the immigrant marches. Both are quickly followed by landscape pictures of the White House and of the Washington Monument flanked by two U.S. flags; these pictures accompany the official prompt that this project is for the "benefit of all cultures." Once again, familiar images that many Americans, not solely Latinos, would recognize complement the narration, such as the actor Ricardo Montalban, television personality Don Francisco, fashion mogul Carolina Herrera, artist Jean-Michel Basquiat, boxer Oscar De La Hoya, and labor leader César Chávez.

Not surprisingly, the only pictures that are neither of a Latino icon nor of a recognizable politician or entertainment figure are all representative of the dominant media-favored "Latina look," light skinned and upwardly mobile: a young mother and child, a smiling young Latina reading the newspaper, a business-suited young man, a man wearing a conservative blue button-down shirt and flashing his wedding band, a young girl holding a university diploma, a female doctor cloaked in white robes, and so on.[2] The only images representing people of color, who are recognizably black, Asian, or of Native American background, are all shown when the narration appeals to "all those interested in the richness of the American experience." In other words, it is not clear if these raced images index Afro-, Asian-, and Indo-Latinos or if they are meant to represent all "diverse" Americans interested in diversity. The ambiguity is highly effective because it does not mark Latinos as "raced"—which could possibly scare off supporters—but instead appeals to a larger diversity that already exists in American society, of which Latinos are simply a part. The video ends by inviting people to provide input about the proposed project and "its position among our nation's treasure of museums and its place in our great nation" and about how it can advance Latino "art, life, history, and culture."

Notably, the components of art, life, and culture that the museum is supposedly meant to address are safely indexed through "high-art" examples, including an image of *Untitled Skull* (1981), one of Basquiat's most famous paintings, of Henry Muñoz's architectural façade for Museo Alameda, and of a fashion runway show by a designer I could not identify but soon learned had been included as an oversight. The featured designer is Argentinean Allo Martinez, who is based in Buenos Aires, and the picture is from a show he did in Colombia, which the museum's public relations spokesperson described as an "unfortunate oversight." Apparently, the contractor charged with producing the video had not quite got-

Model Latinos featured in the promotional video for the National Museum of the American Latino.

Basquiat, architecture, and fashion exemplify the museum's representation of Latinos' culture and history.

ten the distinction between what is Latino and what is Latin American and had failed to include a Latino designer. The end result, however, is the rare representation of a black female body on a high-fashion runway, an image that is hardly seen in the mainstream Spanish-language media landscape, even if the model is probably Colombian and not Latina. Still, the museum's public relations agent maintained that a second video, currently under production, will no longer feature this image. I could go on about the contradictions involved in this "oversight" and what it may suggest about the larger debates about how the museum will define what is "Latino/a" and how that will be represented—whether the museum may even outsource its representation, as was likely done with the video. For now, I simply point to this example as an instance of the types of issues that will undoubtedly arise as part of the project's development.

I first saw the video at the "VIP" cocktail party held at Rockefeller Plaza the evening before the New York City hearing that was held in the summer of 2010. The hearing was part of a series of hearings held in Texas, Florida, New Mexico, and Illinois, among other U.S. cities, and in Puerto Rico. A who's who of New York City Latino/a artistic, political, and social advocacy sectors was there, most, like me, invited at the very last minute by e-mail invitations that were described as "VIP" and "nontransferable" but that were sent along from person to person like spam in a matter of hours. It was there where I heard another important pitch that also dominates arguments supporting the project's legitimacy: Latinos' significant and largely unrecognized military contributions to the United States and the fact that Latino soldiers have fought in every major conflict since the American Revolutionary War.[3]

This message was reinforced at the official hearing the very next morning during the solemn inauguration led by a veteran-led children's cadet group. Dressed in military apparel, the children carried rifles that seemed taller than some of their bearers, providing for a touchingly tragic vision. Their entry was followed by a standing Pledge of Allegiance and by a formal salute to all Latino men and women who are serving in combat. The procession's message left nothing to the imagination: beyond any reasonable doubt, Latinos are part of the United States because they have fought for the United States; consequently, a hearing for a project of this type is more than appropriate because Latinos have served the United States and will continue to do so in the future, as indicated by their children's procession, with their blood and with their lives. This point was further reinforced when one of the local Latino leaders selected to give short testaments before the hear-

ing was officially open summoned the memory of Marine Lance Corporal José Gutiérrez, a twenty-two-year-old Guatemalan soldier who was one of the first casualties of the Afghan war. He fought and died in a U.S. war without being a citizen, and both his memory and his postmortem citizenship were summoned as examples of Latinos' patriotism and sacrifice.

I was told by one of the commissioners that this mode of inauguration is general practice for any hearing organized by a federal commission, but another admitted that they had taken the practice "a step further" and used the military card as an opportunity to showcase Latinos' hidden historical legacy of armed service. Indeed, Latinos' military service was overtly presented as one of the strongest grounds to gain public favor for this project, perhaps because it is the least politically contentious motive for a project proposed in the midst of two wars and in the current anti-immigrant climate. This stance is also reflected in a *Nuevo Herald* editorial in which the museum is presented as "un derecho ganado," or a hard-won right, not only because of Latinos' high enrollments in the military throughout history but foremost because of their service in "NASA, the military and the CIA" (Shoer Roth 2010). Gina Perez's important work on Latinos in the military, however, gives us reasons to be critical of these positions. As she notes, not only are these views part and parcel of very sophisticated public relations campaigns from the military equating Latino values with military values, but they veil that Latinos' embrace of the military cannot be fully understood without accounting for how it has provided them a space for social inclusion, not to mention one of the few sources for accessing economic and educational opportunities, especially for working-class youth (Perez 2010).

The remaining guests spoke generally about the need for an institution that would show Latinos' strength, that would facilitate the education of "our children," and that would provide the structure for a strong future, among other optimistic visions of what a national museum could do for all Latinos. However, the statements that inspired the most public reaction were those that probed critically at what kind of museum would be built, what and who will be shown, and what it would stand for. A call by City University of New York professor Anthony Stevens that the commissioners should move beyond the idea of building "just a building" to ensure that the museum would nurture rather than debilitate Latinos drew the first widespread audience applause.

Others similarly argued for a museum that would move from traditional models, that would collect beyond paintings and objects, that

would represent vernacular stories such as the Puerto Rican "Juan Bobo" folktales, and that would truly represent Latinos. The Spanish-language media's poor record with diversity was summarily recounted, and the museum was presented as the institution that could finally help to solve Latinos' consistent problem of representation. Zenaida Méndez, the president of the National Dominican Women's Caucus, spoke on behalf of Afro-Latinos, asking whether the museum will be a progressive or a conservative museum and whether it will be Eurocentric, Africa-centric, or Latino-centric. Her statements were loaded with significance. They pointed to Latinos' racism and how it affects their own self-representation, while expressing fears that Latino culture would be reduced to the dominant white/black U.S. racial binaries that dominate racial and ethnic analyses in the United States. Like her, others cautioned that no other reference should obscure U.S. Latinos' experiences and stories and their place at the center of the initiative.

These concerns are quite appropriate given the Smithsonian's poor track record with U.S. Latino/a history. Indeed, not only is there a general lack of Latino-specific collections at the Smithsonian, but the few Latino staff at the Smithsonian I spoke to were unclear about the institution's holdings, insisting that little is actually known about what objects may be related to U.S. Latinos. At a panel on the museum held at the 2010 Latino Art Now Conference in Los Angeles, Commissioner Luis Cancel referenced a 1990s Smithsonian survey that identified half a million objects related to Latin America, but he disappointedly pointed out that approximately two hundred thousand consisted of bugs, a dire situation in which to tell Latinos' story.

Chicana anthropologist and art historian Karen Davalos linked the Smithsonian confusion about what specific objects it has that may pertain to a Latino history, art, and culture to three concurrent ideologies: "First, art is not classified by the ethnic identity of the artist, a tale that has helped to whiten collections without recognition; and second, the territorial style of collecting and preserving objects at the Smithsonian; and finally, to the so-called willful neglect of all things Latino." As an attendee of the 2001 conference on the Interpretation and Representation of Latino Cultures organized by the Smithsonian Latino Initiative, Davalos recalled laughing out loud at the introductory remarks by Secretary Lawrence M. Small, who boasted of the four hundred pieces of Latino art the Smithsonian had collected and of the great number of the Smithsonian's Latino and bilingual employees. Not only was this a dismal number of works to

boast about, but the secretary had missed the irony that the largest single category of Latinos employed consisted of bilingual security officers.

In regard to artistic works, I was able to get more accurate assessments thanks to Carmen Ramos, the first and newly appointed curator of Latino art at the Smithsonian Art Museum. As she explained, since the 1960s, the museum has acquired around five hundred works of art by Latino and Latin American artists living in the United States. However, the collection is largely incomplete. Fueled by the Hispanic boom of the 1980s, it represents a "time capsule" of works that were primarily expressionistic or culturally referential; it is heavily dominated by colonial and folk art; it lacks foundational figures; and it is heavily Mexican American and not representative of all Latino groups and artistic currents (Ramos 2010). Then there are the philosophical and political issues involved in defining what should count as Latino-related material culture in an exhibition context. Or as Stephen Velasquez, associate curator of the Smithsonian's Division of Home and Community Life, put it, "As you know, how people define 'Latino' and 'Latino collections' is squishy. Are we talking about people/ identity north of the border? Or, for example, all photographs relating to/from Mexico or Latin America—collections and histories that greatly impact personal and group identity today?" The bottom line here is that considerable investments and research into the realm of collections are just coming to the forefront as an issue of serious analysis and debate, requiring far more curators and scholars who are well versed in Latino/a studies issues than there are at the Smithsonian. It is also an issue that will continue to be of paramount concern for the project's success.

At the end of the hearing, the audience was asked to participate, and people were not shy: "Let's not build a cemetery." "What about young people with hybrid identities who don't go to museums?" "How about presenting local everyday people instead of focusing on 'stars'?" "Will oral histories be featured?" An audience member questioned the lack of commissioners representing New York State. Another queried why we should build a new museum when so many public archives are languishing. This speaker brought up a key point, already discussed in chapter 3: the dire financial state of most Latino arts and cultural institutions. In 2010, the National Association of Latino Arts and Culture (NALAC) held a series of "National Conversations" on the state of Latino arts and culture institutions, and this issue was forcefully made by all attendees. According to the final report on the conversations, "Most [organizations] operate with budgets of less than $350,000 per year." They work "hac[iendo] de

tripas, corazones," or making hearts out of tripe, operating in "a highly structured, competitive field . . . [where] a mid-sized organization in the broader context is a large organization in the Latino context" (Méndez Berry 2010a, 2). The report also showed that of the $50 million stimulus package that President Obama dedicated to the arts, only $600,000 was allocated to Latino organizations. The dire state of Latino organizations, starved and shortchanged in the distribution of public funds, raises questions about the feasibility of starting a new project of the scale proposed and whether it would even be appropriately funded (ibid.).

These are real concerns for Latino cultural activists I spoke to, who were excited about the project but fearful of its outcome. During a panel discussion at the 2010 Latino Art Now conference in Los Angeles, the commissioners insisted that the museum will not operate as a sponge that will absorb all funding and resources or work to ghettoize all things Latino within one institution. Instead, the commissioners repeated that it will work in collaboration with smaller Latino institutions across the nation while insisting that all other Smithsonian units strengthen their Latino efforts. But these statements did little to appease fears about the museum's potentially predatory role vis-à-vis smaller institutions. Maria De Leon, director of NALAC, reminded the commissioners that local groups would need support to produce artistic works if the museum had any chance of having things to exhibit in the future.

Finally, a recurrent concern voiced by enthusiasts of the project is whether critical perspectives will be included or compromised by the museum's association with the Smithsonian Institution. After all, Smithsonian museums are U.S. "official" museums; will there be room in such an institution for alternative versions of U.S. and Latino history? As a participant at the New York City hearing noted, "Yes, we have the 65 Infantry, but we also have a Pedro Albizu Campos," pointing to both the volunteer Puerto Rican regiment that served in a number of U.S. wars and to the 1950s nationalist Puerto Rican leader who is a symbol of anti-American colonialism. In sum, he was countering the hearing's overly militaristic and assimilationist perspective with a reminder of Puerto Ricans' anticolonial revolutionary legacy, which also deserves recognition.

The call for including progressive views about the Latino experience was also advanced by a student, who testified about the lack of any historical perspectives on Latinos taught at schools. He wanted the museum to fill this void, by teaching students not only about their history but also about the less known and more controversial parts, such as "how Domin-

ican dictator Trujillo ruled or how Puerto Rican cane workers had been enslaved." His comments opened up another key issue. The museum has been conceived as a project that will focus on U.S.-based experiences north of the border; yet U.S. Latino history is a direct outcome of North American imperial inroads into the South. The two events that the student wanted to see represented in the museum are immersed in that history: the Dominican Republic was occupied by the United States twice after the Spanish-American War, and Trujillo had been supported by the U.S. government; and the story of the mistreatment of Puerto Rican cane workers cannot be told without a discussion of the U.S. sugar companies that took over the island's plantations after the United States seized it as a colony. As Juan González has noted, Latinos in the United States represent a "harvest of empire," and there is not a single group of Latinos who came to the United States without a previous history of U.S. involvement (González 2001); thus, will these stories be told too? Another speaker pushed this point when he pleaded to the commission, "Don't water down our history. We lost our history already. Let's not lose it again, if we have to compromise showcasing it." He warned that "history is always told from the winners' perspective, and Latinos have not been winners."

Indeed, the project's political overtones were concerning to critics, who wondered whether politics would take priority over issues of accuracy and accountability. These concerns are not farfetched considering that ever since the culture wars first brought the politicization of art and culture to the forefront, the Smithsonian has been at the center of many debates in which political considerations prevailed over curatorial and scholarly ones. Most recently, the removal of artist David Wojnarowicz's *A Fire in My Belly* from "Hide/Seek: Difference and Desire in American Portraiture" (October 30, 2010–February 13, 2011), the first major exhibition on same-sex desire at the National Portrait Gallery, exposed the institution's susceptibility to political pressure and gay-rights censorship—in this case to conservative groups that shunned the exhibition's supposedly anti-Christian themes. Even the museum project's name is permeated with political connotations. For one, the National Museum of the American Latino is technically a redundant name. As a North American–generated ethnic identity category, *Latino* already implies and references *American*; hence, there is no need to specify "American Latino" in the name, unless to emphasize the project's "North American" tenor. Even more revealing is the marketing blunder of the resulting acronym. As a critic pointed out, by adding "American" to the name, the museum's

acronym, NMAL, conjures *mal*, or "bad" in Spanish, a slipup that was seemingly ignored in favor of the more politically palatable title.

These issues are already at the forefront in the development of the Smithsonian's National Museum of African American History and Culture, which is scheduled to open in 2015. This museum has also been presented as one that will explore African Americans not in isolation but in relation to greater U.S. society, raising issues about whether its mission will be diluted to becoming a "healing" space with little room for critical perspectives on U.S. history and race (Taylor 2011). It is noteworthy that this museum's process has been greatly informed by the reception of the National Museum of the American Indian. Seeking to avoid the type of criticism leveled at the National Museum of the American Indian's overly activist mission, the National Museum of African American History and Culture is described as being squarely rooted in scholarship. Yet considering the glaring gaps in the scholarship of racial minorities in this country, especially in regard to the thorniest parts of the U.S. history of racial discrimination and empire, this stance is quite concerning. It raises the question of why exactly these museums should be built, if they are fashioned to reproduce the Smithsonian's overtly "research" outlook and its status as an "official" national institution. Would not this narrowed perspective shape them into yet another institution reproducing the same dominant (white) strand of national history, in ways that contradict the need for developing new and alternative spaces altogether? This is one of the points that tend to be veiled by postracialist positions: race- and ethnic-specific initiatives stem from racial minorities' exclusion from the U.S. canon and from its history and institutions. Accordingly, ethnic-specific initiatives are central to guaranteeing a more unified society, and banishing their existence can only lead to a society that is less representative and less informed about its history. Ethnic-specific initiatives do not exempt mainstream institutions from becoming more inclusive. However, they provide spaces for more exhaustive considerations of marginalized histories that can both enrich our understanding of U.S. history and help challenge the public's ignorance about the contributions of these populations. The fact is that discussion about the feasibility of a Latino museum primarily has exposed people's hopes and wishes for an exciting and inclusive institution that will help to expand public debate over Latinos as intrinsic components of U.S. society and history. This corrective position is needed today more than ever given the xenophobic and nativist climate enveloping public debates over Latinos, making this

initiative so necessary as a fix for ignorance and exclusion.[4] Yet, as this book goes to press, all the excitement I witnessed at the New York City hearing I also saw tempered. Public announcements that a report with recommendations for Congress would be issued in September 2010 were soon countered with a decision to delay its unveiling until an unspecified date that would be more politically conducive to the project's success. At least this is what I was told by different commissioners and what was publicly announced at the 2010 Latino Art Now conference, much to the audience's chagrin. In the question-and-answer period, Armando Durán, a collector of Latino art, gave voice to the audience's frustrations, as evidenced by the applause that followed his remark: "It's a mistake to wait for the political reality to change. We need to advocate for the project no matter the reality. You need to stick to what you promised."

Indeed, within a year of the project's nationwide hearings, the political climate had worsened swiftly. The midterm elections saw the Democrats lose the House and new representatives put in place. These changes, coupled with the rise of the Tea Party and the continued recession, were believed to have worsened the already-hostile context in which to advocate for a multimillion-dollar Latino project on the National Mall. Still, the commission's political decision to hold its cards close and not to release its report with recommendations was a great contrast to the boosterism I had witnessed. The turnaround serves as an unambiguous sign of the project's fragility and of the fear that one bit of bad press, along the lines of the *Washington Post* editorial quoted earlier, or one political stone not moved could represent the project's demise. The lesson is obvious: it is all up to Congress, and the commissioners will have to play politics. And we should not be surprised by the turn of events. Evaluation is always the outcome of politics, and even more so for the evaluation of Latino arts, culture, and history at the national level. Hopefully, the politics around this project are just beginning.

I conclude, however, by summoning the experience of the National Museum of the American Indian, the only "minority" museum that has successfully been built on the Mall. Certainly, Latinos will soon have fruitful lessons to learn from the opening of the National Museum of African American History and Culture, when it finally opens on the Mall. With luck, this museum will place African Americans' history at the national forefront, becoming a medium for voicing the significant critical perspectives that are unavoidable and necessary for any museum of its type. For now, however, I limit my musings to the National Museum of the Ameri-

can Indian, a project that was also the subject of national politics and of congressional debates; it took fifteen years to open in 2004, after its creation was finally passed into law in 1989. However, this project represents more than a hard-won political battle. For one, the project was informed by an active social movement and by an alternative philosophy of representation, from which Latinos could learn generative lessons. Specifically, the museum did not acquiesce to dominant curatorial practices but sought to transform them and turn them around in the service of empowering a diverse Native American community. This explains the stark reaction it has provoked among critics, many of whom have dismissed the innovations as a sign of a lack of scholarship and rigor. These reactions miss the project's originality and its most important contribution, the fact that it presents a significant ideological intervention and an alternative to dominant museological frameworks that have historically dominated the collection and exhibition of Native Americans' art, history, and culture.

In sum, no institution involved in representation can ever be fully exempt from criticism. However, I believe that the National Museum of the American Indian represents, at least, a collective critical effort generated in recognition of the perils and opportunities involved in the construction of a national museum on the Mall. Latinos have never been subject to the type of objectification that Native Americans have suffered at the hands of museum anthropologists and curators. However, as we pursue the necessary politics to ensure the success of any National Museum of the American Latino that may be imagined or built on the Mall, or elsewhere, we would do well to recall this example to ensure that our museum politics not only are of acquiescence but also strive to be empowering and transformative.

5

Through Commerce, for Community

Miguel Luciano's
Nuyorican Interventions

Since the 1980s "Hispanic art boom," when museums and galleries dis-covered the marketability of exhibiting Latino and Latin American artists under a pan-Latino category, Latino artists have had to maneu-ver through established boundaries of artistic and identity categoriza-tion. Unrecognized by either the Latin American or the North American art canon, a handful of Latino artists attained sudden celebrity, with few institutional structures to support them in the form of museums and gal-leries, with few professional interlocutors such as critics and curators to translate and validate their work, and with a lack of an established market that would appraise and help market their work. Almost thirty years later, the number of curators, galleries, and collectors who are versed in or familiar with Latino/a art and artists has grown considerably, but the field of Latino/a art still lags significantly behind in recognition and infrastruc-ture, while, as discussed in chapter 3, Latino arts and culture institutions have become precariously vulnerable in the current economic downtown.

Arguably, artists are more vulnerable than arts and cultural institutions are. Not only are artists dependent on institutional structures to exhibit and market their work, but they suffer from a general lack of artists-directed funding, as most arts funding is aimed at institutions. A 2009 NALAC sur-vey of Latino artists showed that 44 percent, almost half, have incomes of under $25,000, 58 percent had experienced a decrease in income from the previous year, and 61 percent had experienced an increase in the amount of their own resources that they were asked to invest in order to present and

exhibit their work, such as by lowering or forgoing artists' fees or providing their own materials and labor. Similarly, just like their institutional counterparts, few Latino artists have had the luxury to work solely in the arts. Yasmin Ramirez's survey on New York City's creative class of color showed that 82 percent of the artists surveyed reported being full-time workers or having regular jobs in addition to their studio work, whether it be self-employed or as educators or in the nonprofit world, the two main categories of employment among Latino artists (Ramirez 2010).

In sum, Latino/a artists seeking to earn a livelihood with their work must exercise great ingenuity in regard to how they position and market themselves and their work, especially in New York City, an arts-saturated city where ethnic-specific galleries and museums are few, and many of them are in crisis. To this difficulty, we must add dominant trends toward postidentity postures in the arts that parallel neoliberal resignifications of race and that have continued to undermine ethnic-specific galleries and museums as a medium for artists to move up the ladder of mainstream artistic "authenticity."

Following up on the dominance of multiculturalism and identity positioning throughout the 1980s and 1990s, which were not less problematic, the new framework has presented unique challenges to how Latino artists and curators negotiate their place in the mainstream arts world. For one, postidentity positioning is predicated on the dominant Western-based universalist notion that art is most valuable the more global, universalist, and disconnected from particular communities it is posed to be, leading many artists and curators sometimes to do away with ethnic-specific categories altogether.[1] The traveling exhibition "Phantom Sightings: Art after the Chicano Movement" (2008), the first comprehensive exhibition of Chicano art in almost two decades and the first of its kind at the internationally renowned Los Angeles County Museum of Art, represents a relevant example of the trend to negotiate the insertion of Latino art into larger postidentity spectrums. While the exhibition was praised for its dialogical and self-conscious approach to identity, it also raised questions about its presumption of the "Chicano movement" as homogeneous in its range of artistic production, as well as raising concerns about its silencing of voices that both then and now have continued to rework or find inspiration in the Chicano movement. Questions were also raised about the exhibition's unease and apologetic tone toward identity politics, becoming complicit with interpretative frameworks that may do little to validate Latino art and artists on their own merits, rather than on the basis of

imposed frames (Shaked 2008; Davalos 2011). After all, Latino artists do not shed their identity so easily within mainstream artistic circles, while mainstream arts spaces are barely expanding to include their work, as evidenced by the lack of Chicano art exhibits at the Los Angeles County Museum preceding "Phantom Sightings" and by my discussion of the state of the Smithsonian's Latino art collections in chapter 4.[2]

In what follows, I examine the work of Miguel Luciano (b. 1972), a Puerto Rican–born and New York–based Latino artist whose work and trajectory speak to some of the larger issues that frame the work of many Latino artists in New York City and beyond and whose work reflects critically on some of the hierarchies of cultural value that many artists have consistently had to navigate. In particular, Luciano's work is laden with references and commentaries on the commodification of Puerto Rican and Latino culture, the politics of space, and the ascendency of neoliberal market logics and values, all of which are related to the central concerns of this book. Luciano's work is additionally interesting because it has gained some international recognition, having been incorporated into diverse Caribbean, Puerto Rican, Latino, and Latin American exhibits because of its hybrid combination of genres and elements that are easily translatable to global concerns, all along maintaining a deep commitment to his Puerto Rican identity and a clear reference to Puerto Rican and Latino communities in New York and elsewhere.

Attaining recognition within these multiple positions has not come easily to many Latino artists, who are often ghettoized within narrow identity frameworks, and much less for Puerto Rican artists, whose colonial Puerto Rican background hinders their easy categorization into American, Latin American, or Caribbean exhibitions. All of this adds to my interest in Luciano's work, as an artist who has been able to revalidate and anchor the value of communities through work that is simultaneously assertive and critical of identities, especially of narrow and commodifiable forms, and that systematically questions the preeminence of neoliberal logics and economies. Foremost, Luciano's work reflects on some of the larger processes that affect the fate of most Latino artists, involving both the commercialization and privatization of culture and the narrowing of spaces for showcasing their work, and the limiting of their creations through frameworks that either narrowly fit them into strict identity categories or entirely disavow matters of community and identity.

I met Luciano in 2001 during his first New York exhibition, at the Taller Boricua in East Harlem, a small community space yet a historically

important local stronghold of the Nuyorican art movement that signals the importance of culturally specific museums and galleries in validating and exposing the work of many Latino artists. By "the Nuyorican art movement," I am referring to the aesthetic and political social movement of the 1970s, a part of larger civil rights struggles of the times, that emphasized Puerto Ricans' ideological decolonization through cultural affirmation and that led to the formation of important artistic and cultural production in the visual arts and in poetry, as well as to a variety of ethnic-specific institutions in New York City and beyond (Y. Ramirez 2005a, 2005b; Valentín-Escobar 2010). In fact, most Puerto Rican and Latino artists who have gained notoriety in the New York City arts scene and internationally, such as Juan Sanchez and Pepón Osorio, had similar origins, having been first exposed and recognized within smaller Puerto Rican and Latino-specific institutions almost entirely at the margin of the mainstream scene. Luciano had just finished his MFA at the University of Florida and had moved to New York City because he was attracted to what he described as the city's symbolic importance for the Puerto Rican community. His works have always had an interactive and community-involvement focus—as a student in Miami, he had been engaged in a range of murals and public art projects—and he felt that New York City would provide a fertile space for residencies, partnerships, and other opportunities to reach wider constituencies.

At the Taller, I was met by Luciano's piece *La Mano Poderosa Racetrack*, a sculptural installation that served as a suggestive introduction to his work. The piece combined a large-scale sculpture of one of the most revered symbols of Puerto Rican folklore, the Catholic symbol of the Powerful Hand of Crucified Christ, with a twenty-foot-long Hot Wheels racetrack, just like the ones that had been at the center of a popular consumer phenomenon on the island. Except Luciano's racetrack extended from the stigmata starting gate of the giant hand to a finish line within a carved wooden Sacred Heart. The installation was inspired by the Mattel Hot Wheels craze that enveloped the island in the late 1990s, when Puerto Ricans took to competitive toy-car racing on makeshift racetracks, leading Mattel Hot Wheels car sales to skyrocket. Luciano's piece presents a critical but playful take on the phenomenon by replacing the traditional figures of Jesus, Mary, Joseph, and other saints of the Catholic pantheon that usually adorn the "Powerful Hand" with made-up "saints" of commercial culture, such as Ronald McDonald, KFC's Colonel Sanders, and Mama Inés (the Cuban version of the "mammy" character, adopted as a

marketing symbol for a Puerto Rican coffee brand), and by reproducing the ethos of community and play at the core of Puerto Ricans' appropriation of the popular commodity.

Luciano interviewed Mattel's marketing representative on the island and was surprised to learn that the company had been entirely unaware of what had driven the Hot Wheels craze and that, delighted by it, had tried unsuccessfully to capitalize on it and to export it to other markets. A commemorative Puerto Rican Hot Wheels model developed by Mattel also floundered because it was made from a lighter material. The company had been oblivious to the fact that the most coveted cars were the heaviest and thus the fastest ones to race. With *La Mano Poderosa Racetrack*, Luciano interpreted the island's Hot Wheels craze as a contradictory mix of consumerist values and defiance, in which Puerto Ricans demonstrated consumerist excess over a toy commodity but also surfaced as producers of new cultural meanings that were ultimately not so easily commodifiable.

This was not the first time that Luciano had experienced corporate attempts to capitalize on and commodify Latino vernacular culture and its effects on local communities. In Miami, he had witnessed how one of his public mural projects had transformed a public basketball court in a disinvested community into a tourist attraction that was inaccessible to communities and used as a background for commercial ends, with little regard or compensation for the artists and the community that had created the mural. These intimate experiences of commercial cooptation alongside his background in commercial freelance work, illustrations, and sign painting—not uncommon among Latino/a artists of his generation—were soon put to work in Luciano's critical commentaries on commercial culture.

What struck me first about Miguel Luciano's work has continued to characterize many of his creations. This is the playful, accessible, yet critical way in which Luciano explores the corporate commodification and cooptation of Puerto Rican and Latino/a culture. In this regard, Luciano's paintings draw from some of the most well-known characters of consumer culture, such as the Cracker Jack sailor, the Trix rabbit, the Kellogg's Corn Flakes cereal rooster, Ronald McDonald, and KFC's Colonel Sanders—characters mostly drawn from the fast-food chains and commercial brands that plague Latino/a neighborhoods, supermarkets, and bodegas, as well as Latino/a bodies, with higher rates of obesity and diabetes. Yet Luciano is not only concerned with exploring the perils of these seemingly innocent cartoon-

La Mano Poderosa Racetrack (performance detail), Hot Wheels racing competition, Chicago, Illinois, 2004. (Photo courtesy of the artist)

ish characters. Instead, he works through them, using their familiarity for regular consumers to draw in viewers to even greater societal perils, including the stark political realities of colonialism and imperialism, and to scenes of extermination and political struggle. Consider the *Cracker Juan* print, in which "highest combat fatalities in U.S.," "caramel coated Puerto Ricans for peanuts," "citizenship prize inside" are subtly stamped in the marketing banners of a Cracker Jack box.

Additionally, Luciano's work exposes the fantasy and the disenchantments of consumer culture while reevaluating elements of folklore, popular culture, and history that are regularly obviated or disregarded as

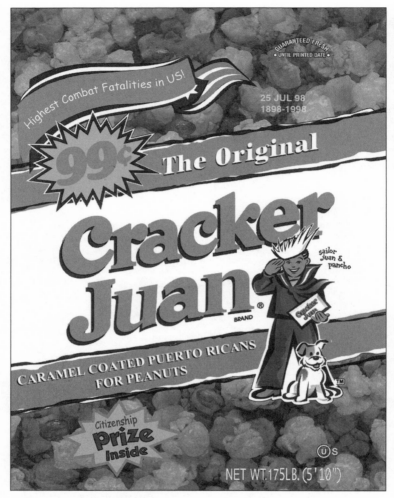

Cracker Juan, archival ink-jet print, 24" × 18", 1998. (Photo courtesy of the artist)

insignificant according to dominant Puerto Rican and U.S. mainstream society's evaluative frameworks. Specifically, Luciano's creations draw from Puerto Rican folkloric icons, from the street vending carts used by informal workers, and from the humble green plantain, all of which have been disparagingly associated with popular classes but also popularly remade into iconic symbols of Puerto Rican identity. The plantain,

in particular, informs a popular Puerto Rican metaphor that equates the difficulty of removing the "mancha de plátano," or the stain produced by the plantain when it is cut from the tree, to the impossibility of fully shedding one's Puerto Ricanness, despite one's efforts to move up the ladder or distance oneself from one's native background. It conjures cultural resiliency, as it also does in other Caribbean contexts, as well as the affirmation and pride that stems from finally embracing a formerly dismissed or berated identity.

However, in Luciano's hands, these popular symbols of identity are further revamped, embellished, and revalued into precious objects that are inherently valuable, not only because they become memorialized as art but because of the superior craftsmanship and quality materials with which they are made or become enveloped. Hence, in the *Pure Plantainum* series (2006), actual plantains are covered in platinum, the most precious of metals. The object boasts a pristine layer of the precious metal on the exterior, while the actual fruit decomposes within. In *Pimp My Piragua* (2008), a vending cart is turned into a shiny, bright-orange, fiberglass bicycle pushcart that is hypermodified with a high-powered sound and video system. The contrast Luciano establishes between mundane objects of popular culture and the larger-than-life guises they take serves as a poignant commentary on the evaluation of culture, not unlike the blending of high and low art forms that was used as part of the aesthetic strategy and visual language of the Chicano and Nuyorican art movements. Tomas Ybarra-Frausto's discussion of the aesthetic sensibility of *rasquachismo*, or the flamboyant, "unfettered and unrestrained" mixing and combination of materials and references, is relevant here (Ybarra-Frausto 1991, 133). In Luciano's pieces, this contrast helps emphasize the divide between what is precious and what is mundane, while confounding these values when they become incorporated into the very same art piece/commodity object.

Plátano Pride, a photograph depicting a dark-skinned Latino boy flashing a *Pure Plantainum* pendant with unabashed pride, is perhaps one of the most well-known and circulated examples of this conceptual strategy. The image was flashed all throughout Paris when it became the face for "Kréyol Factory" (2009), an exhibition of contemporary Caribbean art at Parc de la Villette; it was also prominently exhibited at Brooklyn's first major exhibition of Caribbean art and artists, "Infinite Island: Contemporary Caribbean Art" (2007), and used on the book cover for the first scholarly collection about reggaeton (Rivera, Mar-

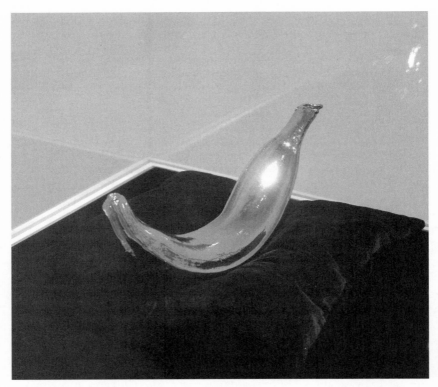

Pure Plantainum, green plantain, plated in platinum, in vitrine, 2006, collection of the Brooklyn Museum. (Photo courtesy of the artist)

shall, and Pacini Hárnandez 2009). The proud boy is depicted showing off the plantain jewelry; but is he most proud of the expensive platinum jewelry or of its depiction of a plantain? Or are both intrinsically connected? With the plantain's platinum plating, Luciano calls attention to the shiny superficial cloak of consumer culture and to the ways it facilitates particular fronts, feelings, and identities among all of us. This is the power and fetishism of commodities, and our tendency to mask, express, and engage with our fears and insecurities, as well as our very identities, with and through commodities. After all, inside the platinum coating lies a rotting plantain. This is the most hurting and the most vulnerable center, evoking individual and communal wounds, perhaps the terror and destruction of colonialism—another key reference of Luciano's compositions, most directly explored in some of his paintings

(see for instance *Exterminio de Nuestros Indios* [2003] and *Pelea de Gallos* [2002]). However, the plantain's core endures through, and despite, the artificial consumer veil; its shape outlines the silhouette and comes through as the unmistakable fruit.

Plantains' power of endurance and might is further explored in the *Manga-Mancha* paintings and drawings (2006), in which we see a Japanese manga figure crowned with hair made out of plantains, the superhero's source of supernatural powers. *Plátano Pride* and some of the *Manga-Mancha* paintings were exhibited together to emphasize the artist's vision during Luciano's first mainstream gallery show, an exhibition curated by Juan Sanchez at the Chelsea-based CUE Art Foundation, through a program in which prominent artists are asked to curate shows for new, younger, or emergent artists. Luciano's selection for a solo show by the revered Nuyorican artist Sanchez was especially meaningful to Luciano and was evocative of his longstanding identification with the Nuyorican artistic community. Juan Sanchez is not only one of the few Nuyorican artists who has received nationwide legitimacy from mainstream galleries and collectors; he is also an artist who has never been shy to explore topics related to Puerto Ricans' identity and experiences with poverty, colonialism, marginalization, and empowerment both on the island and in the Diaspora. These are concerns that Luciano shares with Sanchez and that induce his pride in having his work identified with a Nuyorican artistic tradition, even though, in his own words, he is a "transplant" who did not experience what he described as a "typical" Nuyorican trajectory, having moved to New York City from Florida. The key identification is neither geographic nor historical; a "Nuyorican" tradition is thus conceived as the extension of the politicized and community interventions of Taller Boricua and the community of Nuyorican artists who broke artistic barriers in the 1970s alongside the Nuyorican movement to formulate work that was in intimate conversation with the empowerment of the Puerto Rican community both in the States and on the island. Luciano connects culturally and politically to this movement, even though by his own admission, this is an extremely fragile, undocumented, and marginalized history—and not one that many Puerto Rican artists either know or wish to be linked to.

It is worth noting that, unlike Chicano art and artists, who have been the subject of a small but growing scholarly literature, there is almost no documentation of the work and contributions of Nuyorican artists.[3] There are many reasons for this void, not least of which are Puerto Ricans'

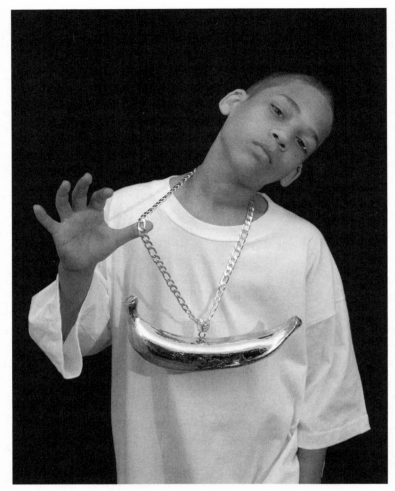

Plátano Pride, chromogenic print, 40" × 30", 1/5, 2006, collection of the Brooklyn Museum. (Photo courtesy of the artist)

historical marginalization in New York City and the island's colonial status, which has hindered Puerto Ricans' easy placement in the Latin American and American artistic canon, among other reasons not dissimilar from what initially led to the formation of Puerto Rican–specific art and culture institutions in the late 1960s and early 1970s.[4] Additionally, the Puerto Rican artistic community in the United States is small and

fragmented. The few U.S.-born Puerto Rican artists who actively identify as artists in New York are greatly outnumbered by Puerto Rican–born artists who come to the States primarily from middle-class backgrounds to pursue MFAs and have different backgrounds and concerns than their U.S.-born counterparts. Not only do many of these Puerto Rican artists not know the legacies of Nuyorican pioneers, but through their MFA programs they become quickly professionalized into neoconceptual and intellectual artistic trends that have greater international appeal. Many of them purposefully distance themselves from their Puerto Rican identity or embrace it only when it is strategically useful, while developing a lukewarm connection to Puerto Rican communities.

Luciano is part of a small cadre of U.S.-based Puerto Rican artists that are exploring the legacy of the 1970s, such as Yasmin Hernández and Wanda Raimundi-Ortiz, and who distinguish themselves by embracing a legacy that has few recognizable figures, that is dismissed by dominant intellectual trends, and that can arguably compromise the mainstream artistic recognition of their work.[5] Still, he feels that this position gives his work the most meaning, especially producing work that is relevant and in conversation with communities. In this regard, Luciano expressed concerns with the tendency among art-world critics to celebrate post-identity/postpolitical positions, as does the *New York Times* critic Holland Cotter whenever he reviews Latino exhibits (Cotter 2003, 2005). That Cotter would do this, as a reviewer that in the past has shown support for East Harlem Puerto Rican artists, such as by covering the exhibits of Taller Boricua, was especially puzzling to Luciano. It is enough that he has shifted to reflect and influence a dominant postidentity position in the gallery world, but most problematic for Luciano is the influence this dominant position may have on Latino artists in guiding their processes toward more commercial ends.

Luciano also spoke critically about the limitations that are intrinsic to gallery and commercial spaces in regard to exhibiting and promoting works that may seem less commodifiable or whose richness stems from audience interactions and performative exchanges. In his words,

> One of my challenges in accessing commercial spaces is that these have not been the most interesting spaces for my work, because they are interested in the bottom line and in selling to their base. I'm interested in having these conversations about culture, history, identity, and empowerment, and this type of work works best with

institutions where I can work with communities and where a con-versation can be built around the work and where the concern is not with the market but with the experience of the work.

Luciano's skepticism of the market seems to be at odds with the look and feel of his work, which tends to be loaded with commercial symbols and exuberantly done in ways that would appear to give preeminence to commercial logics. After all, it is through commercial and media signs and symbols that such varied mundane objects as a plantain or a shaved-ice cart are refashioned as extravagantly shiny, brightly colored, smoothly finished, and fantastic. Placing Luciano's conceptual strategy alongside hip hop's vernacular visual culture, particularly its emphasis on the aes-thetics of bling and shine, however, leads us to a very different conclu-sion. Art historian Krista Thompson has discussed how these strategies are used by black artists to push visibility to its limits by calling attention to the very shininess and light among other optical effects involved in the process of coming to representation (2009). This self-referential use of bling expands the repertoire to express black subjectivity in an age of black hypervisibility and disappearance, she notes, in a similar way to the effects produced by Luciano's use of shine and bling in his pieces. Indeed, I would argue that the end result provoked by Luciano's use of hip hop's visual repertoire, such as the "pimping" of his pieces, is exactly the oppo-site of what would be most predictable and that far from a valorization of the commercial qualities of the object, it is an abstract community of pride that his work helps to summon and valorize.

This recuperation of community becomes especially alive through the public performances that often accompany Luciano's pieces. His installa-tions, in particular, engage viewers to interact with his work in ways that are always joyous and playful and assertive of communities. In *La Mano Poderosa*, viewers are asked to participate and compete in Hot Wheels car races, and winners are awarded plantain-mobile trophies. In his *Pimp My Piragua*, people are invited to interact with the cart and to gather around it, to dance to the music and video, while enjoying a sweetly flavored *pira-gua* (shaved ice). And just as with the platinum plantain piece, at the cen-ter of the pimped-out, modern, and hyperfetishized *piragua* cart lies the simplicity of the *piragua*, prepared in the same traditional manner that street vendors do. This adds another interesting element to the piece. The artist has to literally work up a sweat shaving each individual *piragua*, just

as street vendors regularly do, an action that serves to rescue and reevaluate the strenuous manual labor that the addition of a modern blending machine would do away with so easily. The contrast provided by a jazzy cart topped with such archaic ice-shaving technology intimates what may ultimately be the most valuable element in the piece: namely, the intangible manual work that is involved in the making of each individual *piragua*. A modern blender would certainly make a better match with the state-of-the-art cart, but it would not produce the snowy consistency that distinguishes *piraguas* from any other shaved-ice treat.

Each of these installations summons people to have a good time and to meet and construct community, while evoking the labor and value of informal street vendors, who are regularly persecuted and policed from accessing public space. The *piragua* project was conceived with these issues in mind. Luciano described this project as a commemoration of one of the oldest traditions in the Puerto Rican and Latino community, one that grew out of early migrants' need to make a buck at the margins and that is as endearing to Latinos as it is considered a nuisance to public space. Luciano's *piragua* cart is purposefully intended to be paraded around public spaces and to stop traffic and demand attention—who can miss the sound and sight of a loud, bright-orange *piragua* pushcart bike? And arrangements had to be made with the local police to allow the cart to be ridden publicly, because, as Luciano learned, these carts are not issued permits, because they are considered a nuisance to public space. But as an art piece, Luciano's *piragua* cart successfully circumvents these rules, reinstating Latino culture into public space, which is not unrelated to the joyous response from popular communities that the cart consistently triggers.

Indeed, when the *piragua* cart is paraded across New York City neighborhoods, it overtly showcases Puerto Rican and Latino popular culture in public landscapes, in direct contrast to the many urban ordinances generated by city administrators geared toward keeping difference invisible or at bay. As Johana Londoño's important research warns us, laws against murals and graffiti or against noise pollution are some of the ways in which physical landscapes are regularly whitewashed and "anesthetized" from Latinos' presence. Ironically, these processes are often accompanied by the aesthetic reconversion of Latino/a culture in urban planning and design, such as through the incorporation of color and "Latino-themed" architecture (Londoño 2011). Luciano's work challenges exactly these types of regulations of Latino vernacular culture in the phys-

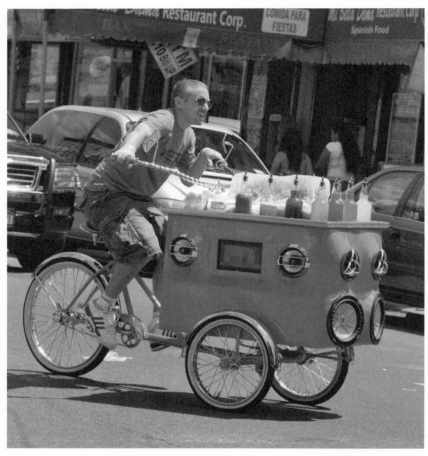

Pimp My Piragua, in Flushing Meadow Park, Queens, New York, 2008. (Photo courtesy of the artist)

ical landscape, especially when he parades his *piragua* cart through New York City's gentrifying neighborhoods, such as Brooklyn's Williamsburg.

Another piece in which Luciano makes a direct commentary on Latinos' right to public space is the *Learning to Love* (*Latinos*) piece created for the Volunteer Lawyers for the Arts (VLA) residency exhibition at New York City's Maccarone Gallery. The piece was inspired by the racial controversy launched over a mural at Miller Valley Elementary in Prescott, Arizona, which had been initially intended to explore themes of children's

safety and diversity. When the mural depicted actual school students and a black Latino child at the forefront, some community members demanded that the artist lighten up the nonwhite kids, triggering a racist debate that gained national media attention. The school initially endorsed the protesters' views but then retracted, acknowledging that it had made the mistake of bowing to racially motivated demands.

Luciano's piece becomes a testament to this unfortunate debate; it highlights the dark-skinned Latino student at the center of the racist controversy with a banner that reads "Learning to Love," alongside a video clip of the debate. In the context of the gallery, the news-report video seems almost surreal: the event harks back to pre-civil-rights times, but the media reporting style makes it unmistakably contemporary. Altogether, Luciano's display lays bare the racist underpinnings of the debate—the same anxieties over the makeup of the United States at the core of Arizona's stringent immigration law passed that same year.

During my interview with Luciano, he described how he deliberately seeks out more community-geared museums and exhibition spaces for his work because they provide more room and freedom to produce interactive projects. *Pimp My Piragua* was part of a public art project commissioned by the Queens Museum to engage the local community, while two other interactive projects of Luciano's had similar origins in community projects generated by the Newark Museum. Luciano's preference for these community-oriented spaces adds to my previous concerns about the effects of a general shrinkage of funds for maintaining alternative and community initiatives and for promoting collaborative and interactive projects such as Luciano's. Luciano has also turned to other nontraditional spaces that are conducive to fostering community exchanges with his work, namely, to "streets, the insides of bodegas, and the gum-spotted sidewalks of New York City," all of which have served as sites for some of his pieces, such as *Coqui Kiddie Ride* and *Pimp My Piragua* (Castillo 2010). This is another quality that Luciano shares with early Nuyorican pioneers, who purposefully took art to the streets, organizing outdoor exhibitions as a way both to reach out to wider communities and to highlight and circumvent the whiteness of mainstream museums and galleries (Dimas 1990).

The reception of Luciano's work also helps to expose some of the narrow identity frameworks in which Latino artists are asked to perform in exhibition settings, as well as some of the challenges they pose to dominant representation frameworks. Luciano's paintings and sculptural

installations have been incorporated into a variety of exhibition settings: his *Pimp My Piragua* has been featured in exhibitions on global warming and on bicycles, his *Pure Plantainum* series was part of an exhibition on Latin American jewelry, and his paintings and installations have been part of conceptual shows on democracy, consumption, and branding. Because many of his creations are filled with references to the forced Americanization and corporatization of Puerto Rican culture, they have also been featured as part of larger conversations on cultural change, as during the "Converging Cultures" episode for the series *Art through Time: A Global View*, produced by New York City public television. Interestingly, the PBS producers contextualized his work in terms of hybrid and convergent cultures in global contact, primarily through his anime-inspired works. Namely, his *Manga-Mancha* series was used to position Luciano as a Latino artist who was inspired and influenced by Japanese culture, not unlike the way Van Gogh and Mary Cassatt were when they were inspired by Japanese prints, as if Luciano's explorations of the convergence of colonialism and consumerism in Puerto Rican culture were not sufficient examples of "cultural convergence."[6]

Still, Luciano's work has not been exempt from narrowcasting and stereotyping. When it was first exhibited in the CUE Art Foundation, in a show that represented Luciano's introduction to the mainstream Chelsea art world, the *New Yorker* dismissed his "nifty satirical objects (platinum plated plantains)" as "late entries to the 1993 Whitney Biennial," discounting his work as passé and "identity trapped" ("Goings On about Town" 2007). Describing the 1993 Whitney Biennial as identity trapped, however, is already problematic; the fact is that cultural diversity at this biennial was greatly overblown and more evocative of the curators' rhetorical position than of the number and range of artists of color represented at the exhibit (Noriega 1999). Such a dismissal of a piece that is so self-referential also begs the question of exactly what identity it is seen to be referencing or trapped inside. Interestingly, *Plátano Pride*, one of the photographs in the *Pure Plantainum* series that seemed so concerning on these grounds, became one of the most commented-on pieces on the Brooklyn Museum's "Infinite Island" exhibition blog (2007). There, it was obvious that no one subjected the piece to such narrow dismissive readings. Instead, posters who identified themselves as Puerto Rican, Dominican, West Indian, and Latin American, or did not identify themselves at all, raised issues about consumerism, pride, hip-hop culture, commercial appropriation, and stereotypes, along with expressions of awe, rejection,

and endearment for a piece that was seen to represent such a variety of positions and identities.[7]

The fact is that Luciano's main challenge is not dissimilar to that faced by many Latino artists, especially those whose work is engaged with critical identity issues: that curators do not always know where and how to exhibit their work. By now, decades of criticism by Latino/a scholars, curators, and art historians has exposed how the dominant practices of art historians and museums have adversely affected the exhibition and full appreciation of Latino art and artists. In this regard, conceptual currents have come and gone, yet some of the critical issues raised in relation to the earliest exhibitions of Latino and Latin American art have remained largely unchanged.

Early on, Mari Carmen Ramirez exposed the limited conceptual frameworks guiding North American curatorial practices. Among them, she pointed to the ascendancy of Euro-American modernism and its inability to engage with cultural and racial difference, such as the notion that aesthetics can be separated from sociopolitical contexts. She also pointed to the early penchant for surrealism and the fantastic or else concerns with folkloric authenticity as the only repertoire to represent and engage with Latino or Latin American art (Ramírez 1992). She exposed the most problematic neocolonial practices that homogenize the diversity of Latino and Latin American cultural production into a single consumable current, and their reduction to representing one nationality or group through the dominance of group-show survey formats. Coco Fusco went even further when she exposed the nationalist dynamics affecting the representation of Latino artists, how that representation veils artists' different national and colonial histories, and how artists may negotiate or reject ethnic and national identity categories (Fusco 1995). Most of these early critiques focused on what happens when Latino and Latin American art is represented within mainstream museums and galleries; however, the curatorial practices of Latino and ethnic-specific museums have not been free from criticism. Chicana anthropologist and art historian Karen Davalos's *Exhibiting Mestizaje* (2001) neatly exposed how exhibitions in so-called minority museums are similarly shaped by the politics of identity and race, and how the canons of nationalism have limited these exhibitions from fully engaging with mestizaje's fluidity and progressive aspects. In a similar vein, my examination of the Latin Americanization of Puerto Rican institutions documented how this process was accompanied by hierarchies of representation that were linked to the dif-

ferential institutional capitals exhibited by the range of Latino and Latin American interests that have become involved in the promotion of Latino and Latin American art (Dávila 2008). In sum, Chicano, Nuyorican, and U.S. Latino–based art and artists share similar experiences at the margins of the North American art world: not fully recognized and lacking in institutional evaluative structures. These are artists whom one is not likely to find represented in international fairs, not even in the international Art Basel in Miami Beach, where Latin American art and collectors have become more common (Taylor 2010).

Moreover, as Karen Davalos notes about Chicano art, the Chicana/o scholarship has not kept pace with the multiplication and expansion of Chicana/o visual arts production in the past forty years (Davalos 2011). Art history programs remain notoriously whitewashed; students in these programs are often encouraged to pursue more recognized artists and movements in Latin American or European art history. Consequently, instead of in art history, it is within American studies and ethnic studies that scholars are producing the most cutting-edge literature on Latino art, though this literature is largely unrecognized within art history.[8] One exception is Nuyorican art historian Yasmin Ramirez, who told me that she was only allowed to write her Ph.D. dissertation on the Nuyorican art movement because she had had an ample curatorial experience before entering her Ph.D. program. Moreover, as Davalos goes on to note, a lot of the research on Chicano art, and also by extension the few studies on Puerto Rican art, still fall prey to dominant art historical frameworks that reduce artistic production to temporalities, such as before and after the Chicano movement, or to identifying different aesthetic trends within the movement or else to integrating Latino artists within Euro-American canonical movements and established trends. Not only do these narrow conceptions tend to homogenize what is in fact a largely undocumented and not-well-understood cultural production, but the emphasis on breaks with the Chicano movement tends to overlook important continuities. Just as problematic, integrating Latino artists into the mainstream movements fails to relate these artists back to their cultures of origins or to the ethnic-specific movements, institutions, and communities that mentored and helped fuel their artistic trajectories.

A significant continuity that cannot be so easily erased is the sustained marginalization of Latino communities and of Latinos' artistic production. This was evident in Luciano's answer to my query about his identification as an exponent of a Nuyorican tradition: "I like the question actu-

ally. What I think of in terms of a Nuyorican tradition or history is not so much an aesthetic tradition but rather a tradition among artists and poets whose work was connected to community, activism, and to socially and politically motivated work that addressed the conditions/concerns of the Puerto Rican Diaspora, and the empowerment of an identity that is rooted in both the *aqui y allá* [here and there]." Luciano was making clear that he is not connecting his work to an "aesthetic tradition" that can be neatly represented or described by art historians. Instead, he is connecting it to a political position inspired by the ongoing structural conditions faced by Puerto Ricans and by the larger Latino community.

Indeed, the white-dominated world of the arts, and the dire need to insert critical race and identity issues, cannot be so easily overlooked by any observer, art critic, or scholar. Even Holland Cotter, an avid critic of identity positions, acknowledges that identity shows are still a "practical necessity," as he recently said of the 2011 "(S) Files" show of emergent Latino artists at El Museo del Barrio (Cotter 2011). In his view, this is the main reason why "multiculturalist terms like identity, hybridity and diversity may sound like words from a dead language in Chelsea, but they are the lingua franca of the Brooklyn ["Infinite Island"] show" (Cotter 2007). Reviewing this show, in which Luciano's platinum sculptures and photographs were featured, Cotter goes on to acknowledge that

> the average Chelsea artist—white, male, middle class, born in the United States and a graduate of one of four or five powerful art schools—is a preapproved art-world player, as are his dealers, collectors and critics, who mostly fit the same demographic. Cultural identity is not likely to be a burning issue for any of them.
>
> But if you are an artist in one of the 14 Caribbean nations represented in the Brooklyn show, the basics can be more complicated. Your roots may be African, Asian or indigenous. And you were very likely shaped by histories of colonialism, slavery and radical displacement. These histories may dictate your class status and economic prospects in the present. (Cotter 2007)

Indeed, Cotter was confronting a show that was squarely rooted in identity issues, which he regularly considers to be a "passing fad for the New York art establishment" (ibid.). And his review was quite lukewarm. In fact, he did not seem to like the show, with the exception of some more "abstract work, much of it performance-based" (ibid.). In his view,

the exhibition was all over the place, unoriginal, sluggish, generic, and filled with categories such as religion, memory, and popular culture that appeared to him as conceptual clichés. At the same time, he could not dismiss the structural conditions that would make identity less an issue for white versus Caribbean artists, nor could he fail to point to the art establishment's racial and class homogeneity, which made this first exhibition of Caribbean art at the Brooklyn Museum such a significant event. The exhibition's magnitude is further underlined when we consider that Brooklyn has been a historically important stronghold for many communities of Caribbean descent. What is more, for over forty years, representatives of these varied communities have paraded in front of and alongside the museum during the popular West Indian Parade and Carnival, without contemporary Caribbean art having ever been featured inside it.

Writing on the politics and aesthetics of exhibiting Latino art, Chon Noriega points to some interrelated concerns that contribute to the common question of why "minorities never get to represent more than their marginality" (1999, 59). Mainly, he shows how within the context of museums, Latinos and minorities are conceived not as an integral part of the exhibitions and of the artistic debates but rather as presenting an "unsettling" set of "outside demands" that must be addressed through outside programming or through the inclusion of Latino theoretical and aesthetic concepts, such as border culture, hybridity, and mestizaje, but not necessarily of Latino works or artists (ibid.). These trends have been exacerbated by the growing corporatization of museums, due to a decrease of federal support for the arts, and by the growth of corporate instrumentalities such that exhibitions have had to turn up their marketing and become more event oriented and audience friendly. Both of these trends have contributed to Latinos' being seen as "constituencies" rather than as central to the imagining and functioning of the museum and the arts establishment.

Most tellingly, Noriega notes how the turn to multiculturalism and political art in the 1990s was more the product of the curatorial and political agenda of the times than a direct result of the art itself. Indeed, it is important to remember that the political climate at play in exhibition settings may at times seem more or less open to exposing different types of art and artists; it may sometimes lead to a "discovery" of politics, identity, or gender or even of Latinos or minorities. However, these realities and identities are not simply rhetorical discoveries of the art world but very real and visible, based as they are on history and on structural conditions,

not to mention on people's racialized and gendered bodies (Alcoff 2005). Nuyorican performance artist Wanda Raimundi-Ortiz breaks this down in her very insightful video *Ask Chuleta: Contemporary Art*, in which the character Chuleta, a savvy working-class Bronx Puerto Rican who has gone to school and studied art, provides a basic lesson on contemporary art. The video starts by acknowledging the whiteness of the mainstream world and its exclusion of people like Chuleta. As she explains, her intention is to "bridge the gap between museums and communities," so people "don't give you shit" if they see in you in the museum, because they will see that "you're classy," "because you know [art]." Predictably, among the terms defined are "identity politics" and "postidentity politics," which Chuleta astutely defines in relation to the "white box," the mainstream gallery world. The first term she tries to define without much success; she stumbles—this term obviously confuses her. "It's a real complicated one. It's something I'm trying to figure out myself." "Identity politics" is defined as the art by and about blacks and Latinos, "people like us" (establishing a common bond with her audience assumed also to be outside the "white box"), while "postidentity politics" is defined in relation to retro clothes or anything that happened once but comes back in another way, something you have flipped, like "leftovers you cook over" to make anew. The two points Chuleta makes decidedly clear, however, are that matters of identity in the art world have never gone away and that determinations such as "identity politics" or "postidentity politics" or "post-postidentity politics" or "postblack" all originate from within the mainstream world: "At some point the white box decide[s]."[9] In sum, these categorizations and historical positions do not simply come and go based on whether critics and curators summon or shun them. They may be "flipped" or renamed; but they are always there. Fed as they are by the continued homogeneity of the art world, the pull of these categories can only dissipate if and when the art world becomes more colored and diverse.

And just as we saw in chapter 3, in the current context, diversity is not sufficiently conceived in relation to the incorporation and representation of ethnic and racial others within the art establishment, with regard to artists, curators, and other interlocutors. Instead, what is most pressing is the inclusion of more expansive definitions for evaluation that account for alternative practices produced outside of mainstream museums and the commercial gallery circuit, or outside the dominant curatorial coordinates standardized by professional art schools. If the only source for legitimacy involves "making it" in the narrow world of the commercial gallery

circuit, ignoring the art and artists who maintain or are fed and inspired by connections and through reference with living communities, the evaluation of Latino/a art will remain incomplete and largely unaddressed.

It is against these larger coordinates in the art establishment and in museums that the work of artists such as Miguel Luciano appears as such a daring and significant rejoinder. In particular, Luciano's commercial plays become a critical response to neoliberalizing trends in the art world, a space to critique and comment on the ascendancy of commercial logics and to laugh at them out loud, while reinstating what is most transcendent and valuable: the power of place and the imagination and resilience of living communities.

And that is the relevance of Luciano's anchoring of his work in an earlier Nuyorican tradition. Writing about the Nuyorican art pioneers, Yasmin Ramirez documents how their work was not only about local empowerment but about challenging Eurocentric constructions of identity, as well as of art and value itself (Ramirez 2005a, 2005b). As she notes, the alternative institutions that Puerto Rican/Nuyorican artists founded during the 1970s and early 1980s were interdisciplinary spaces that reinvigorated the most debased elements of Puerto Rican culture, history, and language from the standpoint of Eurocentric positions, such as indigenous Taino symbolism, the African legacy, and Spanish/English code-switching, or Spanglish. These and other elements of popular culture were reevaluated as resources for cultural production, in ways that validated the power and resilience of communities. The end product was work that refused to be seen through Eurocentric eyes but instead was part of larger political initiatives that were educative and formative of alternative imaginaries for Puerto Ricans and other marginalized communities. In other words, these were no simple artists but rather "Artivists," in Wilson Valentín-Escobar's perceptive term (2010).

This ethos and position for cultural production is as essential today as it was when the Nuyorican vanguard first elaborated it. In fact, given the overarching power of commercial logics guiding the work and operation of the art world and of the larger society itself, this position may even be more pressing today, as Luciano's work so perceptively reminds us.

6

Tango Tourism and the Political Economy of Space

How often do you travel to a foreign country and run into seven friends in the same bar? ... But by now on this fifth visit, I have grown accustomed to bumping into people who I not only recognized, but who I know personally from all parts of the world.
> —Tammy McClure, "Buenos Aires: Birth of a Phenomenon"

What happened to tango? What happened to the elegance of the dance? To the overcrowded milongas stuffed with locals? Tango Disneyland. Where the locals can no longer afford to ride.
> —Deby Novitz, "The Secret Society"

The tango sentiment may be universal, but tango in its essence is a Porteño [from Buenos Aires] product.
> —Pablo Rodríguez, professional tango dancer and milonga organizer

For years, tango has been Argentina's most prized attraction, to the point that tourism representatives often equate its promotion with that of Buenos Aires and Argentina at large. From shows to souvenirs to classes to tango-themed dinners, tours, and festivals, tango is now at the core of Buenos Aires's growth as a global city and is estimated as a $450 million per year industry (OIC 2007). These figures do not account for the purchase of classes, clothing, shoes, and other ancillary items or for a vibrant and diverse tango service industry that is developing apace and

that includes, but is not limited to, tango taxi dancers who escort dancers to milongas (tango dance venues), street performers, and a new generation of teachers incorporating the latest fads, whether Eastern mysticism or kinetic physics.

Today, it is not uncommon for tango tourists to outnumber locals in some of the most "traditional" milongas during the peak tourist season and for inquiries about the location of tango shoe stores to be the number-one query fielded by tourist kiosk attendants. Yet despite tango's rapidly growing dominance of Buenos Aires's tourism economy, there is a dearth of studies of tango tourism with an eye to its effects on issues of urban development and cultural equity in Buenos Aires's creative economy.[1] In 2006, the government of Buenos Aires recognized this void when it launched its first study of tango's economic impact (OIC 2007). However, while the study recognizes the vibrancy of this sector and its dependence on international consumers, who pay more than three out of every four dollars that comes into the sector, it leaves untouched the larger social and political implications of tango tourism. As a result, the growing recognition of tango's role in fueling Buenos Aires's growth has yielded little insight into how this development is affecting the participation of local residents in the tango economic circuit, or about the ensuing inequalities and distinctions around who is more or less able to participate and profit from this booming industry. The global exchanges and networks that are sustained and created through tango and the consideration of which citizens are included in them and which are excluded have also remained unexamined.

This chapter looks into these questions, adding to the literature of tango while contributing to wider debates about the role of culture in contemporary urban development. Indeed, despite tango's notoriety in Argentina's national imaginary, the literature on contemporary tango is surprisingly scant. Scholars have documented the transformation of tango from a despised cultural practice of working classes to a symbol of Argentinean national identity, showing the aestheticization that tango underwent in the 1920s and 1930s as part of state-sponsored modernization (Garramuño 2004). Writers have also tracked tango's African roots, unearthing the role played by Afro-Argentinean composers and performers of the genre (R. Thompson 2005); others, performance scholars in particular, have focused on tango's sensual aesthetics, by probing into the gendered, sexual, and racial identities that are regularly expressed and contested through the dance (J. Taylor 1998; Savigliano 1995). In fiction,

a plethora of works continue to reify tango's sensuality through "coming of age" stories of global citizens, mostly women, undergoing personal transformations through tango dancing. Typical of this genre are *Kiss and Tango: Diary of a Dancehall Seductress*, a *Sex and the City*–style story of a bored thirty-year-old advertising executive who turns to tango to find meaning and transcendence in her life (Palmer 2006), and Patrizia Chen's *It Takes Two* (2009), about a woman's cultural and sexual rebirth through tango.

But what about the local social and economic aspects of the tourist sector at the center of these stories of sensuality, enjoyment, and social transformation? In sum, how is tango tourism affecting Buenos Aires's cultural economy and claims of belonging and citizenship to the city? These are important questions considering tango's well-known commodification and its value as a global commodity embodying exoticism, eroticism, and passion, as well as its current marketing in cities such as New York (Dee 2005; Savigliano 1995; Viladrich 2005). In particular, little is known about how these dynamics are playing out in the city of Buenos Aires, the supposedly global "cradle of tango," especially in light of the dramatic economic and spatial restructuring that has accompanied the city's economic recovery. I am speaking here of the "new Buenos Aires," as transformed by the 1990s neoliberal reforms that attracted massive private investments, exacerbating spatial and class divides and displacements (Prevot Schapira 2002; Ciccolella 1999).

In fact, in the past decade, Buenos Aires has emerged as what is best described as an international "Disneyworld of Tango," a city structured to accommodate the tastes and every possible whim of the global tango tourist. This development has been documented in barrio Abasto, the former neighborhood of famous tango interpreter Carlos Gardel, whose memory became central to Abasto's transformation from the "Porteño Bronx" (*Porteño* refers to residents of the port city of Buenos Aires) into the site of one of the city's largest shopping malls (Carman 2006). This transformation is also evident in the much-celebrated bohemization of Buenos Aires, which the international press attributes to the many "bohemians in exile" and expatriates with money and contacts who are settling there and launching new restaurants and initiatives in the arts, in fashion, and in the local music scene, among other ancillary culture industries (D. Lee 2008; Politi 2009).

The travel press, in particular, attributes Buenos Aires's popularity to its so-called elastic culture and openness to foreign influences, which has

turned the city into a laboratory for cultural creativity; yet I question how elastic and open local Buenos Aires residents are to this foreign influx of cultural enthusiasts. Additionally, how is this influx affecting the participation and access of cultural workers such as local musicians, teachers, dancers, and vendors to these more upscale and profitable spaces? Some pressing concerns are the effects of the city's upscaling and greater segregation on the development of the type of large-scale popular protests that have been common to Buenos Aires's popular classes (Grimson 2005). As Argentinean anthropologist Alejandro Grimson notes, Buenos Aires differs from other Latin American cities, where favelas, or urban poor barrios, are easily visible at the outskirts of upscale centers. Instead, Buenos Aires is characterized by a greater spatial segregation of difference and by a range of visible and invisible frontiers inhibiting the movement of popular classes to upscale barrios, unless as transient workers. Another concern is the spatial structuring of labor, not only in regard to the creation of sanitized tourist bubbles but also in the rise of new geographies of difference, produced through the control of cultural workers' access to different sectors of the tourism economy (Gregory 2007).

I am especially intrigued with how tourism is generally regarded with glee and open arms by many locals, rather than implicated in growing inequalities or in the city's transformation, despite the visible transformations that could be linked to the advent of international tourists. This chapter suggests that this reception has less to do with Buenos Aires's "elastic culture" than with the central economic role that tourism plays in sustaining a new tango economy, as well as with the work tango tourism does in shaping a sanitized image of Buenos Aires as a modern city that is desired by Western visitors. I make this argument by first exploring the economic aspects of tango tourism, while also exposing some of the ways in which it contributes to residents' hierarchical and differentiated participation in this key sector of the tourist economy. I then turn to examining the global community of tango tourists and the racial and ethnic dynamics that it reflects. In this regard, I explore tango tourism in a larger context in which Buenos Aires continues to redefine its identity as a white, European-like city and as the most stylish, developed city in Latin America; though this time, this identity is not constructed in reference to its European immigrant past but rather in reference to tourists, as well as to the American and European expats discussed in chapter 7.

This and the following chapter are based on research I carried out during four consecutive summers (2008–2011), when I observed and partici-

pated in milongas and interviewed milonga organizers, tango teachers, musicians, taxi dancers, and local merchants involved in the local tango tourism scene, including vendors who work in the informal economy. During that time, I also immersed myself in the tango scene as a dancer, taking classes and attending milongas, where I met and interviewed a number of international tango expats who introduced me to a larger expat community, which is the focus of the next chapter. One of my stays coincided with Argentina's bicentennial celebration, providing additional opportunities to evaluate the country's self-assessment of its past, present, and future as debated and showcased in the press and in the country's official celebrations.

On the Rise of Tango Tourism

Tango tourism is a topic of many contrasts. Since the 1990s, the government of Buenos Aires has increasingly embraced and fostered tango as central to the city's identity and image; yet tango dancing is not anchored in most city residents' quotidian experience of leisure and daily life. Decades of military repression, alongside a postcolonial-fueled resistance to the acceptance and validation of tango, took a toll on how Porteños learned and related to the dance, to the point that few dancers, except newer generations or older dancers, have memories of learning to dance within the family or in intimate social encounters. In my interviews, older dancers recalled that after the Revolución Libertadora in 1955, tango dancers would be followed from milongas, questioned, and harassed by the police and that subsequent military governments promoted rock music and global rhythms, which were considered less politically volatile. Because of this legacy, learning to dance tango has become a matter of schooling, a time-consuming and costly venture more accessible to middle classes than to the popular sectors that historically originated it. In sum, the tango–Buenos Aires connection is not generalizable to the entire city or to all sectors of society. As one musician explained, "There's no tango in the *villas miserias* [slums], there's no tango in the *provincias* [provinces]." There you are more likely to hear cumbia or other more popular rhythms. Consequently, the tango tourism circuit operates as a highly developed and self-contained sector, whose popularity and visibility are widely recognized but whose scope and influence are almost imperceptible to the wider Argentinean society unless one becomes involved in

the milonga circuit, whether by taking classes or by attending a milonga. As a twenty-six-year-old clerk at Comme Il Faut, one of the most popular tango shoe stores among tourists, explained, "Prior to working in this store, I did not know that people came here for this. You are not aware of this global fanaticism that people have with tango. We Argentineans go to the *boliches* [dance clubs]."

The tango renaissance is also a relatively new phenomenon, rather than a continuing trend in the city's history, as tourist brochures may have it. Neither is it an intrinsically generic development, but rather it is fueled by the global circulation and consumption of tango. In particular, the promotion of tango tourism throughout the 1990s was part and parcel of President Carlos Menem's neoliberal government project of Argentina's modernization and insertion into the international free market and, hence, of the same policies that led to massive tourist- and consumption-led developments at the time. These include the Puerto Madero waterfront, the luxurious downtown shopping malls, the hypermarkets, and the Tren de la Costa tourist railway, among other massive foreign investments in consumption-based developments geared at sustaining tourism, all of which have brought up questions about the governmentability of zones undergoing privatized development (Guano 2002; Ciccolella 1999). Anthropologist Emanuela Guano has discussed these new developments as spaces of spectacle and segregation that help perform middle-class identities while keeping marginal classes at bay (2002). No modernizing project is ever complete, however, without a dose of cultural policies that restore authenticity to newly sanitized landscapes (Baud and Ypeij 2009). This is where government policies directed at the promotion of tango, including the creation of institutions and programs intended to preserve and promote it, come in. Among them are the creation of the Academia Nacional del Tango in 1990; the creation of the Ley Nacional del Tango in 1996, which declared tango an integral part of the national cultural heritage; and two years later, in 1998, legislation by the city of Buenos Aires that anchored tango to the city's heritage and the development of the annual tango festival that is now internationally known as the Buenos Aires Tango Festival (Morel 2009).

Additionally, and just as when the tango was first locally popularized in the 1930s and 1940s, the current tango renaissance was also fueled by its global circulation, especially by its embrace by North Americans and Europeans (Savligiano 1995). Most specifically, the widespread popularization of the musical *Tango Argentino*, which made a big splash among

international audiences in the early and mid-1980s, and of *Forever Tango*, which opened on Broadway in 1997, became key catalysts to the redis-covery of tango back home. This influence of tango's global circulation on locals came up repeatedly when locals described to me what had ini-tially led them to learn tango. A trip or a stay abroad where they were confronted with tango's international popularity and the expectation that they could dance because they were Porteños was commonly summoned as the impetus that had originally turned them to dance. In other words, at that time, tango became legitimized as a medium for Argentineans to belong to the "first world" while still being recognized as Argentinean (Gallego 2008).

Foremost, tango tourism is anchored in the economic collapse of 2001 and the peso devaluation in 2002, when North American and European tourists began to benefit from favorable exchange rates of approximately four to one (pesos to U.S. dollar) or three to one (pesos to euro), open-ing up Buenos Aires to global tourism like never before. Previously, the one-to-one peso-dollar equivalency had made Buenos Aires consider-ably less accessible to tourists. Susana Miller, the longtime milonguera[2] who is world renowned for having popularized the milonguero style by naming and codifying the "intuitive" style of the most traditional dance floors, recalled the amazement that a French or foreign dancer would stir at a milonga back in the 1980s—a stark contrast with today's milongas so packed full of tourists. At Milonga Niño Bien, a popular milonga on Thursday evenings, I estimated there were three tourist tables for each table of local dancers, including an entire section bordering the dance floor occupied by tourists who did not dance but were there as part of a tour to grab a bite and watch the dance floor.[3]

It is important to recognize that tango tourism is quite diverse and involves a variety of tourist attractions for diverse constituencies (Morel 2009). There are the tourists and visitors who flock to the Casas de Tango, the elegant thematic dinner shows, which are primarily produced "for export" and consumed and priced almost exclusively for tourists. These productions have become the most recognizable and standard fare for tourists, who are even picked up and dropped off directly from their hotels, for an entirely sanitized experience of tango solely as spectacle. In these shows, it is the highly styled tango, with high kicks and lifts—which would be almost unrecognizable, much less feasibly danceable, at a milonga—that dominates. Then there is the milonga circuit, the social dance venues that attract tango dancers from all levels and that fuel ancil-

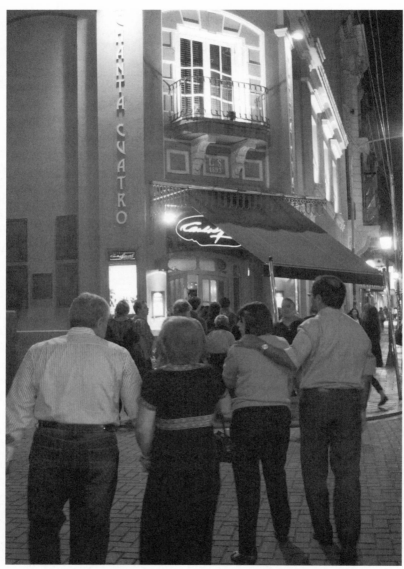

Couples entering La Esquina Carlos Gardel tango show, a "for export" tango-dinner show in Abasto, one of the latest developments that are part of the neighborhood's gentrification and resignification as a tango barrio. The show is located in a historic building that dates to 1893 and was reconstructed in the early 2000s, nearby a memorial statue honoring Carlos Gardel. (Photos by Laura Benas and Nicolás Herzog)

lary dance-related services and shops to accommodate the needs and tastes of dancers, from the most experienced aficionados to the most eager novices. Casas de Tango constitute elaborate tourist productions, where some measure of social strife and distance between tourists and locals is to be expected. Just my mere mention of them to people who work in tango provoked stories of families who were displaced from old historic houses to make room for these establishments; of dancers who made a hundred pesos for a show, with no remuneration for time spent for rehearsals or compensation for injuries, when tourists paid over a hundred dollars to see the show; and of musicians' dependency on these generic shows because they provide one of the few sources of steady work. Dancers lack a union to represent their interests as workers; consequently, while selected dancers may make it big in the international circuit, most suffer from underemployment.

But it is the tango tourism that revolves around the milonga circuit and the dance that most interests me, rather than the more clearly tourist-marked sector that dominates the Casas de Tango. For one, this dancing tourist sector displays the greatest degree of interaction between tourists and locals around the dance and the social venue of the milongas—alongside the growth of "tourist bubbles," or sectors set aside for tourists—in ways that flaunt some key contradictions of contemporary tourist initiatives (Judd and Fainstein 1999). Tango tourists may be segregated in the more upscale tourist areas in the daytime, but the nighttime's enjoyment is always predicated on the authenticity of mingling and dancing with Porteños.

This tango tourist sector also constitutes a global community for which Buenos Aires is not solely a tourist destination but is rather a renewable attraction, a site for pilgrimage and a rite of passage. Buenos Aires and Argentina may rank low in tourism visibility in comparison to Europe or the Caribbean, and they may be a more remote destination for leisure travel, but with tango, they become quite attractive for tourist purposes. One may visit a museum or an architectural site once, but tango tourism provides a renewable draw that can become part of a regular pilgrimage for newcomers and seasoned dancers alike. A trip to Buenos Aires can sometimes function as a status-defining trip for establishing one's identity as a serious and experienced dancer, as someone who has studied at the source, danced with "authentic" dancers, and so forth. In sum, this trip becomes self-identifying, akin to how travel to Disney World or a shopping spree in Miami becomes foundational to middle-class iden-

Street dancers in Lavalle and Florida Street. *Left to right*, Mara Oveido and Luis Can-seco, Rebecca O'Laoire and Mario Vaira, Sonia Gabriela Cantero and Jose Carlos Romero Vedia (Carliño). It is not uncommon for female expats to engage in street dancing. Rebecca is an Irish citizen who went to Buenos Aires to take a course in Pilates and then stayed principally for tango. At the time of this photograph, she had been in Buenos Aires for two years, and she is currently seeking to legally relocate to the city. (Photo by Laura Benas)

tity among some Latin American middle classes (O'Dougherty 2002) or to what a trip to India may entail for a yoga enthusiast from the United States. The result is a global community of tango enthusiasts that makes it almost impossible for repeat visitors not to encounter "friends" during their trips.

This dancing vacationing sector is also important in fueling the local milonga circuit; it is this sector that attends milongas, pays for private classes, overspends in shoe stores, and purchases tango CDs to take back home—all the while spending money on lodging and food and other ancillary services. It is also to meet the demands of this sector that Buenos Aires has seen the growth of myriad private and public ventures turning the city into what appeared to me, even on my first visit, as a Disney World of Tango, a city that is entirely consumable and decipherable as a tango Mecca to its dancing visitors. These ventures include tango tours, from those developed more informally by tango teachers to more standardized packages offered by specialized travel agencies, and tango-themed hos-

tels and hotels, from small-scale ventures such as Caserón Porteño, where visitors are offered the opportunity to take classes and make connections with like-minded tango visitors, to high-end hotels such as the Abasto Plaza, where selected rooms feature private dance floors and guests can buy dancing shoes in the comfort of the hotel's lobby. These developments have been accompanied by a proliferation of tango magazines and guides listing all the available milongas, practice sessions, and classes, with detailed hours and directions. In sum, this sector is directly involved in maintaining Buenos Aires as the tango capital of the world and is most implicated in transformations of the city's tango economy.

Toward an Analysis of Tango's Economic Dimensions

By most accounts, tango tourism is regarded as a sign of Buenos Aires's coming of age and of the cultural revitalization and appreciation of a local culture long disparaged. Viviana Parra, a professional dance teacher who left for New York City in the mid-1990s and later returned to Buenos Aires, recalled that there were hardly any tango orchestras and very few milongas when she left. In Buenos Aires, tango was then still largely associated with old people, with tourists, or with "*la prole*," or the lumpen classes, associations that have been largely shed, though they still circulate among some middle- and upper-class sectors of society. Upon her return, however, she described being moved to tears by a surprisingly changed and revitalized tango scene, where tango could be heard "*por todos lados*" (everywhere). Like many others, Parra attributed tango's revitalization to tourists. Indeed, tourists are credited with maintaining milongas throughout the economic crisis and with the overall success of the tango economy, which is healthy when tourists are numerous and lags when they are not.

Tango tourism has also provided some local dancers and musicians welcome opportunities for travel, work, and visas and for payments in dollars and euros. The most popular dancers may earn more than a full year's income from a single international tour, and, as a result, it is not rare to meet dancers in their early twenties who have left university careers behind to pursue a career as a teacher or a dance professional. That they view this as a viable decision, however, demonstrates the changing economic climate and the diminishing prospects for youth making economic decisions. For one, making a living from tango is difficult and

taxing. It requires constant travel, and it is unpredictable, erratic, and highly dependent on tango's popularity abroad. Consequently, to "internationalize" is not a decision that dancers with secure full-time jobs take easily. Travel visas are prohibitively expensive for dancers, and most go on working tours without permits, risking fines. Also, unless they are well known in international circles, dancers can hardly book enough private lessons abroad to subsidize their trips, which can cost thousands of dollars.

Consider the case of Aldo Romero, with whom I spoke in New York on his way to Ireland, where he was going to work for five months. He was on his last leave permit from his government job as a text transcriber and was considering whether to do tango professionally and to retire from his job. We discussed the cost of internationalizing—it may work for a while, but you cannot rely on being the only Argentinean dancer wherever you end up. Others will surely come. People will get tired of you. Where would you live? And so on. But as he noted, he had the privilege of making this choice as a fully employed worker. Most youth leaving traditional careers for tango do not and possibly may never again face a similar position, as government-sector jobs dwindle.

Opportunities in tango are also not equally distributed among Porteños. Instead, they primarily benefit middle-class Porteños, who have greater resources to tap into tourism. As I was told by a tango teacher, "Vivís en el barrio, morís en el barrio"—if you live in the barrio, you die in the barrio—by which he meant to express how rare it is for dancers from working-class barrios to access opportunities through tango. English proficiency, for instance, a mark of educational opportunities that few working-class dancers have, increases access to working with tourists and the possibilities of contracts abroad. A member of the Asamblea del Pueblo of San Telmo, one of the left-leaning community organizations that sprung up after the mobilizations following the 2001 economic collapse and that has been at the vanguard of fighting evictions in the town, explained these inequities even more succinctly: "Tourism does nothing for us; it takes away jobs, takes away our housing and access to public spaces. There are very few *gente humilde* [poor folk] who speak English and will be hired as a bartender; to us, tourism means displacements and more policing."

Still, tourists' greater demand for tango offerings has increased employment opportunities for many dancers, whether in Casas de Tango, as taxi dancers, or in the informal economy striking tango poses or dancing for tourists. The tango economy has also affected tourism workers,

whether or not they dance tango—most notably the taxi drivers and hotel concierges who serve as intermediaries for tango shows and milongas and get kickbacks for bringing tourists to different shows.

Foremost, the need to project and maintain the authenticity of the dance, and hence the number-one reason why tourists come to Buenos Aires, has fueled a range of authenticating responses, all of which have had economic repercussions.[4] After all, tourists come to "the birthplace of tango" seeking an altogether different experience than they have back home. Indeed, dancing with old-timers; experiencing the *cabeceo*, the practice of asking someone to dance with a look or with a turn of one's head; or even watching Porteños dance were among the draws tango tourists mentioned to me for their visit to Buenos Aires. Steve, a New York City dance instructor, said that he attended milongas just for the joy of watching locals interpret the music: "Even when the dancing isn't technically good (whatever the hell that means), you really see the music in the bodies. They've been hearing it their whole lives!" In sum, people come either to dance with Porteños or to see them dance; consequently, as I was repeatedly told, "a milonga without Porteños is not a milonga."

Thus, when 60–80 percent of the attendees in some of the popular milongas, according to a seasoned milonga organizer, are in fact tourists or tango expats, issues are inevitably raised about the transformation of the Porteño dance floor. Whether the dance would become diluted by the number of dancers on the dance floor, whether the code of ethics governing who asks whom to dance and how would be maintained, and whether good dance manners would be practiced to ensure harmonious relations between locals and foreigners were all causes of worry and alarm among milonga organizers I spoke to. In fact, these concerns are shared by tourists and visitors as well. Deby Novitz, a self-described North American former computer geek turned tango-bed-and-breakfast owner and the author of a tango blog, posted a revealing entry about visitors' disappointment with the lack of locals on the dance floor (2010). As she notes, tourists' expectation that locals attend milongas every night entirely ignores the high costs that prevent that from happening: up to twenty pesos for entry, ten more for a drink, in addition to transportation costs. And while seasoned dancers and patrons are often extended complimentary entrance, locals can hardly afford to go dancing on a nightly base, as is commonly done by tourists.

These concerns, along with the demand for "authentic Porteño" dancers, have helped launch the booming business of taxi dancers, or tango

dancers for hire, who are especially coveted during international festivals and events, when foreign dancers may outnumber locals. This is one area where some of the gender differences at play in this tourist economy become transparent. Tango dancing is suffused with gender codes that favor the male dancer, who initiates the dance, over the woman, who is asked to dance. Of course, local Porteñas insist that it is women who initiate the dance by first looking at the men, who subsequently acknowledge or ignore their look by inviting them to dance or not; but female tourists are not familiar with these codes. At a milonga, a female tourist is thus more likely to be a wallflower and to be in greater need of hiring escort dancing services, even if just to "show her off" as someone who can dance. This disparity, alongside the greater number of women relative to men at most milongas, translates to men being more able to make use of the milonga circuit as an economic resource, where they can recruit students or initiate all types of social and intimate relationships that can also result in economic gain. This possibility gives the taxi dancer sexual overtones: as a sex worker disguised as a dancer or as a *pícaro*, a cunning predator who furtively courts female tourists—a reputation that persists irrespective of the fact that sexual exchanges between tourists and local dancers resulting in economic exchanges are not limited to the taxi dancer–tourist relationship. This reputation pervades taxi dancers, however, because they are the only ones involved in tango who are openly identified through economic means as workers, irrespective of the multiple identities and roles that may be involved in the taxi dancer–tourist relationship. Research on the economy of intimacy is relevant here for reminding us about the coexistence of intimacy and profit, that all types of intimate relations, from friendship to sexual intimacy, are commodified but that economic exchanges do not invalidate the intimate aspects that may be involved in these relations (Cabezas 2009; Zelizer 2007). It is also worth remembering that the work of taxi dancers can be quite demanding: it requires hours of dancing with inexperienced or beginning dancers, which can lead to bodily injuries, not to mention boredom and frustration when they have to match tourists' level and lower their own.

Another authenticating move that has had economic repercussions has been the identification and solidification of particular dancing styles that are considered to be representations of "authentic Argentinean tango" (Morel 2009). Among them are the milonguero, the canyengue, and the Villa Urquiza styles, which are regarded by different local constituencies as the most authentic. Taken as a whole, however, these debates have

greatly contributed to marketing the art of authentic tango dancing as that developed or danced within particular Porteño neighborhoods, and even within particular milongas, serving in turn as an attraction for tourists seeking to experience these supposedly more authentic and authenticating spaces. Accordingly, milongas such as Lo de Celia, Confiteria La Ideal, Gricel, and El Beso become associated with milonguero style, Sunderland with the Villa Urquiza style, and Practica X with the most vanguard moves of Nuevo tango. In sum, the same globalization of tango that is creating reasons for concern within the local tango community has nevertheless helped to reaffirm and anchor tango's authenticity in Buenos Aires in novel ways. As Susana Miller described to me when assuring the continued authenticity of the Buenos Aires tango scene, "Here even the smell of the milonga is Porteño; *la picardía, la malicia* [the cunning] is different. To organize a milonga elsewhere is like a recipe without dill or a key spice." Or as a Porteño dancer put it, "The difference is that if you dance with a Russian, you've danced with them all. They are like clones. But each Porteño dances only like himself, because he dances with his heart." Or as he added, "Foreign dancers are only concerned with how they look, but the milonguero is only concerned with what he feels within the embrace."

Finally, concerns over authenticity have also led to the launch of new alternative milongas. In contrast to the more established milongas, news of these milongas circulates through word of mouth, rather than through the tango magazines that are regularly distributed at tourist milongas; thus, they attract far fewer tourists. They also are located in less touristy and more neighborhood-oriented spaces. One of these milongas that I visited, named the Milonga del Otro Lado (Milonga of the Other Side) to signify its location beyond the city's tourist center, had a crowd that was mixed in age and background and had only a sprinkling of tourists. Notably, within a year, this milonga had been renamed as Milonga del Gardel de Medellín and was attracting far more tourists, even promoting a festival anchored in the neighborhood's style of dance, though its relative distance from the tourist center had helped it maintain its local identity and flavor.

Then, there are milongas that are amply advertised but that have a self-professed mission of promoting the integrity of tango as a distinctive and traditional form. A particularly interesting space is Practica 8, which attracts dancers in their twenties and early thirties and represents part of a booming tango renaissance among the youth. When I visited,

the organizer was garbed in a T-shirt and baggy jeans, and his beard and long dreadlocks defied any stereotype of the smoking-jacketed dancer of the past. But he could not have been more adamant about his strong sentiments about tango. "La pista es sagrada" (the dance floor is sacred), he noted as he described his vision for this space as one where innovations were made with considerations for the dance's integrity. And true to the milonga's vibe, I found young dancers admiring each other's form and the quality of their embrace while bemoaning showy moves that compromised form. There is also an entire circuit of couples-oriented milongas that are only open to married and established couples and that remain at the margins of the primarily singles tourist circuit.

Yet, while locals work hard to maintain tango as an authentic Argentinean product, tango's globalization continues apace, posing questions about how much longer it can be marketed as an exclusively local product. In this regard, it is not neighboring Uruguay's claim over tango's origins that poses the greatest challenge but rather tango's growing global proliferation. From San Francisco to Berlin to Turin to Istanbul, a variety of global cities now have vibrant tango scenes and international tango festivals of their own, fueled by international tango entrepreneurs intent on celebrating tango as a global product that sustains a global community of dance enthusiasts.[5] This development explains the ambivalent response by some locals when UNESCO designated tango as one of world's intangible heritages in 2009. In particular, locals feared that this designation would expedite the global appropriation of tango, leading cities across the world to claim tango as rightfully theirs, as Buenos Aires does.[6] Indeed, there are now a variety of international tango festivals, and tango tourists are flocking to Berlin, Istanbul, Montreal, and New York City, among other cities known for their "developed" tango scenes, which are believed to provide tourists with more modern, comfortable, and accessible and less sexualized venues to fit their interests and needs, in ways that some Porteños feel could lead to the eventual demise of Buenos Aires's tango scene.

This crossroads of tango, work, and nationalism came to the forefront during the 2011 Campeonato Metropolitano de Tango, a tournament organized by the city of Buenos Aires, in the debate that ensued after foreigners were excluded from competing. Foreign couples had become frequent participants in recent years, but the 2011 tournament limited registration to couples who were "Argentine natives," with one of the partners required to be an official resident of Buenos Aires. No distinctions were

made between foreigners who are residents and those who are tourists. The decision was loaded with meaning: this tournament is not only a key showcase for dancers to get commissions and contracts and work, but it is also a source of great repute for foreign dancers to claim that they have come of age as dancers. Its winners are also awarded guaranteed entry into the world championship. It turned out, however, that one of the affected couples included a constitutional lawyer, Christian Rubilar, who sought to participate with a foreign partner who had lived in Buenos Aires for three years. Rubilar initiated a lawsuit against the city on the basis of discrimination against foreigners, arguing that the measure challenged the Argentinean constitution, which forbids distinctions between foreign and native residents of the city in regard to questions of civil rights. The judge upheld the constitution while appealing to tango's universal nature when he decided in favor of the plaintiffs, to his own surprise, annulling the tournament's results. As this book goes to press, the final determination of whether the city appeals and whether the tournament is replayed has yet to be made. Supporters of the tournament's decision to exclude foreigners explained that foreign dancers can quality if they are official residents of Argentina (with the proper immigration documents), or they can participate by qualifying through tournaments held in their respective cities. Everyone I spoke to agreed that foreigners who are legal residents of the city should be able to participate, yet the informal basis on which many expats become permanent residents of the city, as I discuss in chapter 7, was concerning to some. In the view of some local dancers, foreign dancers are already favored in the world championship because of organizers' interest in promoting international visitors, and these locals felt that a distinction between foreign residents and tourists was needed to ensure that local dancers can participate and thrive.

Tango's designation as a universal heritage has also led to a variety of local responses and to its increased politicization. In particular, tango has become inserted into wider debates around the political future of the country, as two models of government contest each other publicly in the political arena: the more nationalist- and socialist-oriented federal government of President Cristina Kirchner and the center-right business-friendly neoliberal administration of Buenos Aires's Mayor Mauricio Macri. In 2011, the youth political organization La Grupa launched "Peronista milongas," a collective of milongas that challenge the commercialization of tango advanced by the city's administration through its penchant for organizing international festivals. In the Peronista milongas,

tango is promoted and celebrated as a national and popular product by and for the youth. Pablo Rodríguez, the 2006 winner of the city's Metropolitan Championship and one of the organizers of the Peronista milonga La Discépolo, put it in succinct terms when he noted that tango in its sentiment and enjoyment may be universal but that in its essence it can only be a Porteño product. This milonga is noteworthy for linking and reinvigorating tango's militant legacy at its heyday during the rise of the Peronista party in relation to the national political project of the present and in sharp contrast to the current neoliberal administration in the city of Buenos Aires. La Grupa's tagline "el tango no es soya" (tango isn't soy) conveys this different treatment of tango as a revered cultural product rather than a profitable exportable commodity.

Yet debates over tango tourism are not limited to issues of cultural authenticity or of economic opportunity. Tango tourism is also undeniably linked to the gentrification of Buenos Aires and has been responsible for heightening social inequalities. Indeed, walking through the streets and browsing the newspapers makes evident that contemporary Buenos Aires society is up in arms. Inflation is up, and people in the street no longer trust the government's official economic indicators. The street's indicators do not misrepresent: they show that the price of food and of basic goods and housing have all risen, much faster than people's incomes. In this dire economic situation, tourism's effects on prices and housing costs have been especially damaging. Tourism is estimated to be the leading reason for property conversions and displacements and also to be responsible for a growth of between 72 and 142 percent in the number of displaced people, numbering up to thirty thousand (Paz 2007).

Tourism is also implicated in the heavier policing and political repressions involved in the sanitization of space. Leading these efforts is the controversial Unidad de Control del Espacio Publico (Unit for the Control of Public Space), which, after it had been active for years, was institutionalized in 2008 by Mauricio Macri, the right-wing mayor of Buenos Aires, upon his election in 2007, as part of a repressive urban cleanup campaign. The unit's tactics and strategies have been denounced by civil rights groups, to little effect; the few and rare hard-won government subsidies for displaced people are not enough to guarantee permanent housing solutions for the thousands who are displaced (Carlos Rodríguez 2009; Veiga 2009). Also, just as we saw in Puerto Rico, the greater policing of space has led to shrinkage of eco-

nomic opportunities for informal workers, by limiting the spaces where they can easily solicit tourists. South American immigrants have been especially affected by these measures; they are favorite police targets, part and parcel of the racism that is implicated in the city's cleanup efforts.

Tourism has also contributed to the growth of two parallel economies, where goods and services are priced differently for tourists. Though this practice was officially banned in 2008, it continues, and though it seemingly is protective of locals, it has been especially hurtful because it creates incentives for marketing goods and services primarily or exclusively to tourists ("Pese a que está prohibido" 2008). The preference for renting apartments to tourists provides a good example. Tourists are seemingly unfavorable tenants: they come and go and do not stay for long—except that a landlord can cover his or her monthly expenses and more by renting to a tourist in dollars or euros for a week, even if the apartment remains empty for weeks. In contrast, renting to locals ties landlords to a longer contract and means that they will have to forgo potential opportunities.

This segregation in the price of goods and services is manifested to different degrees in all sectors of the tango economy, with more and more schools, restaurants, and stores becoming strongholds for tourists, who are the ones most able to support these spaces. In fact, some of the best tango schools that had been recommended to me by seasoned dancers in New York turned out to be primarily tourist hubs, where most of the students are international tourists or long-term expats who had moved to Buenos Aires to pursue tango on a full-time basis.

Buenos Aires's gentrification is normalized and codified by the "Tango Map of Buenos Aires," a colorful foldout of tango-related shops and milongas and one of the key Disneyfying tourist aids in the city. First developed by the founder of the hostel Caserón Porteño in 2003 as a guide for his guests, the map is now distributed throughout all the milongas and is a much-requested souvenir to bring back home. On the map, Buenos Aires is represented as a consumable tango Mecca: only landmarks, stores, and milongas of interests to tango tourists are identified, each red-dotted and codified, ready to be pointed out to a taxi driver by any visitor. Meanwhile, some of the most touristy neighborhoods are identified with their gentrifying names, such as Palermo Soho, rather than Palermo Viejo, and Palermo Hollywood. Most significantly, the map renders visible while also erasing the spatial segregation that is economically and symbolically constructed around Rivadavia Avenue, which divides the

prosperous north side of the city, which includes the middle- and upper-class neighborhoods around the city's economic center and most tourist sights, and the marginal south side, where *villas miserias* and poorer barrios abound (Grimson, Ferraudi Curto, and Segura 2009). These distinctions are manifest in the concentration of tourist sights of interest and in the greater number of red-marked spots around the city's center toward the northeast side of the city (what is popularly known as the North). But these boundaries are also erased for tango tourists, for whom the city is rendered as an undifferentiated background to be accessed by simply following the red spots listed on the map. In sum, the map allows tourists to selectively access the "most authentic" milongas in the poorest outskirt barrios of the city, without ever fully venturing into these barrios.

On the dance floor, tourists' greater access to tango's goods and services is visible in the most mundane details, as in the type of dancing shoes that are more accessible and likely to be worn by tourists. Female tourists can be easily picked out by their Comme Il Faut shoes, the dainty, colorful, and high-heeled shoes generally known as the Manolo Blahniks of tango shoes, which retail for over $110–$130; local women are more likely to wear less flashy colors and designs, as they can afford fewer pairs of shoes altogether. Local women's choices are further limited by the export of the fanciest designs to the United States and Europe. A shop attendant at Comme Il Fait confirmed matter-of-factly the primacy of tourist consumers when she shared her intricate system for classifying tourists' tastes according to nationality: "The Spanish women like black sober shoes, South Americans go after color, as do the Italians, while Germans take the longest to decide because they don't know much about high heels." I laughed at her stereotypical classifications but bought directly into them when I picked a multicolored sandal with hot-pink heels, what she described as a pair perfectly suited to my Latin/Puerto Rican taste. The contrast between tango tourists and local shoe-store clerks could not be starker; few of the clerks actually danced tango at all, preferring *boliches* of rock, electronic, and salsa music, where there are far fewer tourists.

Yet the most concerning development following the rise of tourism has been a steepening of racial and ethnic hierarchies. It is important to note that tango tourists are not the only foreign bodies entering Buenos Aires; for decades, immigrants from bordering Bolivia and Paraguay, but also increasingly from Peru, have also been coming in search of jobs. Since the 1990s, this migration has been more visibly concentrated in Buenos Aires, challenging Argentina's dominant image as a white homogeneous

Shoe store on Suipacha Street, in the center of the city, a street that is home to a cluster of tango shoe and clothing stores. (Photo by Laura Benas and Nicolás Herzog)

Female shoppers inspecting the shoes at Darco tango shoe store. (Photo by Laura Benas and Nicolás Herzog)

country of Euro-descendants (Carmona 2008). Though this dominant image is falsely constructed through the erasure of native descendants, mestizos, and blacks from the national imagination, it is nonetheless very much alive. Foremost, it feeds contemporary racism centered on border immigrants, primarily Bolivians, who have become the umbrella category for the dark and the urban poor, irrespective of their actual nationalities (Grimson and Kessler 2005).[7]

One needs only to browse the local news for evidence of the differential treatment of foreign bodies: border immigrants and dark-skinned subjects are visible in news about crime and displacement; expats are mainly visible in stories of renewal and cultural revitalization. In this regard, it is worth considering the special place that tango tourists occupy in the contemporary racial and national landscape. In the following section, I suggest that tango tourists are extended a legitimate place in the city because of their dancing interests, because of who they are and what tango represents. Specifically, they are given a favored status as global modern citizens over and beyond other immigrants and poor Porteños, because of the work they do in sustaining Argentina's image of progress and exuberance.

On the Global Epidermis of Tango

Sexy, alive and supremely confident, this beautiful city gets under your skin. Like Europe with a melancholic twist, Buenos Aires is unforgettable.

—*Lonely Planet Buenos Aires*

I had expected that the tourist saturation of milongas would be considered a nuisance among locals and that inequities, such as the exchange-rate differential between tourists and locals, would be cause of considerable conflict. Yet I soon learned that the situation was far more complex. Outside the milonga circuit, residents affected by the gentrification and transformation of their neighborhoods that have accompanied the rise of tourism were visibly alarmed about its effects. They made no qualms in identifying the local fascination with "first-world tourists" and the benefits they immediately accrue on the basis of their nationality. Rubén, from the Asamblea del Pueblo in San Telmo, spoke passionately about the subject: "Here a Peruvian does not have rights, a Colombian is a narco or

a refugee, but here comes a Swedish or a Hawaiian, and they get a hearing with the chief of staff!" Telling a story evocative of the way black and Latino/a youth are often treated in U.S. cities, he went on to describe the different treatment that locals and tourists undergo at the hands of the police as evidence of how tourists benefit from Argentinean racism: "If there are three dark-skinned kids on the corner, drinking beer and smoking a cigarette, the police comes and quickly sends them off to jail, but if it's three foreigners and they are smoking pot and drinking scotch, the police asks them where they live and offers them a ride."

However, within the milonga circuit, especially among dancers, promoters, teachers, and entrepreneurs, tango tourists are not considered as just any regular tourists but rather as *"gente como uno,"* as people like oneself who share similar interests and hobbies. As Omar Viola, organizer of the Parakultural milonga at Salón Canning, one of the most tourist-packed milongas, put it when describing his foreign patrons, "I don't consider them tourists. They are simply people who practice tango in another place." He went on to make a distinction between the tourists, who come to see a tango-themed show and experience tango from afar, and the dancers, who come to "be" and to participate in the milonga circuit. Octavio Maroglio, the director of the Escuela Argentina de Tango, confirmed these views, when he described a tourist as "the one who comes through an agency and with a package and foreign dancers as those who come to improve their tango and on their own." He went on to say that 90 percent of foreign students attending his school return to take more classes, explaining that many of his students had purchased apartments, becoming part-time residents by default. Indeed, buying property and moving to Buenos Aires is a growing trend among tourists, so much so that tourist guides are adding sections on "moving to Buenos Aires," addressing tourists' attraction to lower costs and property prices while appealing to the ingrained racism that may attract visitors to a city that "resembles more Paris than Mexico City" (Cousins 2008, 226). Never mind how easily this vision is challenged by the broken sidewalks, the beggars, the lack of infrastructure, and the many popular demonstrations encountered by anyone who ventures beyond the city's high-scale barrios.

In a way, distinctions over who should be accurately described as a tourist or simply as a dancer can be seen as yet another authenticating vehicle within the milonga circuit. These distinctions help to accommodate foreign tango enthusiasts as dancers whose very visit helps to refurbish Buenos Aires's undisputed role as the capital of tango.[8] Or in the

words of Susana Miller, "No hay extranjeros en el tango, si entendés el tango como producto porteño" (There are no foreigners in tango, if you understand tango as a Porteño product)—a view that leads her to think of teaching tango as a matter of teaching a "Porteño language" and a "whole way of life." Accordingly, a tourist can shed part of his or her tourist identity by participating in and complying with certain codes of conduct and demeanor, which always favor the authenticity of the Porteño dancer but afford the tourist a degree of acceptance and measures for insertion into the milonga circuit. Women's being too eager to dance, asking men to dance, not waiting to be seated by the milonga organizer, or dressing poorly and men's approaching women to dance at their tables, dressing too informally, or having poor navigating skills on the dance floor and bumping into other dancers were all given as examples of behaviors that are generally frowned on. In sum, following the traditional milonga codes of how one should select and invite a partner, bring him or her to the dance floor, start the dance, leave the floor, and behave at the milonga are more than part of the behavioral repertoire dancers are expected to master along with the dance (Carozzi 2009). They become criteria for distinguishing mere tourists from foreign tango dancers, safeguarding the view that, as I was told by a milonga organizer, "foreigners may dance more tango than do Argentineans, but it is Argentineans who really know how to dance."

Yet the special role given to tango tourists, especially their characterization in familiar terms, is not solely about protecting the space of the milonga as one of dancers rather than of tourists. The practice of distinguishing dancers from mere tourists also points to the working of a global community of tango tourists and to the particular racial and ethnic dynamics at play in Buenos Aires, which this community reflects and helps sustain. I refer back to the global community of dance enthusiasts I spoke about earlier and its role in veiling and bridging differences among tango dancers as a key factor affecting this perception of tango tourists. Specifically, these types of responses evidence that participants in this tourist sector, be they visitors or local residents, are made up of globalizing middle classes, many of whom share similar class and cultural codes regardless of their country of origin, and that this similar background is fundamental to softening the social strife and the tensions that could arise if the existing differentials in economic and global capital were more evident. Recall that despite the working-class origins of the tango milonga circuit, it is now primarily a leisure social space, where it is tango workers

(dance teachers, taxi dancers, and others who make a living from tango) and middle-class professionals and upwardly aspirational groups who predominate.[9]

Here it is worth delving into the meaning of "middle class" in Argentina and into the transformations in who can rightly belong within its increasingly flexible confines. Due to Argentina's history of worker activism, the concept of the middle class is one that has been historically tied to workers and to being an Argentinean and part of a modern society devoid of the extreme social/class stratification at play in other (darker) Latin American countries (Grimson and Kessler 2005; Svampa 2005). However, neoliberal reforms since the 1990s and the ensuing economic collapse and growing globalization of the most dynamic economic sectors have radically transformed possibilities for traditional middle classes. These transformations have led to a growth in class polarization and to a pauperization of the middle classes, especially among professionals and small-industry and government employees, who have experienced lower wages and greater unemployment. This impoverishment has been gradual and has also been accompanied by a growth in middle-class sectors that are tied to the most dynamic sectors of the new economy (global services, digital work, tourism), which has helped veil the overall decline of the middle classes (Grimson and Kessler 2005; Svampa 2005). Pauperization has also occurred among people in sectors that have strong economic, historical, and cultural ties with the middle class, because they have education or are professionals, or among people who still can claim to have a job. In this context, "middle class" has become more and more a matter of maintaining a lifestyle, especially among those people who still have access to education or to a job.

At milongas, almost everyone I spoke to who was not a professional dancer, a musician, or a milonga organizer described him- or herself and others as *"profesionales,"* either journalists, university professors, engineers, students, or business owners, groups that are therefore squarely linked to the middle class, however delicate their hold on it may be. Even people who worked in the service and informal economy, as taxi drivers or as vendors, or who were unemployed or in between jobs identified themselves in this manner or as a worker, someone who is employed and hence "middle class." It is also worth recalling Buenos Aires's racial and ethnic identity as a city of white, formerly European immigrants, where, by and large, many Porteños nurture a European identity and do not see or feel themselves to be too different from Europeans. Marta Savigliano's

discussion of Argentina's denial of its own colonial status, despite its long history as a sovereign state, is relevant here. For her, the crux of the problem is that Argentina's economic richness of the past and history of European immigration have obscured its continued reality of underdevelopment, exploitation, and dependency. As she notes, "For Argentinos the burden of colonialism has been translated in endless efforts to reaffirm our whiteness," and this is most evident in the country's own forgetting that it was colonized (Savigliano 1995, 26). In sum, the colonial and racial dynamics that are often central to tourism involving Western visitors from advanced economies to smaller, developing countries or to former subjects of empire are thereby effectively elided in the context of Buenos Aires.

In this way, tango tourism is not experienced as an alienating force among middle classes who dominate the milonga circuit but as one that exposes local dancers to a not-too-foreign or not-too-distant world from their own European past or to their future aspirations for worldliness and travel. The case of Perla, a local dancer in her forties who had memories of travel abroad with her family prior to the economic collapse and the alteration in exchange rates, is indicative. She had not traveled abroad since the mid-1990s and could not envision any travel in her immediate future, though this did not stop her from establishing contacts with foreign dancers she had met in Buenos Aires, assuring me that she knew where to land and whom to contact when she finally visits major cities throughout the United States and Europe. Then there are the friendships and romantic relationships between local tango dancers and repeated tourists that also help mediate class/background distinctions. Not unlike tango communities elsewhere, the tango community in Buenos Aires is quite steady: dancers tend to patronize similar milongas, and regulars hold reservations at the same tables, which facilitates visitors' ability to meet and recognize local dancers. Visitors are also likely to bump into friends from back home during their trips, while locals learn to recognize the repeated travelers and sometimes form lasting relationships with them that lead to affairs, to marriages, and to tango-related business ventures (Viladrich 2005).

These types of exchanges and connections diminish the economic and cultural differences between local dancers and visitors, though the fact is that, contrary to the common view voiced on the milonga circuit, tango tourists share very little with local dancers. These differences, which are explored more fully in the next chapter, include tango tour-

ists' greater resources and mobility relative to locals. Consider the case of Maria, a South African business owner in her thirties whom I met at DNI tango school, which is very popular with tourists and tango expats. The school's name is quite suggestive: DNI in Spanish-speaking countries usually stands for Documento Nacional de Identidad, or National Identity Document, so the school's name anchors tango's role as a point of entry and belonging for foreigners. Maria had been her mother's primary caretaker until her death, after which Maria sold her house and her business to spend a whole year learning tango in Buenos Aires. She has no definite plans for her return but can count on her mother's estate upon doing so. Then there is Ben, a thirty-nine-year-old mechanical engineer from Sweden, who also sold everything when he left behind a high-stress situation to pursue more artistic interests in Buenos Aires. He spends his time writing, taking photographs, and dancing and survives from consultancy jobs he does for old clients he kept and continues to nurture from Buenos Aires. When he needs to, Ben travels back to Sweden to solicit more business opportunities. Jonas, from Denmark, a former computer and information technician, had spent three years in Buenos Aires and had even bought an apartment that he now rents out to other tourists, effectively inserting himself in the tango tourist economy. François, from France, comes every year during his vacation; he has been known to live quite comfortably for months at a time simply with the money obtained from renting his apartment in Paris. Recently laid-off North Americans seeking to extend their pensions while they weather the economic recession are also common. Like other tango tourists, they all renew their stay every three months by taking a short ferry trip over the border to neighboring Uruguay and back, a common recourse among foreign visitors to extend their stay in Buenos Aires. These tales of free or easy access contrasts with the stronger enforcement of border controls with Paraguay, Brazil, and Bolivia.

In sum, tango tourists, like many expats who are settling in Buenos Aires, are members of a highly flexible and privileged creative class; they can insert themselves in the most advanced sectors of the local economy because of their disposable income, as easily as they can keep entirely disconnected from the local scene, drawing from it solely for leisure, while generating income from contacts abroad whenever needed. In particular, these global tourists benefit form the privilege afforded their race, citizenship, and nationality within the local context. They are not just one more artist, writer, MBA, or digital nomad, as they would be in their

home countries; they are also different and unique because of who they are in the particular spatial, racial, and national context of Buenos Aires. But these global tourists do more than benefit from the comfort and ease of living with U.S. dollars and euros. They also sustain Buenos Aires's image as a city of opportunities for everyone in times of economic uncertainty and decline. After all, as long as the nationality and cultural capital of those who are fueling new growth are not broadcast, the foreign-led bohemization is easily kept under the radar.

In this regard, tango surfaces as an important cultural sector that helps reflect and negotiate disparities between global tango tourists and locals, resolving them in favor of Porteños, at least seemingly insofar as it is Porteños who remain the undisputed rulers of the dance floor. Tourists add a cosmopolitan feel to the milonga, facilitating for the Porteño middle class a symbolic insertion into and participation in a global community of tango, in which it is they, not the tourists, who prevail. Tourism also creates economic opportunities for many locals, who otherwise are facing diminished prospects for employment and advancement, in a sector of the economy that seems limitless, even if this sector is also reaching saturation and its scope is more mythical than real. I recall the story of Nico, the airport taxi dancer who after sixteen years of working with tourists, with much sacrifice and some debt, had proudly purchased an apartment in the Buenos Aires neighborhood of Palermo, which he planned to rent to tourists. He is obviously one of the winners. But his friend, who seeks to emulate him, has much fewer resources to achieve such success and has far fewer opportunities in a shrinking and saturated real estate market.

Thus, it may not be too remarkable after all that tourism continues to be received with optimism and open arms by locals, rather than implicated in growing inequalities or in the city's transformation. As we have seen, tourism serves as a catalyst but also as a buffer to ongoing social transformations. And in the larger scheme of things, tourists are actually pretty irrelevant to locals' expectations and future economic well-being. An artisan in La Boca, perhaps the tourist neighborhood par excellence in Buenos Aires, summarized this view when she shared her analysis of the situation: "It's not the tourists' fault; it is the government and the private industry that is to blame, for wanting to move us as they wished and for wanting to promote unrestrained growth." She, like many street artisans, profits from tourists but now faces uncertainty; the spot on the street where she works is coveted by more powerful commercial interests, and

she faces a move to a less transited sector. Rubén from the Asamblea, mentioned earlier, shares her view. In his view, the issue is not tourism but rather the unabated sale of and speculation with people's space, housing, and jobs fostered by the government's enthusiasm to promote tourism at any cost. In sum, both of these informants were pointing to the larger structural context in which tourism operates, which is the same larger context that tango tourism contributes to shaping.

Overall, tango, as the product of popular classes transformed into a national and global art form, has always been a subject of contrasts and tensions. I hope to have shown that tango continues to embody enduring tensions and that thinking through them can yield important lessons about the workings of neoliberalizing processes. For tango is not as international, mobile, and global as tourist proponents would like us to think. Instead, the tango economy is best seen as a space where who travels for pleasure, who travels for work, who can enjoy settling in Buenos Aires, and who is increasingly excluded from the city's globalization are all on display and consistently at stake.

Urban/Creative Expats

Outsourcing Lives in Buenos Aires

We're a second wave of immigrants, smaller but just as powerful because we belong to middle and upper classes and we're all entrepreneurs.

—David English, quoted in
"Argentina,Tierra de Inmigrantes VIP," *La Nación*

We like to read this type of news because they make me feel that not everything is bad, that if foreigners choose our country, it is not because of folklore or indigenous themes, but instead because they're looking to improve their quality of life and for better opportunities. If they find opportunities in our country, it means that we can also find them here.

—Rafael García, online comment on
"Argentina, Tierra de Inmigrantes VIP," *La Nación*

Tourism has often been prized by Latin American governments for the profit and validation it bestows on their countries' cultural attractions. But when first-world citizens from the United States and Europe with education, options, mobility, and resources choose to settle more permanently in cities once regarded as unfit for modernity or too economically and political unstable, some interesting questions arise. What does the move of first-world citizens to the Global South communicate about the state and impact of global economies in both sending and receiving countries, and what does it reveal about expectations and

possibilities for progress, modernity, citizenship, and well-being among those who leave and those who remain in place? Most specifically, what can we learn about the contemporary state of creative work globally and about possibilities for creative workers from examining the influx of creative expats into the Global South?

In Buenos Aires, a city that is a relative newcomer to large-scale international tourism, this influx has become an important reference for anchoring the city's upwardly mobile aspirations as a "first-world" city that attracts "first-class" citizens from all over the world. This view is amply evident in the local press's awe and fascination whenever it touches on the topic of expats. The tone is always one of marvel and pride at how the city is sought after by people from the same countries that locals have always coveted.[1] This view is also at play in the national pride around tango tourism, welcomed for the validation it brings to Buenos Aires as an international attraction. However, tango sojourners are part of larger flows of repeated and long-term visitors who are choosing to settle permanently or on a semipermanent basis in a city that the international press has touted as the "capital of cool" and lauded for its cosmopolitan identity and as a place where one can pretend to be in Europe for a quarter of the cost (Byrnes 2007; Politi 2009).[2] In particular, the favorable conditions of the peso since the crisis of 2001, the city's upscaling as a result of neoliberal reforms, its gay-friendly status and official recognition of same-sex marriage, and its overall international reputation as a creative capital (popularized in ratings measuring creativity and quality of urban life, for example, in the *Gunn Report*) have turned the city into a magnet for myriad independent writers, graphic designers, cultural entrepreneurs, and other creative types.

Creative expats make up a diverse community. A spoof of different expats to Buenos Aires, posted on one of many expat-related blogs, identified a series of "types," from those who come to escape the past (a heartbreak, an economic problem) to those who come to delay the future (having to make permanent decisions of the economic or social kind), as well as the volunteers, the retired, those seeking global opportunities, and the "learners" (of language, tango, etc.). Then there are the many expats who come to work on a project, who are perceptively described as those who "save up enough to live in the former colonies without working so they can use their time to finally write that book, that masterpiece, that itch that they've been meaning to scratch."[3]

For the most part, expats tend to be young, mobile, educated, and highly skilled professionals, as is also characteristic of the many high-

income transnational workers who circulate in the global economy. However, in contrast to transnational and managerial elites or intercompany transferees who circulate around the needs of particular industries (Beaverstock 2005), these expat professionals are not sent by individual companies. Their travel is also not driven by ethnic or national ties with Argentina; family networks are seldom expats' primary motive to move. Still, given the disparities between the countries involved, with their imperial and peripheral histories, ethnic and racial considerations are almost always implicated in their move. Thus, following David Roediger's discussion of the "wages of whiteness" (1999)—how whiteness provides value to white working-class workers and helps sustain their exploitation—one argument I advance here is that creative expats in the Global South almost always benefit from the "wages of empire" afforded by their nationalities, in ways that soften the economic uncertainty, insecurity, and downgrading that increasingly characterizes workers in creative sectors in the United States and Europe.

What follows focuses primarily on creative types seeking opportunities for creativity, for repose, and for taking risks that would be unfeasible and unimaginable at home, from the independent writer who seeks a cheaper location to make a royalty check last to the laid-off Web designer who is living off a severance package until she figures what her next steps will be, to the successful systems engineer for whom this move represents a downward economic turn but one taken to improve his overall quality of life. I use "creative expats" to refer primarily to creative classes with educational and institutional capital, in a different way than I did in chapter 3, where I focused on barrio creatives who may lack these types of institutional assets. Still, I use the term broadly, to include not only those who engage in traditional creative endeavors in the arts and culture but also those who are involved in knowledge-producing industries and in consumption-based entrepreneurial activities and hence share similar tastes with creative constituencies.

At the same time, I recognize that most visitors to Buenos Aires come seeking some sort of cultural experience or opportunity for self-creation. In fact, the tourism industry has recognized tourists' increasing preference for cultural experiences, by marketing more immersion activities rather than explicitly tourist ones.[4] Tango tourism, my first draw to the topic of expats, is full of stories of people seeking the allure of an authentic dancing experience. However, unlike tourists and study-abroad students, or more transient visitors, expats end up relocating on a more per-

manent basis in Buenos Aires, whether this is initially intended or not, and attaining a certain degree of integration into the city, as regular consumers, workers, and residents. Some even shun the category of "expat," preferring instead to be known as an "immigrant" or as an "Argentinean" or a *"perma-turis"* (permanent tourist) to underscore their intention to integrate, to mark their distinctions from mere tourists, or even to avoid the elitist connotations of the term.[5] Still, unlike most immigrants, expats have a higher standard of living and consumption power, not to mention racial capital as "Europeans" or "Americans," that frees them from social stigma. Also unlike immigrants, whose transnational connections with their countries of origin are limited by their legal status and economic condition, expats remain always potentially mobile across borders. This is so despite the fact that few expats hold documented status as legal residents in Buenos Aires.

The expat phenomenon in Buenos Aires is further assisted by Argentina's constitution and its immigration policy, historically conceived in relation to European immigrants. Articles 20 and 16, in particular, state that foreigners have the same civil rights as Argentineans and disavow any prerogatives of blood or birth among residents, while article 25 promotes the state's role in furthering European immigration. Meanwhile, the country's immigration law, historically directed at controlling immigration from the working poor from bordering states, has been generally indifferent to the entry of more upscale immigrants from Europe and the United States. The same can be said about the interdisciplinary literature on immigration, which has focused on emigration of "third-world" peoples into the United States and Europe, ignoring the emigration of Americans abroad (Freidenberg 2009). In fact, in 2004, Argentina passed Law 25.871, which has been internationally lauded as a major step toward global immigrant rights because it establishes migration as a human right while extending antidiscrimination protections to immigrants as well as access to social services, health, and education (Hines 2010). While the law has been criticized for a general lack of enforcement regulations and clarity that limit its reach and enactment, it has undoubtedly put Argentina at the forefront of immigration policy by providing considerably easier processes for establishing one's official status, especially in comparison to the increasingly draconian immigration policies at play in many parts of Europe and in the United States.

Generous provisions for obtaining a *"rentista"* permit especially favor the settlement of expats with resources, such as those who have access

to some set monthly income from investments or pensions from abroad of at least eight hundred dollars, as well as those who can sponsor themselves by setting up businesses and investments. The *rentista* permit facilitates obtaining a DNI (Documento Nacional de Identidad; National Identity Document), which allows legal status to work, sign contracts, and have basic medical coverage. Expats I interviewed who had gone through this process described imaginative ways of setting up income to appear as *rentista*, and not tied to income earned in Argentina, confirming that there is considerable room for maneuvering in these guidelines. Three consecutive renewals of a *rentista* permit allow expats to apply for citizenship or to continue as permanent residents. However, most expats stay as permanent "tourists" by renewing their visas through a short ferry ride to Uruguay. A few take the riskier move of paying a fee for overextending their visa—a relatively insignificant amount of three hundred pesos, or about eighty dollars, a fee that had been a mere fifty pesos some years earlier. Many make investments and buy property, while never formalizing a more permanent visa. One expat claimed to have traveled abroad and back fifteen times, each time paying the fee for overextending his visa, without fear that he would be barred from reentry.

In fact, lawyers often advise expats to stay put and not to mess with papers, since they may be better off working and living without any official documentation: "What I tell them is to stay undocumented. That way no one knows they exist, and if they are discovered, then you can appeal that you have the same rights as residents. It's very easy to defend yourself through the constitution's twentieth article, unless you present a threat to national security." In this way, expats' nationalities and financial prowess allow them to circumvent the Argentinean state altogether; it is easier for expats to live as "residents" of Buenos Aires than it is for many Argentineans from the provinces or for many Mercosur immigrants. The latter may be afforded easier paths to citizenship but are constantly under suspicion because of their nationalities or the color of their skin. The city's racial exclusivity was in full display in the mayor's publicity campaign, which was plastered across city subways in 2011. Intended to challenge Mayor Mauricio Macri's reputation as the overwhelming supporter of an elite, white, upscale, and privatized Buenos Aires, the ads show pictures of popular classes, workers, hippie-style youth, and Latin American immigrants—in sum, the very groups that are most publicly suspect in the neoliberalizing Buenos Aires—set against an abstract collage of colored triangles, evoking a colorful aesthetics of inclusivity like interna-

tionally known gay-pride flag or even the flags of the *pueblos originarios*, Argentina's indigenous peoples. Most significantly, the ads are stamped with the tagline "Vos sos bienvenido," or "You're welcome," a very obvious tagline that implies that these groups were not already part of the city. Instead, the campaign treats them as newcomers who have to be extended an inaugural welcome.[6]

I am aware that people with means and dreams have long embarked on adventures of self-discovery, while Westerners' penchant for immersing themselves in and escaping to "another culture" as an antidote to the ills of modern society has been around as long as the very start of modernity. My analysis, however, examines Buenos Aires's expat phenomenon in 2010, close to ten years after Argentina's crisis and peso devaluation opened the country to massive international tourism, and in the midst of a global economic crisis in which opportunities and social security for all workers, including creative workers, have dramatically shrunk.

Creative workers and highly educated knowledge producers were once lauded as constituting the core of the new global economy and regarded as a protected and privileged sector that would lead all American workers into twenty-first-century capitalism (Reich 1992). Yet the current crisis has shown otherwise. Creative workers have not shown the resilience to global economic changes that was once augured; they have been greatly affected by employment instability in creative work. The social costs and investments needed to attain the standards of living and consumption that we associate with these sectors are on the rise, but the rewards are harder to come by (McGuigan 2010; Ross 2009). The case of "hipsters on food stamps," or the many unemployed creative and young professionals in their twenties and thirties who are overcoming old taboos and turning to government help to maintain their consumption tastes in a shaky economy, provides a revealing portrait of this downgrading (Bleyer 2010). Quoting numbers from the U.S. Bureau of Labor Statistics, the *New York Times* confirmed this trend when it noted that Americans between the ages of eighteen and twenty-nine, the so-called Millennial generation, face 14 percent unemployment, a figure that when added to the 23 percent who are not even seeking a job totals 37 percent, which is the highest rate in over three decades and one reminiscent of the 1930s (Uchitelle 2010). It is in this context that Buenos Aires surfaces as an attractive alternative that allows people to fulfill their preconceived expectations regarding consumption, leisure, and work that are seen to be fleeting in the United States and Europe.

The year 2010 also marked Argentina's bicentennial under an allegedly "anti-neoliberal" administration that seeks alternatives to the openly neoliberal economic policies of the 1990s that culminated in the crisis of 2001. However, as in other parts of Latin America that have attempted more "socialist"-based strategies, the local government is still tied to market-driven models that limit the state's anti-neoliberal strategies. For instance, President Cristina Fernández de Kirchner's distributive measures, such as the institution of a universal benefit per child for parents who are unemployed or working in the informal sector, continue to be tempered by the country's unequal distribution of resources: 50 percent of arable land is in the hands of seven thousand families, and twenty million hectares are foreign owned (Colominas 2010). Similarly, despite efforts at redistribution, Argentina shows patterns of growing income inequality, with the poorest sectors accruing 1 percent of the country's total family income, versus the 35 percent accrued by the richest sectors (Argañaraz 2010). The country's lack of ownership of energy resources, of transportation, and especially of most of the press and communications industry, which sneers at any of the government's redistributive policies, also limits the state's anti-neoliberal reach. As Marcelo, a musician from Nueva Pompeya, one of Buenos Aires's most marginal barrios, put it, "Of what state can you rightfully talk about when the state doesn't own the country's main sources of energy or the communications industry?" In this context, Argentina has seen a rise in social democratic discourses and nationalist appeals, instilling imaginaries of modernity, autonomy, and justice that may ameliorate but are unable to address all social inequalities.

This stance was evident during Argentina's bicentennial celebration, in which the country was imagined and represented as vibrant and modern, and Buenos Aires as a metropolis anchored in the arts and culture. The reopening of the remodeled Teatro Colón served as anchor to the multimillion-dollar celebration, along with massive concerts of rock and folkloric music and stylized exhibitions and displays of the country's history. Especially poignant was the inclusion of critical assessments of Argentina's tortured past through exhibits and floats honoring the Mothers of Plaza de Mayo, activists who bring attention to the disappearance of children and family members during the country's military dictatorship. All of these events helped celebrate Buenos Aires as a modern and openly democratic city.

Official statements that Argentina is among the countries that have best faced the global crisis and that it is in far better shape than Greece,

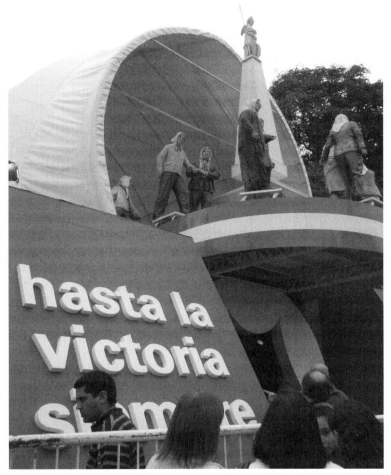

The exhibition commemorating the Mothers of Plaza de Mayo was one of the most popular displays at the bicentennial celebration, signaling a new engagement with the country's military past. May 25, 2011. (Photo by the author)

whose debt crisis sent shock waves through Europe and the world in 2010, are also signs of this growing buoyancy, which critics regard as too optimistically premature given the rising inflation ("El país" 2010; Colominas 2010). Expats, even if unwittingly and by the mere fact of how their presence is interpreted by locals, feed on this nascent boosterism in ways

Visitors taking pictures in front of the bicentennial's celebration exhibit on the Mothers of Plaza de Mayo. (Photo by the author)

that have significant implications for the local debate about Argentina's political and economic future.

Buenos Aires's expat phenomenon also speaks to neoliberalism as a global process that is sustained and enabled by the balance of conditions that are simultaneously produced by different countries. This is apparent when exploring Buenos Aires's growing expat phenomenon in light of the declining economic vitality of creative work and the decreasing usefulness of education and creative capital for gaining sustainable work in this sector. This larger context frames the choices of creative expats as they seek to maintain their class identities by reconstituting the coordinates against which such identities are framed. All along, the move of creative workers to the Global South helps sustain and feed disparate class and national identities, not only those of first-world expats but also those of many middle-class Porteños who remain in place.

The Pull of Culture: On Finally Balancing Work and a Good Living

At the forefront of Buenos Aires's expat community is Martin Frankel, a former marketing executive from New York City in his early thirties who came after he lost his job and has become one of the community's most visible spokespeople. Frankel is the founder of Expat Connection (http://www.expat-connection.com), a social website linking foreigners who have moved to and settled in Buenos Aires; of Areatres, a shared office/work station that attracts digital nomads; and of Sugar, a popular bar among the expat community—all of which operate from Palermo Soho, a highly gentrified neighborhood that serves as a stronghold for this community. From Areatres, Frankel has become one of the most high-profile expats, having been interviewed hundreds of times by the local and international press, as proudly attested by the wall filled with newspapers clippings that meets visitors to his modernly decorated office. Frankel was very eager to discuss the expat community with me; it is his main business target and a "brand" he carefully cultivates.

"They are a different breed than those of the past," he first offered. "They are Expats 2.0," he added, because of their high degree of education and their expertise in creative fields and newer technologies. As he noted, "These are not traditional expats, like those who worked in multinationals and were sent as a package for a fixed amount of time and with a driver; these are people who make a lifestyle choice to move to Buenos Aires." Indeed, expats come with money, with pensions, with degrees, with work experience and connections, and with the possibility of returning to steady situations back home, if and when the economic crisis subsides. Foremost, expats come with high degrees of cultural capital. As a North American expat stated during a television interview, these are people with "*mente abierta*" (open minds), a self-selecting group of creative Americans, among the few Americans who own passports and an even smaller group who venture as far south as South America. One needs only to browse the "Expat Files" in the *Argentimes* (since renamed the *Argentina Independent*), the English newspaper directed at this community, for evidence of the hyper cultural capital of the average expat. There is the Belgium journalist, the London horror-film maker, the Indiana yogi and artist, the Harvard-educated economist who came to Buenos Aires for a quiet place to write a book, the Scottish gallery owner, the London

aristocrat/artist, the London DJ who opened the first "boutique" hotel in Buenos Aires, the Canadian peanut-butter entrepreneur, among other primarily white, young, educated expats who came and stayed (http://www.theargentimes.com/culture/balives/).

Frankel went on to explain that expats are attracted to Buenos Aires by the economic opportunities afforded by the city, but most of all because of its quality of life and supposedly "warm and easy culture." He stressed the same view that I was subsequently to hear from other expats: expats come because they want to "vivir para trabajar, no trabajar para vivir," to work in order to live, not live in order to work, as is customarily done in Europe and the United States, where there is little to no time for family and friends.

As Frankel noted, most creative expats describe their move as a life choice. This choice may have been taken to address economic, cultural, and social needs, but it is almost always couched as a choice taken to facilitate creative pursuits and endeavors. Chad, a software developer who came with his own and two other families after one of them made the economic calculation to sell their homes in Seattle before the start of the recession, even used the term "existential expat" to describe his experience and that of many expats he knows. The term, inspired by a study of "existential migration," looking at voluntary migrants in London, underscores the quest for self-expression and discovery as a key impulse for relocation abroad (Madison 2009).

This quest for a more balanced life was repeatedly mentioned by expats I spoke to, who openly shunned the stress and tediousness that they felt was characteristic of their respective career paths back home. Drawing on familiar dichotomies of rationality versus emotion, work versus enjoyment, and technology versus arts and beauty that have historically circulated as part of nationalist/imperial ideologies to distinguish the United States from Latin American countries, they tended to see Argentinean culture as an oasis of familiarity, social life, enjoyment, and leisure that many believe to be characteristic of Argentinean culture and the unique cultural disposition of Argentineans, rather than the product of the political and economic conditions that facilitate expats' ability to achieve a greater degree of leisured living.

Also veiled by these dichotomies are the labor laws and social welfare provisions of the Argentinean state and the cultural and social strategies engaged by locals to make ends meet. Job security and working conditions for Argentineans were greatly weakened as a consequence of neo-

liberal legislation promoting *"flexibilidad laboral,"* or the deregulation of labor in the 1990s. However, and notwithstanding these changes, Argentina's labor legislation still provides relative job security for public-sector workers, and the country still has a vibrant union sector. Consequently, although unemployment and underemployment still plague Argentineans, if the employed sectors that expats encounter do not seem to face the same "urgency," "stress," and "competition" in the work-life environment that expats feel is characteristic of their work lives back home, it is not because of Argentina's culture but because of its history, most specifically its legacy of labor activism and unionization. Still, while the recent turn against neoliberalism has maintained public-sector jobs as a viable choice, this sector remains quite fragile. Owing to its pathologization as inefficient, backward, and fraudulent during neoliberal decades, the public sector is still imagined as one of the greatest impediments to Argentina's modernization, and it remains a matter of contention.[7]

In addition, expats' romantic views of Argentineans' work-life balance ignores the fate of many Argentineans, who are still affected by unemployment and underemployment and, most of all, who do not recognize themselves in these idealized images. An architecture teacher who supplements her income by sewing tango clothes on the side and still lives in her parents' home to make ends meet, weighed in on expats' image of Argentina: "I'm not always partying. I work. I can't afford to go dancing, nor eat *asado* every night." The romanticized *"asado,"* the Argentinean tradition of communal grilling of meat, which is done as part of special social events or family gatherings, was repeatedly mentioned by expats as a sign of Argentineans' good living practices. Yet the sharing of expenses and the mutual obligation for reciprocity that are also a central part of this tradition were not always noted by expats who got invited to *asados* by their local friends but rarely reciprocated.

American expats, especially independent workers or those who had been recently unemployed, are also especially attracted to the greater and cheaper accessibility of health care in Buenos Aires. In Buenos Aires, expats can find health plans that offer comprehensive medical care for around $50 to $60 a month; a premium plan covering cosmetic plastic surgery can be obtained for a monthly fee of $150. These plans are costly for most Argentineans, who take the basic government care, but the greater affordability of private health plans make them a real choice for expats in ways that are unimaginable in the United States.[8] The global economic crisis has also contributed to making Argentina a desirable des-

tination. Because the country had already gone through and survived a massive recession, expats believe that the local economy has nowhere to go but up—not so for the economies of Europe and the United States. Or as Frankel put it, "If things are shitty everywhere else, then why should you not come?" Indeed, the current economic crisis continues to keep low the opportunity costs for going to Argentina, as this decision does not entail the giving up of significant opportunities back home.

Yet Buenos Aires's greatest draw from expats' standpoint is the city's vitality and its many and varied cultural attractions. In this regard, expats are really not interested in Argentina. The countryside and the provinces are only of interest for weekend trips, with the exception of rich provinces such as Mendoza, the wine-producing area.[9] Instead, what most creative expats seem to desire is Buenos Aires's cosmopolitan urban life and cultural offerings to fit their tastes and needs, whether it is for Wi-Fi access, for good food, for transportation facilities, or for a vibrant cultural life and entertaining nightlife. This is another area where I found expats tended to essentialize Buenos Aires as an intrinsically creative city because of something innate to its culture, rather than as the product of the historical accumulation of wealth by elites in the capital or of uneven urban policies that have treated Buenos Aires as the country's showcase, while keeping the poor and the dark-skinned at bay (Oszlak 1991). Government financing of arts and culture has also historically disproportionately favored Buenos Aires over the rest of the country's provinces. The city receives the largest amount of the government's budget for the arts, over and beyond the rest of the country, as well as much press as the site of international festivals and events of great repute, such as the International Book Fair (SInCA 2010).[10] However, the more expats mentioned the appeal of the city's culture, the more it was evident that the attraction had little to do with Buenos Aires's theater and music scene. Instead, "culture" functioned as a euphemism for the racial capital that the city was seen to embody. For instance, cultural offerings surfaced repeatedly as a reason why some cyber expats chose Buenos Aires over other countries that appear to provide a more economically practical choice. In the technology sector, for example, the Philippines has a bigger pool of programmers, and India has a cheaper pool of English-speaking workers, yet only Buenos Aires was described as providing an appealing "culture" that made moving there an attractive choice. Closer inspection reveals some of the racial motivations behind these views. One cyber expat confessed that he had found "Indians too stupid and too foreign" and Asia "too

different and difficult." Asia demanded that he adapt to a new culture, whereas Buenos Aires made him feel immediately at home. Similar views were circulated during a New York City meeting of Latin American and North American entrepreneurs involved in start-ups in Argentina.[11] A North American expert on "emergent markets" acknowledged that China offers cheaper operation costs but could never compete with Argentina, the most "expressive" of the emergent markets. In his view, Argentineans' "love and passion for life" made them inherently creative, as opposed to the Chinese, whom he described as "copiers rather than innovators and creators," echoing the same racist understandings that have long marginalized Asians as "smart but unoriginal" and hence as unfit for creative industries (Tu 2011, 5). Again and again, Buenos Aires's "cosmopolitanism" was described by expats in relation to the city's greater modernity and Europeanness (read: whiteness) relative to other countries of Latin America and the rest of the world. Kristie Robinson, the founder of the *Argentimes* put it lucidly when she explained that Buenos Aires makes for a perfect "halfway house" between Europe and the United States, on the one hand, and the rest of Latin America and, for that matter, the rest of the world, on the other.

Racial motives were also evident in expats' claims of not feeling like "foreigners" and not sticking out in Buenos Aires as they would in other parts of Latin America, with the presumption that Buenos Aires is its own racially homogeneous country, a characterization that is representative neither of the city nor of the rest of the country. Expats' view that they could blend in with or had become Argentineans was also especially puzzling because I met few of them who spoke Spanish with ease or fluency and who were not identifiably foreign whenever they spoke in heavily accented Spanish. The few expats who are black or nonwhite did not share this dominant view of Buenos Aires as a place where foreigners can blend in easily. Ethnic and racial diversity is often marketed as an index of a global city's cosmopolitanism,[12] but Argentina remains fixed on its whiteness and Europeanness, and as a consequence, racial diversity is easily noticed as "different" or out of place, at least in the middle-class and affluent neighborhoods where expats tend to live and play.

Expats' view of the supposedly boundless opportunities they find in Buenos Aires also deserves measuring against the city's "underdevelopment," compared to ideas and businesses that are commonplace in Europe and the United States. Expats come to a city that they consider

to be lagging behind their own countries and, hence, ripe with opportunities to remake in their image, in a context where many "old" ideas can be considered anew. I am thinking here of the expat who opened the first taco restaurant or who began to sell bagels or cupcakes, among other ideas aimed at meeting expats' consumption tastes and providing continuity with their lives back home. There was nothing new to these business ideas, except that they were new to Buenos Aires; they acquire value in a similar way that expats themselves acquire value: by the mere fact of moving to Buenos Aires.

Expats' renewal as "creative entrepreneurs" is welcomed by many who, recently laid off, had been confronted with their devaluation into one of many talented, creative, and hardworking types that had been displaced by the global economic crisis. Once again, Frankel explained the benefits of this geographically based renewal: "I could have stayed in New York and looked for another marketing job. But I would have been one of the many college-educated MBAs in the corporate ladder. Here I'm more than just another white guy in a suit. I'm seen as bringing something different." That "something different" is, of course, his "first-world" status, which, in the new context, immediately renders him as a "modern, global citizen," someone seen as best equipped to bridge Argentina with the rest of the world. This point brings up Argentina's location and the dominant perception among local middle classes that they live in the *"culo del mundo"* (the world's ass), an idiom that is used to evoke locals' perceived geographical isolation from the dominant centers of power and that also colors their positive reception of North American and European expats—albeit to different degrees: Argentineans' enthusiasm for Europeans is always more forthcoming than for North Americans, who still generate more indifference and disdain for historical and political reasons.

Then there is the category of "cyber workers," who occupy one of the highest economic tiers of the expat community because they nurture clients abroad and are paid in euros or U.S. dollars while living in a peso economy. I interviewed three cyber expats for whom this life change represented a downward economic move; they all had been successful vice presidents in important U.S. companies or had achieved a considerable level of success, such as the purchase of a home in a "nice" neighborhood. But they found themselves bored, dissatisfied, overworked, and craving more time and freedom or, as one put it, looking for a place where "less time is tied up making a living, and if one works more, it is only to live as a

king." Indeed, the currency of time was a big pull for expats in this sector, who found common inspiration in Timothy Ferriss's national bestseller *The Four-Hour Week* (2006). Ferriss's manual for reaching the pinnacle of the "new rich" through life-styling, outsourcing, and mobility even starts with a vignette from his participation in the semifinals of the Tango World Championship in Buenos Aires, one of the many cities he traveled to in search of the maximum pleasure with the minimum work. Successful cyber workers in Buenos Aires include the founders of software-development consultancies and of global real estate websites (uplifted.net, moveglobally.com) and, perhaps most intriguingly, the developer of Virtual Dating Assistants, the outsourcing dating-service company that finds dates for the "lonely and busy" and that was featured in the *Washington Post* (McCarthy 2010). All of these companies are globally positioned and serve clients throughout the world.

Not unlike other expat communities, however, the one in Buenos Aires remains quite close-knit and inaccessible to locals (Beaverstock 2005). In the words of Kristie Robinson, "It's a tight *barrio cerrado* that is not geographically bounded but functions like a closed, gated community." They friend each other on Facebook, invite each other to events, barter services (such as home schooling), purchase the same private medical insurance, patronize the same vegan and gluten-free restaurants owned by other expats, share advice for dealing with and maneuvering through the local bureaucracy, help each other find placements and contacts, and often remain cut off from the local political scene. Consequently, while it is commonplace to laud Buenos Aires's "cultural attractions," these remain a backdrop to a relatively cocoonish life. At the most bubbled end is the expat who came for a sabbatical because the city was cheap, had Internet connections, and seemed more modern than other parts of Latin America. He could have well been in Hong Kong for all he cared. At the other end of the spectrum are the expats who purposefully seek to integrate and who shun the stereotype of the utilitarian expat who is here to take, not to contribute. A number of expats made this integration by purposefully living in pesos, hiring Argentineans, and opening businesses for locals. But these were a notable minority; the expat community is constantly renewing itself, and new entrants are easily pulled into established networks.

In particular, cultural initiatives by and for expats serve as magnets for interns and for free or low-cost labor from Europe and the United States in the form of students and young expats seeking to pad their résumés

with "international" experience. Grant Dull, the North American cultural promoter who popularized Zizek, the electro-cumbia group, described being "showered" by interns after the international boom of the group. When I spoke with him, he was assisted by one intern who had traveled from England to work with him, as well as by a marketing major from Boston working on his MBA. The *Argentina Independent* newspaper has even developed a formal internship program to handle the many requests from foreign interns. A Web designer described the preference for hiring expats in his industry: "Expats are perfect. They need to work a little and are technically savvy. It's easier to hire a student whose parents are supporting him or her and is eager to do a little work while he or she dances tango. There are no legal issues to deal with, and in six months they are going to leave." The stock of expats as workers is so consistent that one North American entrepreneur had been running an entirely dollarized marketing business serving U.S. clients by hiring mostly twenty-something North American expats. In eight years, only one of his employees had been Argentinean.

Indeed, the same traits that make Argentina's culture so carefree and attractive among expats are also the ones that many of them use against hiring and doing business with locals. More than one expat admitted that their foreign clients and advertisers preferred salespeople who are foreign, because they are mistrustful of Argentineans, fearful of being deceived. Expats complain of locals' poor working habits, lack of trust, overly presentist orientation, and overall unfitness for capitalism, entirely disregarding that locals may not trust expats as employers or the fleeting nature of their ventures.

The fact is that most expat start-ups and businesses operate mainly "*en negro*," or under the table, the common slang for work that is unregulated and undocumented. This contributes to the community's self-containment: their monies and investments from the outside flow through this community and back again to the outside, leaving shopping and local consumption as their primary economic investment. As one explained, "My business is all in *blanco* [legal] in the U.S., and in black in Argentina, but most of us work somewhere in the darker shades of gray." In this way, expats exacerbate the ongoing problem of "*fuga de capitales*," the capital flight and expatriation of dollars abroad, a practice that further weakens Argentina's financial system (De La Sota 2010).

At the same time, expats are not oblivious to the advantages they have, certainly relative to immigrants. Kristie Robinson reflected,

It's really amazing that expats who don't speak Spanish are treated like kings, and immigrants from *pueblos limítrofes* [bordering states] are treated like shit. People from the developed world who come here don't work, don't pay taxes, don't contribute, they pay in *negro*, don't speak Spanish, yet the country loves them. Yet immigrants who work really hard and keep this country running are treated so badly. It's fascinating. I can't write about this because I would alienate my readers, but it's always been most puzzling to me.

This disparity was especially puzzling to her because, unlike immigrants from *pueblos limítrofes*, expats are often in direct competition with educated middle-class Argentineans for jobs in some of the new and emerging sectors of the economy, such as in the creative entrepreneurial sector.

Tango tourism is a prime instance. Buenos Aires is filled with foreign tango enthusiasts who are becoming involved in the tango economy with greater ease and success than locals are. "Argentineans dance tango, but Americans make business with it" was how a local tango teacher put it. Assisted by income and savings from the sale and rental of properties back home and from contacts that can develop into future clients or business partners, tango expats are opening bed-and-breakfasts and developing new ventures, from tango *orquestas típicas* (typical orchestras) to yet another tango shoe line. Many expats can simply invest in the training that will facilitate a future career in tango. Their local lessons and experiences are investments to refashion themselves as more "authentic" teachers in their home countries. One Canadian expat even offered to work as DJ for free at Villa Malcolm, a popular youth milonga, displacing a local DJ. Who knows where the displaced DJ will go for work next? But the Canadian DJ will invariably accrue cultural capital from this free gig to cash in abroad, as someone who was "authenticated" by his having played music for Argentineans. Expats with savings or access to some capital also have advantages when launching entrepreneurial activities, such as restaurants and clubs, over locals who have difficulty accessing the necessary financing, an outgrowth of Argentina's financial crisis.

A few expats have even become successful brokers of Argentinean culture abroad. Grant Dull is perhaps the most well known; he almost single-handedly achieved the internationalization of the emergent rhythms of electro-cumbia, to what he admitted was the chagrin of local independent producers who had long produced it in underground clubs but had

less recourse to market it abroad. A young woman who in a few years had become a celebrated exporter/representative of Argentinean wineries also reflected on her advantages relative to local sommeliers: in New York City, she had imported French wines, and she had traveled throughout Sydney's wineries, experiences that have given her an advantage over local sommeliers who were not as familiar with wines beyond the local market and who had not worked with wine professionals throughout the world. Finally, in addition to taking coveted jobs in the creative sector, expats have an adverse impact on local middle classes' ability to access the city by adding to rising housing costs and to the city's gentrification.

At the same time, expats' economic impact, which is difficult to measure and estimate, may, in fact, be irrelevant in relation to Argentina's larger economic profile. Here, the largest players remain foreign corporations, whose investments are at the forefront of the problem of *"extranjerización de tierras,"* or the large-scale privatization of lands and natural resources, which has continued apace during the Kirchner administration (Ferro 2010). This is perhaps the greatest legacy of the neoliberal privatization schemes of the 1990s, which saw the privatization of Argentina's oil industry and other natural resources. These processes have remained largely untouched under the new administration, notwithstanding the government's rising nationalist rhetoric (Svampa 2008; Svampa and Antonelli 2005). Consequently, the Argentinean nation-state continues to function less as a regulator and mediator of private capital than as an active facilitator of the depletion of resources (Giarracca 2007). Highly permissive laws expedite the privatization of natural resources in mining, forestry, and agribusiness, but not without a rise in social movements involving new actors such as indigenous communities, movements in which natural resources and the environment take center stage.

Against this larger context, expats appear as mere tokens of the city's and the country's transformation, and it is as such that my middle-class informants seemed to treat them. In their eyes, expats are transient and rootless voyagers, whose consumption power and freedom they may resent—locals do not get to purchase property so easily, nor do they get to take "sabbaticals" in Europe or in the United States—but who are not seen as threats to their own aspirations for mobility. As an attendee at one of the events organized by Palermo Valley, a newly formed group seeking to promote the growth of the cyber professions in Argentina, noted dismissively, "They really don't come with capital or with investments. They bring the value of their recently sold homes in their pockets. They come

to escape the grind, to have a good time." In this regard, I want to suggest that the expat phenomenon is most significant for the imaginaries that it helps feed and for what it communicates to locals about a city, and by extension about a country, that more than ever sees itself as vibrant, as culturally open, as creatively limitless and abundant, and as providing economic alternatives for all.

Contrasting Images

As I have discussed, the migration of educated first-world citizens to Argentina has been primarily met with pride by my middle-class respondents. This position was also evidenced in two episodes of the popular news show *Argentina Para Armar* that were dedicated to the topic in 2009 and 2010,[13] both of which reveled in how flattering locals find expats' image of Argentina as a city of progress and opportunity. "Es extrañísimo" (it is very strange for us) learning why expats come to Argentina, noted the show's moderator with glee and self-delight, when for many locals, leaving the country is a necessary precondition for success. Indeed, again and again whenever I raised the topic with local residents, I was met with more excitement and signs of pride than concern. I was told that Argentina had the best writers and artists; I was reminded of Juan José Campanella's 2010 Oscar win for *The Secret in Their Eyes*, among other signs of a pervasive "cosmopolitan nationalism," a nationalism that is less concerned with the defense of the "nation," however defined, than with asserting its overarching endurance, flexibility and openness, and indelible nature. Accordingly, Argentina was seen as productive, creative, and encompassing and hence as immune to any outside threat. A taxi driver put it in more sarcastic terms: "We're such a big and rich country that there's enough for everyone to rob."

This dominant ideology of Argentina as an open country has historical precedents rooted in the country's immigrant history, and it is a view that has been deployed both as a response to narrow definitions of national identity around a mythical gaucho past and to evoke the elites' dominant European pretenses (Nouzeilles and Montaldo 2002). Jorge Luis Borges's definition of Argentina's national identity, not in relation to its content but to its positioning to what is foreign and its tendency to appropriate while "maintaining an irreverent attitude toward cultural authority," is perhaps the most well-known articulation of this view (ibid., 10). Indeed,

again and again I was told by locals that to be Argentinean is to have an open attitude, and many tied this openness to the country's immigrant history, to which many locals feel different degrees of association. Never mind that equating this early immigrant history with present-day expats entirely erases the different historical contexts framing these groups' entry into the country, especially the primarily working-class background of early immigration waves, which ended up strengthening Argentina's union ranks and which provide a stark contrast with contemporary "VIP" expats.

I recall the three middle-class Argentineans I met at a British-expat pop night, organized by the *Argentimes*, which was held in the solidly middle- to upper-class neighborhood of Palermo. They were all in their early to midforties and had come intent on practicing their English but ended up sitting at a table with other Argentineans, where I also sat, and little English was spoken. The three worked for the government, as is common among middle-class Argentineans with education and contacts in the government, which provides a steady but not the most stimulating job, as one described. They were excited to meet European foreigners, and when I prompted them why, each elaborated on a different view about Argentina's relation to Europe. Luciano began by explaining that for most Argentineans, "the call of European culture is strong," that Argentinians find it is easy to identify with Europeans, not Americans, because they themselves were Europeans, and many still hold European citizenship, as he does—he had transmitted the Italian citizenship for all his family. Or in his words, "Argentineans are Italians and Jewish. That's Argentina." Then there was Dante, who could have Spanish citizenship if he so wished but felt that it was not needed because he "already lived in the world's best country." "It's not true that Argentineans are Europeans," he contradicted his friend; obtaining European citizenship is not about proving a heritage but rather is a strategy. The same was true for his friend Sofi, who was planning to obtain Spanish citizenship, but only "to avoid having to wash dishes" if she had to migrate. Obtaining an European Union citizenship can be costly and time consuming and hence is limited to people with economic means; the poor often have difficulty obtaining an Argentinean DNI, and much less do they have the ability to access records from generations back (Poder Ciudadano 2007). The point I want to stress here is the continued pull of Europe among many middle-class Argentineans, but not as an identity that they claim to have but rather as a political strategy.

This brings me to the local political context that frames the settlement of "first-world" expats and how it involves different levels of confidence, support, and criticism for the current administration. The contemporary setting is one in which different models of government are being confronted and debated. One is generally characterized as a more conservative model that promotes Argentina's traditional role of exporting prime materials to the world and that looks outward to Europe and the United States. An alternative model is of a nascent industrial country that exports goods with added value and is steeped in a larger project of social welfare and justice. Still, while these models are starkly different in their ideology and political worldview, they both demand engagements with the global market economy to succeed. Supporters of the present Kirchner administration, however, tended to see the arrival of first-world expats as justification of the political and economic course of the government, which is seen as more nationalist, protectionist, anti-neoliberal, and redistributive than any administration since the advent of democracy in Argentina. That first-world expats come of their own will to live in Buenos Aires is thus constructed as a popular repudiation of neoliberal policies of the past. A film student explained: "People come to escape a system that is very oppressive for them." In his view, expats settle in Argentina because the United States and Europe are in decline, as is neoliberalism worldwide. One local jokingly referred to expats as "political refugees," laying bare the political work that expats do in the eyes of many Argentineans, even when "economic refugees" would be a far more appropriate description of expats' motives. Opponents of Kirchner's government also have a reason to celebrate expats and tourists in general, as a link with the capitalist world from which, they feel, Argentina is wrongly growing distant.

Then, there is the excitement the expat community inspires among prospective local entrepreneurs who buy into and want to fulfill expats' view of a business-friendly Argentina, as they seek to emulate the success this community has had. The middle-class Argentineans who flock to the events of Palermo Valley come to mind here. In April 2010, the group even hosted a panel featuring expats to discuss "Argentina as a pole of attraction for foreign talent," to promote expats' view of Argentina among Argentineans. As Martin Vivas, one of the organizers, explained, "Argentineans are constantly looking outward to Europe and the United States. We wanted to show Argentineans what foreigners like about our country that we take so much for granted." The event attracted over six hundred attendees eager to hear the experiences of a North American student

turned entrepreneur, a French luxury-brand promoter, and North American founder of an outsourcing design company, among other expats whose presentations predictably emphasized Buenos Aires's cultural and lifestyle attractions and its "unlimited economic opportunities" as major draws.

Thus, as we saw in chapter 6, the expat phenomenon has as much to do with the dreams that expats imagine they can fulfill in Buenos Aires as with those of Buenos Aires's globalizing classes. These double imaginings, from Buenos Aires's middle-class residents who desire a city that is modern and global and from expats for a "cultured" and livable city that provides greater possibilities to fulfill their expectations for consumption and for life standards they no longer can meet back home, feed and sustain each other, even when they may remain largely unfulfilled. At the same time, I want to conclude by exploring some of the critiques and possibilities that may be contained and communicated by these imaginings.

For the most part, the expats I met went to Argentina with genuine interest in changing and transforming their lives and with a desire to discover alternatives in order to live in a more balanced and fulfilled manner. However, the expat community and their life choices are not exempt from global economic pressures. As the community grows, many find that opportunities are not limitless and that inflation has made Argentina a more expensive choice. Turnover among expats is very high, and the few longtime expats are skeptical of newcomers. In Kristie Robinson's words, "I meet people who come here with great ideas and projects but can't last. This is still the *culo del mundo*. They can't stand the bureaucracy, their savings run out, and it's difficult to live in pesos. They leave because expats don't come here to live in poverty."

The fact is that most expats end up returning home or going elsewhere. However, they do not return unchanged. Whether their dreams were met or they leave frustrated or fulfilled, their stay in Buenos Aires becomes a central component in their life-career trajectories, a needed respite to survive and maneuver through an increasingly competitive working environment back home. Some return with a renewed valorization of the working regimes and values from which they had initially fled, longing for the "efficiencies" that were lacking in Buenos Aires, recharged and ready to insert themselves in the grind of their economies after a "time out" that is not afforded at home. But others attain a renewed appreciation of what they admired and found so meaningful in Argentina: a life they have romantically constructed as providing intangibles they never considered

valuable, such as a place where family and friends are valued, where there is time for leisure and vacation, and where money and career ambitions are not seen to rule people's choices. Laura, a high-level fashion executive who had been laid off before her eight-month stay in Buenos Aires, could not even fathom working as hard as she did prior to her stay. Returning to New York would require her to work at a level she now found untenable, and she was considering changing fields so she could pursue a different lifestyle that affords more time to pursue her interest in tango dancing, as well as to spend with family and friends. In all instances, these expats' time in Buenos Aires could be seen as a central component of new work regimes at play in the global neoliberal economy, where countries such as Argentina serve as outlets to temporarily or permanently absorb or, better said, to outsource the kind of dreams and aspirations that "first-world" nations can no longer assure their workers back home.

Argentineans, for their part, are left in place. In fact, the negative peso-dollar/euro exchange rate almost assures that local Porteños do not have the ability to travel abroad and that their short-term interaction with foreigners or their befriending of them on Facebook may be the closest they get to this goal. But their confidence in Argentina and in the city's appeal, for good or for bad, is almost always reaffirmed by these encounters. Javier, a mechanical engineer I met at a very touristy tango milonga, admitted that he wanted to travel, but he could never do or live as the expats in Argentina do; he regarded them as transient nomads who care little about friends, family, and community. "Yo prefiero quedarme aquí a remar" (I prefer to stay here rowing), he said in an almost pitying tone toward the expats in the room. He did not quite know what destiny he would meet in Buenos Aires, but he was sure that his voyage will be rewarding with friends and family aboard. I met many locals who, like Javier, embraced the promises of social justice, equality, and human rights so promoted by the present administration, in direct challenge to a largely oppressive and xenophobic climate they felt was responsible for the United States' and Europe's decay. In the words of Gabriel, another Porteño engineer, "I'd rather live in a third-world country that strives to be part of the first world than in a first-world country that does everything possible to become part of the third world."

Unfortunately, these local middle-class imaginings are also implicated in the current exigencies of a global neoliberal economy that increasingly provides fewer opportunities for people to meet their social reproduction needs as well as their consumption and lifestyle dreams, even for work-

ers once regarded as essential and indispensable. These imaginings also foster a false, premature celebration of Argentina's political and economic condition, of its international clout, and of its national sustainability that further veil the country's economic realities and its continued economic dependency on a growing neoliberal market and an extractive economy that the government's protectionist policies have yet to eradicate. Finally, the boosterism around expats who come not because of the "traditional" and exotic themes that have long attracted people to Latin America but rather to find better opportunities, as this chapter's epigraph noted, is quite revealing. Specifically, I believe that it helps to expose some of the lasting anxieties around race and underdevelopment that lie at the heart of the white modern nation that many Argentineans are so keen to project about themselves, to themselves, and to the rest of the world—in sum, the view that global expats from the most advanced economies come to Argentina to improve their quality of life and for better opportunities substantiates Argentina's putative proximity to modernity and civilization, as a country where locals can find opportunities too. Neoliberalism hence surfaces as a process that is sustained and enabled as much by dynamics at play in nations where it is a commonsense policy, as is increasingly the case in the United States and many parts of Europe, as in those such as Argentina that seemingly reject its economic policies and worldview. Or to put it another way, neoliberalizing processes are hence nurtured as much by the spaces that generate as by those that absorb the hyper creative capital and the people and workers that creative industries produce throughout the globe.

Conclusion

The Cultural Politics of Neoliberalism

I wrote this book with two primary goals in mind. The first was to explore the work of culture in neoliberalism with a critical eye. The cultural turn in urban cultural policies, be it in urban planning or tourism, is often celebrated as the solution to the standardization of space and the mainstreaming of culture that often characterizes neoliberalizing contexts. For one, culture-based strategies are believed to mitigate the inequalities and struggles over cultural equity and representation that these policies also generate. My goal was to challenge this view by exploring the cultural politics of neoliberalism, by exposing how inclined these initiatives tend to be toward middle-class and upwardly mobile sectors and, consequently, how they necessarily exclude many cultural workers as well as many residents as consumers and beneficiaries. In this way, far from an added-on ornament that "softens" or ameliorates the social inequalities of neoliberal policies, culture becomes imperative to their production. This is especially so when culture becomes the primary tool to convey a sense of inclusion and the illusion of representation in ways that veil the overall upscaling of spaces and institutions and the social exclusions that these policies have often wrought.

In sum, this book is offered as a rejoinder to the general assumption that culture is always restorative of social identities and as a reminder of how powerfully distorting mainstream representations of culture can be when issues of equity and creative economies are concerned. In my view, these assumptions reproduce an empty and symbolic politics of multicultural representation that do not account for the racial politics involved in creative economies, while ignoring processes of commodification, appropriation, and mainstreaming that are also at work.

The second goal was to expose the specificities that are often blurred in many discussions of creative and symbolic economies, in which topics as diverse as heritage tourism, consumer culture, and architecture are equally subsumed into "culture," without a detailed attention to the unique institutional structures and the different dynamics that are brought to bear when culture is instrumentalized in such different realms. I have offered ethnographically based case studies to expose the particularities of different institutional spaces and to appreciate some relevant differences. For instance, we have seen how authenticating discourses of what is more or less representative of a national culture pervade cultural politics around tourism as well as governmental cultural policies toward folk art production, whereas museums and art institutional spaces thrive primarily on questions of artistic standards and value. Consequently, concerns about the inclusion of cultural workers, couched in terms of the right to "representation," had relatively more salience in contexts of tourism and government-sponsored events than they did in arts/museum establishments that are more vested in abstract notions of "artistic" merit. Likewise, the racialization of cultural strategies was linked to their association with minority communities or their connection to policies associated with a defined nation or nation-state, as we saw when comparing the greater obstacles Latinos face in providing a rationale for establishing a Latino-specific museum with the case of Puerto Rico and Argentina, where cultural debates abound but not over the existence of unique cultural traditions and expressions that may be worthy of evaluation.

I have examined the cultural politics of neoliberalism through the lens of space, value, and mobility, to highlight how neoliberalizing processes are linked to particular cultural politics that have similar implications around these variables, despite significant differences at play in each site. Indeed, the cases are situated in distinct locations—a minority ethnicity within a larger nation-state, a perennial colony of the United States, and a nation-state permeated by global immigration—yet the cultural politics of each were clearly delimited by neoliberal processes that materialized significant inequalities that reverberated throughout each location. Each evidenced the economization of culture, the construction of entrepreneurial cultural workers, the diminished access to upscaled spaces, the limited social and physical mobility of marginal subjects, a narrowing of what counts as culturally valuable and worthy of investments, and the mystification of neoliberalism through adoption of culture-based developments. Altogether these effects point to some integrative lessons.

Among these lessons is that neoliberalism does not correspond to a single formation. Neoliberalizing processes have always been accompanied by the preeminence of market logics that prioritize elites and tourists; however, these processes have always advanced through locally defined politics and actors. And these actors are not limited to obvious ones, such as market interests and private corporations. Also salient among them are government agents and policies, whether it is Puerto Rico's folk art office or the New York Department of Cultural Affairs, institutions that also have undergone neoliberalizing transformations but that are nonetheless still vested in claims for equity and representation. One interesting development here is how disparities fueled by neoliberalizing processes seem to heighten popular demands for amends and restitution that are almost always directed at government entities in ways that reinstate the moral authority of state institutions against processes of unfettered marketization.

This trend further evidences one of the many contradictory tensions of neoliberalism: its tendency to foment resistance at the very sites involved in its production—hence the rising demands for more equitable cultural funding being directed at the same New York City government institutions responsible for fostering inequities in the city's financing for the arts; hence also the renewed activism that has turned Puerto Rican shopping malls into the preferred venue for public demonstrations against Luis Fortuño's neoliberal administration. Similarly, we saw how Puerto Rican shoppers are savvier than we are led to believe by retailers and marketers; they have learned to see beyond the illusion of the mall for the mere reason that they cannot afford to shop without a job or a steady source of income. Again and again neoliberal projects are riddled with tensions that expose their limits and fallacies, as when praise for entrepreneurship is accompanied by a rise in the policing of the entrepreneurship of the poor and of workers operating in informal sectors of the economy.

The growth of informality, a direct outcome of neoliberalizing processes, is also suggestive of what ultimately may be driving consumption and creative economies in the developing world. When consumption in places such as Puerto Rico is undergirded by informality and government subsidies, and when the shopping mall industry takes for granted monies from the drug economy as part of its calculations for measuring a country's economic health for future investments, it is obvious that the rapid growth of affluence and consumption, alongside dire poverty, should be

probed more critically. At the least, this rising consumption should not be interpreted as a sign of the success of neoliberalizing reforms but rather as another sign of their worrisome fault lines.

The cases of artisans in Puerto Rico and of tango workers in Buenos Aires also warn us against neoliberal processes and policies that help congeal determinations of value and prestige among cultural workers, such as around who constitutes a more representative or marketable performer, artist, or artisan. In each case, these determinations work to limit the wider organization of cultural workers by fostering distinctions among them that veil the larger transformations that ultimately impede most cultural workers from accessing space in which to work and from attaining upward mobility through creative work. This is so because the upscaling of spaces and of the very nature of "creative work" always entails a narrowing of economic opportunities, especially among the newest entrants to this sector or those with the least social and cultural capital.

The chapters on artisans in Puerto Rico and tango workers in Buenos Aires also show the prevalence of authenticating discourses as a response to neoliberal trends, and some of the contradictions involved in this strategy. In fact, appeals to authenticity emerge as one of the most favored "weapons of the weak"—in James Scott's well-known phrase—among many marginalized cultural workers (Scott 1992). These discourses are repeatedly used to reevaluate what, from official standpoints, is regarded as worthless and are used as the means through which workers assert the inalienable value of cultural work that was never appropriately contained by economic determinations alone. Authenticating moves are especially mobilized to defend and assert the value of place and its role in fostering "authentic" cultural products and artists, against the mainstreaming and globalization of cultural offerings. Consider here how artisans in Puerto Rico and tango workers in Buenos Aires position their work and what they do as more authentic than imported crafts or tango dancers from abroad, simply on the grounds that it is they—locally positioned artists—who do it and that their expressions are generated within a particular local context and informed by specific histories, even when innovation and adaptation have always been present in their work.

At the same time, the politics of authenticity represent a tricky ground on which to maneuver. Cultural workers may expound expansive notions of authenticity, but these politics are often prone to essentializing culture in ways that can place limits on innovations, which are central to artists' self-marketing strategies. This is one of the reasons why more expansive

definitions of cultural work and their acknowledgment by the different public and private institutional sectors invested in creative development strategies become such needed developments. For one, more expansive cultural strategies may counter the increased overreliance on the politics of authenticity as the primary recourse for gaining appreciation and support for marginalized workers and cultural products. For now, the lesson is quite simple: as long as cultural initiatives are primarily conceived and developed as top-down developments, without direct involvement of local cultural workers as producers and as equal economic partners and beneficiaries of such initiatives, the politics of authenticity will remain diagnostic of the many social inequalities that these developments engender.

These chapters also raise questions about matters of cultural policy and how best to address demands for cultural and economic equity. This book was primarily conceived and written as a critique of the boosterism that dominates discussion of the work of culture in neoliberalism, but not without appreciation and concern for the growing importance of this sector for many working people around the globe. Consequently, I cannot imagine a set of recommendations or desirable policies that may produce positive outcomes in each location. I am, however, more convinced of the importance of prioritizing the needs of localized cultural workers in any national and global policy debate around creative workers and economies.

A pressing question is whether it is possible to do so without succumbing to the growing prevalence of economic considerations in fields that have been traditionally regarded as in direct opposition to these types of concerns. Indeed, challenging the involvement of economic considerations in the arts and culture has become a truism among critics of neoliberalism, because it is believed to diminish these sectors' value and so-called intrinsic inalienability. I hope to have shown, however, that in light of the dominance of privatization logics in all sectors of society, it is becoming increasingly impossible to consider the cultural and economic realms in direct opposition to or as irreconcilable with each other. In fact, exposing the preeminent role that economic investments play in determining value—such as by assuring financial success and access to markets, to galleries, and to collectors for particular artists and institutions—is central to exposing the relationship between a lack of financial investments and the devaluation of minority cultural workers and institutions. Similar inequalities are evidenced in Argentina, where Buenos Aires has been historically treated as the country's "showcase" vis-à-vis

the rest of the provinces, receiving as it does the bulk of the government's and private funders' financing for the arts.

In sum, awareness of the funding/value dyad that makes value insepa-rable from public and private investments should lead us to demand more equitable investments on the part of government and private funding. Thus, the point made by groups such as New York City's Cultural Equity Group, discussed in chapter 3, is relevant for many workers across the Americas: that all cultural workers and institutions and, by extension, all communities produce value and that such value is less a product of the work they produce than of the financial investments they are able to attract because of the cultural and, consequently, economic worth that they are publicly given.

At the same time, the Cultural Equity Group raises questions that go beyond purely financial considerations. Most specifically, their claims bring attention to what the full meaning of cultural equity may entail for community artistic and cultural groups and practices. The goal here has been to reevaluate the unaccounted value that these institutions produce and the work they do in bringing people together, in fostering the expres-sion of differences, in sustaining dialogue and debate, and overall in pro-moting critiques and alternatives to neoliberalizing systems of value. One critical outcome of their work involves exposing the racist considerations veiled in neoliberal arts policies that obscure Latino/a communities' his-tory of marginalization and people's connection to location and space. Similar arguments have been voiced in demands that any "Museum of the American Latino" be more than a container for objects, that it must be a space that fosters vernacular culture and that does not shy away from exposing critical matters of racism and history. Miguel Luciano's use of commercial references and symbols to craft critical exposés of the con-vergence of consumerism and colonialism can be seen as working in anal-ogous ways, by exposing inequities often obscured by consumer culture's seductive cloak. Overall, central to this section's chapters was the call for alternative forms for evaluating Latino/a art and cultural production beyond those promoted by the mainstream artistic establishment. This involves accounting for multiple practices without pitting the artistic pro-duction that remains connected to communities against the mainstream museum and gallery circuit. This larger context explains why community activism around existing and proposed Latino/a cultural organizations and the interactive work of artist Miguel Luciano constitute such key interventions and rejoinders to logics that erase the value and resilience

of communities. These types of interventions anchoring "communities" and the value of "collectivities" become central to reinstating the values that are most challenged by neoliberalizing logics that seek to present the idea of utopian markets and pure market logics, undeterred by public interest considerations, as commonsensical logic (Bourdieu 1998).

Finally, these chapters draw additional attention to the diversity of cultural institutions and creative workers who are central to the economic well-being of contemporary cities but who remain largely unrecognized and at the margins of most considerations of contemporary creative economies. Indeed, my concern with the narrowing conceptualization of who is a "cultural worker" and what should be rightfully considered "creative work" was another key impetus for writing this book. For years, I have seen the marketization of culture in predominantly minority communities in New York systematically prioritize large commercial profit-making cultural endeavors and technocrats and professional cultural workers, who are more experienced in marketing themselves and their products, at the cost of community members, locally based ethnic entrepreneurs, and nonprofessional artists and cultural brokers. These workers are increasingly devalued and regarded as inefficient and altogether unqualified for economic opportunities, on the grounds that they are incapable of fitting into dominant neoliberal business models that are structurally partial to artists and cultural workers with the education and cultural capital and with the public and business contacts to thrive. Instead, the business failure of nontraditional cultural workers is regarded as self-inflicted, because they are considered as inherently nonentrepreneurial. Even worse, these assessment are made with little consideration of the structural challenges that these workers have historically endured in order to operate as cultural workers and to maintain cultural institutions and programs within highly disinvested communities. Yet, contrary to these views, I hope to have shown that the artists, performers, and cultural workers working in marginalized sectors in New York City's cultural economy, as well in informal sectors in Buenos Aires and Puerto Rico, are extremely effective agents, especially given the beleaguered context in which they work. Not only is their work discounted from the standpoint of dominant evaluative structures, but in all instances, these artists and cultural workers are extremely vulnerable to the politics of urban upscaling and the privatization of space; all the while, cultural work becomes more and more central to how people navigate unemployment and the flexibilization and disappearance of all types of jobs. Lastly, I want to briefly address some of

the integrative lessons around issues of mobility, of both the social and physical type, as they reverberate on the cultural politics of neoliberalism. I addressed these issues most specifically in the chapters on tango tourism and expats in Buenos Aires, though they are present wherever people and especially creative workers experience limited access to upscaled and commercial spaces and a shrinkage of opportunities for attaining social mobility through creative work. What the case of tango tourism brings up is the additional dimension of tourists, expats, and other types of upwardly mobile creative types and the role they play in the neoliberal restructuring of cities. These groups and their creative and consumption needs have become a primary incentive and justification for the construction of new upscale developments and culture-based attractions in many contexts, as we saw in Buenos Aires. There, tourism has helped channel developments in some of the most upscale barrios, not only through the presence of tourists and expats, which has incentivized local developers, but also through expats' direct investments in the purchase of residential and commercial properties and the establishment of creative endeavors geared toward the many international visitors who are settling there on a more permanent basis.

The growth of Buenos Aires's creative expat community, in turn, is especially revealing of the global uncertainty and decline in creative jobs and of the shrinkage of opportunities for people to attain their consumption and lifestyle dreams within these sectors in the "developed" world. Indeed, many of the creative expats we met in these pages had gone to Buenos Aires because they had become superfluous within their home economies; some had had their employment terminated or had had their work hours shortened, while others were proactively trying their luck as entrepreneurs in Buenos Aires in projects that would have been financially prohibitive to undertake in Europe or the United States. These mobile bodies, in turn, have experienced immediate, even if temporary, social mobility in Buenos Aires by the mere fact that they are no longer just one more graphic artist or MBA graduate but are now seen as modernizing agents with the appropriate global, racial, and cultural capital. As we saw, expats' racial/ethnic and national capital is central to the social mobilities they experience, in ways that anchor and help sediment Argentina's own racial and national hierarchies, along with global imperial ones. In this way, Buenos Aires functions as a buffer and refuge for many casualties of neoliberalism that had been produced beyond its borders. All the while, these "refuged" workers ironically further, in this very city, the

same processes of upscaling and gentrification that initially pushed them to try their luck in Buenos Aires. The result is a neoliberal juncture that bypasses the Argentinean government's official anti-neoliberal stance, while assisting the continuation of the same neoliberalizing processes that, on a global scale, are pushing workers abroad.

The type of international tourism generated around tango dancing, a leisure activity that preselects middle-class and upwardly mobile groups because it requires financial resources and leisure time to learn and pursue it, is also quite instructive of another dimension of culture and of the work it is asked to do in neoliberalizing contexts. I am referring here to the symbolic aspects involved in the consumption of cultural goods and practices that come to be regarded as tasteful, cultured, and worldly and that more and more serve as mediums for defining middle-class tastes and dispositions on a global scale. Facebook, designer brands, world music, and international cuisine come quickly to mind, but so do the consumption and collection of art and the learning of tango and other practices through which people may conjoin the expression and definition of middle-class identities with more specific ethnic, gender, or national identities. I am reminded here of the many U.S.-based Puerto Ricans who coordinate their visits to the island to coincide with the celebration of cultural festivals, where they may purchase folk art or access and experience "cultural" offerings to take back home in the form of pictures and videos. Similarly, we could consider the impetus guiding many middle-class Porteños to turn to tango dancing as part of their embrace of a berated tradition undergoing reevaluation on a global scale.

In regard to the cultural consumption of tango dancing, we have seen how it becomes extremely productive of a variety of class and national dispositions, functioning as it does at different levels for each of the varied constituencies that gather around it. As we have seen, tango tourists become inserted in a global network of tango enthusiasts who share similar class, taste, and cultural dispositions with local middle-class Argentineans, who welcome these tourists as cosmopolitan additions within the milonga circuit. For regular tourists, tango provides a dose of exotic culture to observe and consume; for international tango dancers, it provides an experience that validates their dancing through "authentic" dancing experiences with locals; while for locals, the rise in tango tourism provides validation of their country's cosmopolitanism and "coming of age." In this way, tango becomes a repository of dreams and identities, some of which may remain unfulfilled, but that nonetheless are very productive

and sustaining of middle-class and upwardly mobile subjectivities and positionings. This is so both for people who move across international boundaries and for those who remain in place.

Finally, tango brings us full circle to consider the illusions, joys, and pleasures that are so uniquely tied to matters of culture, reminding us that people turn to creative economies because of the intrinsic value that particular "cultures" and cultural contents may hold for individuals and particular communities. It is the cultural content of different creative economies that makes them so valuable, not only as a source of memories or of joy and entertainment but also as the intangible repository of people's dreams, meanings, feelings, aspirations, and identities. As such, this domain remains slippery, politically charged, and most evasive to purely economic logics and determinations, because it is so changing and resilient. At the same time, awareness and appreciation of the vitality of the "culture" part of any creative industry should never deter us from analyzing the economic dimensions involved whenever culture is put to work. This stance is much too risky and places too much at stake, as I hope to have shown.

This point brings me to ponder what lessons, if any, I may offer to all those who, like me, support cultural workers and consider themselves as cultural enthusiasts, supporters, and admirers of cultural creativity across the Americas. Not unlike many tourists and expats, I discovered tango tourism through my own love of tango dancing, while my interest in Latino/a cultural institutions and Puerto Rican artisans is informed by my personal history as a Puerto Rican scholar whose work has long delved into the cultural politics of representation and who is committed to producing politically relevant research that furthers social and racial equality and contributes to communities. I have learned, however, that none of these engagements—in fact, that no position—may guarantee that my consumption of cultural products will not actively or inadvertently end up engaging with neoliberalizing processes and inequalities. They also do not free me from the impulse to romanticize cultural production and producers or from furthering inequalities through my travel, whether this is a subway ride to El Barrio/East Harlem, a short plane ride to Puerto Rico, or a longer journey to Buenos Aires. Stuart Hall has always been insistent that there are no guarantees in cultural politics but that this should not deter us from a continued engagement with cultural politics.[1] The fact is that creative economies are increasingly linked to wider structures of power, yet they are contradictory spaces which we cannot aban-

don so easily without impairing the fate of many cultural workers who seek economic opportunities in this realm. In this spirit, I suggest that similar recommendations to those offered in the realm of cultural policy may help individuals maneuver through the contradictory space of neoliberal cultural consumption. These may include prioritizing the needs of locally based cultural workers, patronizing arts and artists beyond the borders sanctioned by governmental and tourism elites, and challenging and expanding narrow definitions of cultural work to include locally generated definitions of value and what may be some of the expressions and exponents of these definitions. Foremost, we can sustain a critical consciousness around the reality that more and more people make their living from culture and that, in this context, creative economies must always be critically scrutinized to ensure that a living culture and cultural workers, not solely economic considerations, remain the creative and generative engines at the heart of these initiatives. We have become used to the flexibilization of highly educated creative workers working independently or part-time; their identities as creative agents and workers are not jeopardized by these developments. It would be truly revolutionary, however, if we could extend the same flexibility and expansiveness to our conceptualization of the work and contributions of the many barrio cultural creatives who work at the margins of the economy. What I argue is for the recognition of linkages between the degradation in creative jobs that were once regarded as prestigious and secure and the struggles of barrio cultural creatives, and for seeing them as part of the same neoliberalizing processes that are eroding people's jobs and ability to make a sustainable living in creative sectors. This expansive revisioning of creative work is foundational to challenging the dominance and spread of market logics unconstrained from any consideration of the fate and interests of cultural workers and communities, as well as central for a true appreciation of the people who are the creative core of these initiatives.

Notes

NOTES TO THE INTRODUCTION

1. Florida 2002; Peck 2005; see also Yúdice's (2003) important discussion of "culture as resource."

2. Literature documenting these patterns is growing, but see in particular Dávila 2004; Gregory 2007; Reguillo and Godoy-Anativia 2005.

3. National Endowment for the Arts, "About Art Works," http://www.arts.gov/artworks/?page_id=79.

4. Elsewhere I discuss these dynamics in greater detail (Dávila 2004).

5. See Roman-Velázquez 2008 on the public ordinances that have restricted the consumption of Old San Juan as a space of leisure and entertainment for popular classes.

6. For discussions about the uniqueness of aesthetic value and how it is constructed as being intrinsic to artistic works themselves or as stemming from the market, or whether the test of time is its best determinant, see Hutter and Throsby 2007.

7. For more on the concept of mobility, see Cresswell 2006 and Seiler 2008. Another relevant body of literature that touches on mobility revolves around the new international division of cultural labor, looking at the division and organization of creative labor across states. See, for instance, Miller et al. 2008.

8. DeHart discusses these hierarchies in relation to development policies in Latin America. Her conceptualization of hierarchies in mobility draws from the work of Freeman (2001) and Massey (1994) on the gendering of space and globalization.

NOTES TO CHAPTER 1

1. See Segal 2009 on the decline of Americans' love affair with shopping malls. See also reports by the International Council of Shopping Centers, a trade organization for shopping malls that traces the development of the industry and the rise of emerging economies in its monthly *Shopping Center Today*, http://www.icsc.org/sct/.

2. Compañia de Comercio y Exportación de Puerto Rico 2008.

3. These include proposals such as the "Golden Triangle" development in Old San Juan, the transformation of Roosevelt Roads military base into the "Riviera del Caribe," and the "Science City" development, a comprehensive cancer center that will also incorporate medical tourism. More information on these projects can be obtained through Puerto Rico's Department of Economic Development.

4. At the Caribbean Conference of the International Council for Shopping Centers in San Juan, the PowerPoint presentation by government officials from the Office of

Economic Development described Puerto Rico as having twenty-eight million square feet of commercial space, which are largely concentrated in the metropolitan area. Presentation by Marcos Rodríguez-Ema, ICSC Conference in San Juan, 2011. These numbers, however, are currently in flux, as developments are on the rise.

5. Since I conducted my research, a proprietary marketing research report on the shopping habits of Puerto Rican women was produced; it seems to echo my findings about their strategies for maximizing their resources and their overall thriftiness. This report is only available by purchase and is not widely distributed, but discussion of some of its findings can be found at the website of the Asociación de Ejecutivos de Ventas y Mercadeo de Puerto Rico: http://www.smepr.org/index.php?src=events&cat egory=*n&srctype=detail&refno=81.

NOTES TO CHAPTER 2

1. See Dávila 1997 for a discussion that provides a historical perspective on the partisan debates over which of the two dominant parties (the pro-commonwealth or the pro-statehood party) is supposedly more concerned with Puerto Rican culture and how these debates have impacted cultural policy and the funding of local events.

2. This law was amended as Law 166 (August 11, 1995) and has been amended various times since, though the designation of what constitutes folk art and an artisan has remained unchanged. As of July 2011, the staff was in the process of changing criteria for their evaluations, but these are yet to be made public or adopted as part of any formal legislation.

3. This echoes the symbolic strategies that management and workers have adopted worldwide to veil and resist their exploitation by claiming alternative identities and postures, such as through fashion. See, for instance, Freeman's (2000) classic discussion of pink-collar identities in the Caribbean informatics industry.

NOTES TO CHAPTER 3

1. Méndez Berry 2010a.

2. The Urban Artists Initiative was a privately funded program founded by Bill Aguado, one of the Cultural Equity Group members and a former executive of the New York Foundation for the Arts, as a consortium of organizations that included the Harlem Arts Alliance and the Asian American Arts Alliance. This program was the result of a ten-year discussion about the need to develop infrastructure for assisting individual artists; that discussion was facilitated by Leveraging Investments in Creativity (LINC),and led to different projects across the United States. The Urban Artists Initiative consortium model of working through intermediary institutions that have the most direct connection to the communities they serve was one of the most innovative developments of the program. See LINC, "Creative Communities," http://www.lincnet.net/creative-communities.

3. See comments by Las Gallas art collective member Michelle Angela Ortíz and art historian Tomas Ybarra-Frausto during NALAC's "National Conversation" on Latino aesthetics (Méndez Berry 2010b, 2–3).

4. Community groups have also directed advocacy to this sector—the work of the New York City Collaborative for Fairness and Equity in Philanthropy (CFEP) being a primary example. Founded in 2008 as a collaborative of nonprofits of color and foundations to represent Asian, black, Latino, and Native American communities, this group has been calling attention to the lack of representation of these communities in the governance and staff of major foundations and how this lack of representation exacerbates the underfunding of minority communities.

NOTES TO CHAPTER 4

1. This is the first video produced before the commission finished its final report: American Latino Museum, "National Museum of the American Latino Commission," YouTube, April 20, 2010, http://www.youtube.com/watch?v=-NBGgn9Hivo. A second and longer video on the project was produced in the summer of 2011 describing the hearing process and summarizing some of the final recommendations of the commission.

2. I discuss the Latina look in Dávila 2001, but readers can find more recent analyses of the whitewashed politics involved in the production of idealized Latina bodies in Clara Rodríguez 1997; Cepeda 2010; and Paredez 2009.

3. See a statement of this position on the museum's website, by Friends of the National Museum of the American Latino: http://americanlatinomuseum.org/about/about.html.

4. I make this point in an op-ed published in 2011 around the debate over the project (Davila 2011). See also readers' online responses, which are especially revealing of the project's hostile reception among readers.

NOTES TO CHAPTER 5

1. As Karen Davalos notes, this universalist orientation takes the European aesthetic as the standard without naming it or placing it in a specific historical context; this unnamed standard, in turn, is imagined without whiteness or masculinity. Personal communication.

2. Prior to "Phantom Sightings," the Los Angeles County Museum of Art had hosted less than a handful of exhibitions featuring Chicano art and artists, none of which was as comprehensive (Govan 2008). This void by a major museum located in one of the most important strongholds of Chicano/a and Mexican American art and culture added to the politicization of the exhibition, underscoring the continued invisibility of Chicano art.

3. On the lack of archival information and general documentation of Latino arts and artists, see R. González 2003.

4. See Y. Ramirez 2005a and 2005b and Dávila 2008. Notably, the literature on Nuyorican art is not emerging from art history, which remains locked in strict Eurocentric traditions, but from interdisciplinary spaces such as American studies. See, for instance, the important work of Wilson Valentín-Escobar (2010).

5. A good discussion of these themes is included in Rivera 2011, especially in the discussion by Pepón Osorio on the divide between community-oriented work and the mainstream world and how he negotiates this boundary.

6. I thank Yasmin Ramirez for pointing this out.

7. See exhibition blog at http://www.brooklynmuseum.org/exhibitions/infinite_ island/highlight.php?a=EL51.87.

8. See, for instance, Valentín-Escobar 2010.

9. Wanda Raimundi-Ortiz, "Ask Chuleta," uploaded on YouTube by JerseyCityMuseum, February 19, 2009, http://www.youtube.com/watch?v=iQ71BM34bQ8&feature =player_embedded.

NOTES TO CHAPTER 6

1. A noted exception is Maria Carman's study of the gentrification of barrio Abasto and the role played by the memorialization of famous tango singer Carlos Gardel (Carman 2006).

2. *Milonguera/o* refers to a female or male dancer who frequents milongas (dance hall venues and events) and generally subscribes to the nightlife, philosophy, and codes of traditional tango dancing. It is associated with the close-embrace style of dancing that respects the most traditional codes of dancing and gendered comportment in the milonga.

3. Locals are recognized easily after some weeks dancing in Buenos Aires. Many occupy the same tables and frequent other milongas. My estimation of tourists is based on my observation, as confirmed by the main waitress at this milonga, a veteran of the milonga circuit who also attends other milongas.

4. See Buenos Aires's study of tango's economic impact on the city for a larger discussion of how concerns of authenticity have led to local cultural and economic initiatives (OIC 2007).

5. Consider, for instance, the new international tango culture and travel magazine *Tango Zapa*, an enthusiastic proponent of tango's globalization and of tango communities as global equalizers.

6. See Raymond 2010 for a discussion of some local concerns over tango's designation as a world heritage.

7. See also Inadi 2006.

8. See, for instance, the website for the annual milonguero symposium and its presentation of Buenos Aires as the cradle of tango and of tango as a universal language available to all: http://www.milongueandoenba.com.

9. The elitisization of the sector was especially evident in the milongas that are most inserted in the tourist circuit and does not represent the totality of Buenos Aires milongas. My observation, however, is that professional middle classes from outside the city, from Mar de Plata, Entre Rios, and Cordoba, also seek out and frequent these tourist milongas, creating a similar elitisization of this sector outside the city's center.

NOTES TO CHAPTER 7

1. See *Argentina Para Armar* television shows aired on April 20, 2009, and April 26, 2010. See also articles in *Clarín* and *La Nación* in which tourism is discussed as a reflection of Buenos Aires's multiple attractions.

2. According to Argentina's National Immigration Office, between 2000 and 2007, over forty-two thousand residency permits were processed for immigrants of "*bien pasar*" (well-heeled), whereas just in 2009, over three thousand residency permits were processed by citizens coming from Spain, Italy, and the United States ("Argentina, Tierra de Inmigrantes VIP" 2010).

3. "Types of Expats," *exnat* (blog), July 1, 2007, http://exnat.wordpress.com/expat-theory/types-of-expats/.

4. Hence the popularity of "couch surfing," among other tourist programs that promote cross-cultural experiences and even the forging of friendships with locals as a major marketing draw.

5. See Freidenberg 2009 for a discussion of some of the different ways in which expats define the term or maneuver through it.

6. Much more can be said about this revealing campaign. For one, it evokes the thought of nineteenth-century nationalist and assimilationist leader Domingo Sarmiento, who promoted inclusion of all marginal sectors of society through enlightened education. The campaign narrative is welcoming to all, but some of the handout literature specifies who it is that is most welcome: those who have ambition to work, who strive for excellence—in sum, those squarely in the path of upward mobility through work and education.

7. The famous Argentinean comedian Antonio Gasalla's spoof of the public employee as a thief is highly evocative of this dominant conception of the public-sector employee. See acusticodani, "Antonio Gasalla y la Empleada Publica," YouTube, April 28, 2008, http://www.youtube.com/watch?v=Xl49AYEJiqE.

8. See, for instance, the local health insurance plan offered by Expat Connection, http://www.expat-connection.com/localins.

9. Mendoza is home to a large community of expats, many of whom have bought farms and wineries and have organized clubs such as the Mendoza Expat Club.

10. The city also has research validating the contributions of culture and the arts to the city's economic development. According to the Observatorio de Industrias Culturales, an entity that studies and measures the city's culture industries, in 2009, this sector grew at a rate of 7 percent, or at a higher rate than the city's overall growth of 5.8 percent. OIC 2009.

11. This was the first event organized by Palermo Valley, the start-up organization mentioned later: "Latin America Meets New York to Talk Start-Ups," July 6, 2011.

12. Beverly Mullings, personal communication.

13. The first episode aired on the cable news channel Todo Noticias on April 20, 2009.

NOTES TO THE CONCLUSION

1. See the collection of key writings by Stuart Hall and his discussion of ideology, articulation, and cultural studies: Morley and Chen 1996.

References

Alcoff, Linda. 2005. *Visible Identities: Race, Gender, and the Self.* New York: Oxford University Press.

Alliance for the Arts. 2007. "The Arts as an Industry: Their Economic Impact on New York City and New York State." http://www.allianceforarts.org/pdfs/ArtsIndustry_2007.pdf.

Alm, James. 2006. "Assessing Puerto Rico's Fiscal Policy." In *Restoring Growth in Puerto Rico: Overview and Policy Options,* edited by Susan Collins, Barry Bosworth and Miguel Soto-Class. Washington, DC: Center for the New Economy and Brookings Institution Press.

Alvarez Curbelo, Silvia. 2005. "Las nuevas murallas: La Walmartización de San Juan de Puerto Rico." In *Ciudades translocales: Espacios, flujo, representación—Perspectivas desde las Américas,* edited by Rossana Reguillo and Marcial Godoy-Anativia, 55–84. Guadalajara, Mexico: ITESO.

Anderson, Benedict. 2006. *Imagined Communities: Reflection on the Origins and Spread of Nationalism.* New York: Verso.

Aoyama, Yuko. 2009. Introduction to "Consumption-Centered Research for Diverse Urban Economies." Special issue of *Urban Geography* 30 (4).

Appadurai, Arjun, ed. 1988. "Introduction: Commodities and the Politics of Value." In *The Social Life of Things: Commodities in Cultural Perspective,* edited by Arjun Appadurai, 3–64. Oxford: Oxford University Press.

———. 1996. *Modernity at Large.* Minneapolis: University of Minnesota Press.

Argañaraz, Nadin. 2010. "Evolución reciente de la distribución de ingreso." *eLeVe,* April 6. http://www.ele-ve.com.ar/Evolucion-reciente-de-la-distribucion-del-ingreso.html.

"Argentina, Tierra de Inmigrantes VIP." 2010. *La Nación,* August 22. http://www.lanacion.com.ar/nota.asp?nota_id=1296839.

Asociación de Ejecutivos de Ventas y Mercadeo de Puerto Rico. 2009. "Perfil de la 'Shopper' Boricua." http://www.smepr.org/index.php?src=events&category=*n&sr ctype=detail&refno=81.

Basch, Linda, Nina Glick Schiller, and Christina Szanton Blanc. 1993. *Nations Unbound: Transnational Projects, Postcolonial Predicaments, and Deterritorialized Nation-States.* New York: Routledge.

Baud, Michael, and Annelou Ypeij. 2009. *Cultural Tourism in Latin America: The Politics of Space and Imagery.* Boston: Brill.

Beaverstock, Jonathan. 2005. "Transnational Elites in the City: British Highly-Skilled Inter-company Transferees in New York City's Financial District." *Journal of Ethnic and Migration Studies* 31 (2): 245–268.

Bleyer, Jennifer. 2010. "Hipsters on Food Stamps." *Salon*. March 15. http://www.salon.com/life/pinched/2010/03/15/hipsters_food_stamps_pinched.

Bourdieu, Pierre. 1993. *The Field of Cultural Production*. New York: Columbia University Press.

———. 1998. "The Essence of Neoliberalism." *Le Monde Diplomatique*, December. http://mondediplo.com/1998/12/08bourdieu.

Brash, Julian. 2010. *Bloomberg's New York: Class and Governance in the Luxury City*. Athens: University of Georgia Press.

Brooklyn Museum. 2007. *Infinite Island*. Exhibition website. http://www.brooklynmuseum.org/exhibitions/infinite_island/highlight.php?a=EL51.87.

Brusi-Gil de Lamadrid, Rima. 2011. "The University of Puerto Rico: A Testing Ground for the Neoliberal State." *NACLA*, March–April.

Brusi-Gil de Lamadrid, Rima, Isar Godreau, Ian A. Bethell Bennett, and Yarimar Bonilla. 2010. "The Political and Social Aftermaths of the 2010 Strike at the University of Puerto Rico." *Caribbean Studies Newsletter* 38 (2): 39–40.

Byrnes, Brian. 2007. "The Capital of Cool." *Newsweek*, January 15. http://www.newsweek.com/2007/01/14/thecapital-of-cool.html.

Cabezas, Amalia. 2009. *Economies of Desire: Sex and Tourism in Cuba and the Dominican Republic*. Philadelphia: Temple University Press.

Caragol, Taina. 2003. "On the Razor's Edge." Exhibition pamphlet for "La carrera, la parada y lo comprado," exhibition at La Puntilla, Old San Juan, November 21–January 12.

Carman, Maria. 2006. *Las trampas de la cultura: Los intrusos y los nuevos usos del barrio de Gardel*. Buenos Aires: Paidos.

Carmona, Alicia. 2008. "*Bailar con fé*: Folkloric Devotional Practice in a Bolivian Immigrant Community." *E-misférica*, April. http://hemi.nyu.edu/journal/5.1/eng/en51_pg_carmona.html.

Carozzi, Maria Julia. 2009. "Una ignorancia sagrada: Aprendiendo a no saber bailar tango en Buenos Aires." *Religiao e Sociedade* 29 (1): 126–145.

Castillo, Amaris. 2010. "His Art's Reach Stretches beyond a Gallery." *Brooklyn Ink*, November 26. http://thebrooklynink.com/2010/11/26/19811-art-in-a-non-traditional-sense.

Centeno, Miguel Angel, and Alejandro Portes. 2006. "The Informal Economy in the Shadow of the State." In *Out of the Shadows: Political Action and Informal Economy in Latin America*, edited by Patria Fernández-Kelly and Jon Shefner, 23–48. University Park: Pennsylvania State University Press.

Cepeda, Maria Elena. 2010. *Musical ImagiNation: U.S.-Colombian Identity and the Latin Music Boom*. New York: NYU Press.

Chavez, Leo. 2008. *Latino Threat: Constructing Immigrants, Citizens, and the Nation*. Stanford: Stanford University Press.

Chen, Patrizia. 2009. *It Takes Two: A Novel*. New York: Scribner.

Chin, Elizabeth. 2001. *Purchasing Power: Black Kids and American Consumer Culture*. Minneapolis: University of Minnesota Press.

Ciccolella, Pablo. 1999. "Globalización y dualización en la Región Metropolitana de Buenos Aires: Grandes inversiones y restructuración socioterritorial en los años noventa." *Revista Eure* 24 (76): 5–27.

Cohen, Lizabeth. 2003. *A Consumers' Republic: The Politics of Mass Consumption in Postwar America*. New York: Knopf.

Colominas, Norberto. 2010. "La Argentina ya no es Grecia." *El Argentino*, May 30, 3.

Colón, Alice, Maria Maite Mulero, Luis Santiago and Nilsa Burgos. 2008. *Estirando el peso: Acciones de ajuste y relaciones de género ante el cierre de fábricas en Puerto Rico*. San Juan: Universidad de Puerto Rico, Centro de Investigaciones Sociales.

Comaroff, John, and Jean Comaroff, eds. 2001 *Millennial Capitalism and the Culture of Neoliberalism*. Durham: Duke University Press.

———. 2009. *Ethnicity, Inc*. Chicago: University of Chicago Press.

Compañia de Comercio y Exportación de Puerto Rico. 2008. *Inventario de centros comerciales*. Revised on May 25. División de Investigación de Mercados y Economia. Puerto Rico: Estado Libre Asociado.

Coombe, Rosemary. 1988. *The Cultural Life of Intellectual Properties: Authorship, Appropriation, and the Law*. Durham: Duke University Press.

Cotter, Holland. 2003. "Art in Review: The S Files—the Selected Files 2002." *New York Times*, January 17.

———. 2005. "Latino Art, and Beyond Category." *New York Times*, September 2. http://www.nytimes.com/2005/09/02/arts/design/02cott. html?emc=eta1&pagewanted=print.

———. 2007. "Infinite Island: Contemporary Caribbean Art." *New York Times*, August 31.

———. 2011. "Artists Whose Vitality Flows form the Street." Art review of "(S) Files." *New York Times*, June 16. http://www.nytimes.com/2011/06/17/arts/design/el-museos-bienal-the-s-files-2011-review.html?_r=2&ref=arts.

Cousins, Lucy. 2008. "Moving to Buenos Aires." In *Lonely Planet Buenos Aires: City Guide*, 226. Oakland, CA: Lonely Planet.

Cresswell, Tim. 2006. *On the Move: Mobility in the Modern Western World*. New York: Routledge.

Cronin, Anne, and Kevin Hetherington. 2008. *Consuming the Entrepreneurial City: Image, Memory, Spectacle*. London: Routledge.

Cross, John. 1998. *Informal Politics: Street Vendors and the State in Mexico City*. Stanford: Stanford University Press.

Currid, Elizabeth. 2007. *The Warhol Economy: How Fashion, Art, and Music Drive New York City*. Princeton: Princeton University Press.

Davalos, Karen. 2001. *Exhibiting Mestizaje: Mexican (American) Museums in the Diaspora*. Albuquerque: University of New Mexico Press.

———. 2011. "The Art of Place: The Work of Diane Gamboa." In *Performing the U.S. Latino Borderlands*, edited by Arturo Aldama, Peter Garcia, and Chela Sandoval. Bloomington: Indiana University Press.

Dávila, Arlene. 1997. *Sponsored Identities: Cultural Politics in Puerto Rico*. Philadelphia: Temple University Press.

———. 1999. "Crafting Culture: Selling and Contesting Authenticity in Puerto Rico's Informal Economy." *Studies in Latin American Popular Culture* 18:159–170. Reprinted in *Critical Cultural Policy Studies: A Reader*, edited by Justin Lewis and Toby Miller. Malden, MA: Wiley-Blackwell, 2002.

———. 2001. *Latinos Inc.: Marketing and the Making of a People*. Berkeley: University of California Press.

———. 2004. *Barrio Dreams: Puerto Ricans, Latinos and the Neoliberal City*. Berkeley: University of California Press.

———. 2008. "From Barrio to Mainstream: On the Politics of Latino/a Art Museums." In *Latino Spin: Public Image and the Whitewashing of Race*. New York: NYU Press.

———. 2011. "A Fix for Ignorance and Exclusion." Room for Debate. *New York Times*, April 27. http://www.nytimes.com/roomfordebate/2011/04/26/should-we-have-a-national-latino-museum/a-fix-for-ignorance-and-exclusion.

Dávila Santiago, Ruben. 2005. *El mall: Del mundo al paraiso*. San Juan, PR: Ediciones Callejo.

Davis, Steven, and Luis Rivera-Batíz. 2006. "The Climate for Business Development and Employment Growth." In *Restoring Growth in Puerto Rico: Overview and Policy Options*, edited by Susan Collins, Barry Bosworth, and Miguel Soto-Class. Washington, DC: Center for the New Economy and Brookings Institution Press.

Dee, Joana. 2005. "Tango New York." Undergraduate thesis, Barnard Dance Department.

DeHart, Monica. 2010. *Ethnic Entrepreneurs: Identity and Development Politics in Latin America*. Stanford: Stanford University Press.

De La Sota, Candelaria. 2010. "Las divisas del comercio exterior financian la fuga." *Clarín*. May 6.

Developers Diversified Realty. 2011. "Investor Relations." http://ir.ddr.com/index.cfm.

Díaz, Marian. 2009. "Medicina peor que la enfermedad, economistas advierten propuestas del CAREF empeorarán la recesión." *El Nuevo Dia*, January 14, 30–31.

DiMaggio, Paul, and Patria Fernández-Kelly. 2010. *Art in the Lives of Immigrant Communities in the United States*. New Brunswick: Rutgers University Press.

DiMaggio, Paul, and Michael Useem. 1978. "Social Class and Arts Consumption." *Theory and Society* 5 (2): 141–161.

Dimas, Marcos. 1990. "Taller Alma Boricua: Reflecting on Twenty Years of the Puerto Rican Workshop." Exhibition catalogue. El Museo del Barrio, September 15–April 15.

Dougherty, Conor. 2007. "Puerto Rico's Economic Slump Weighs Hard on Consumers." *Wall Street Journal*, August 14, A6.

Duany, Jorge. 2008. *A Transnational Migrant Crossroads: The Circulation of People and Money in Puerto Rico*. San Juan, PR: Center for the New Economy.

Duggan, Lisa. 2004. *The Twilight of Equality: Neoliberalism, Cultural Politics, and the Attack on Democracy*. Boston: Beacon.

"El país, entre los que mejor enfrentaron la crisis." 2010. *El Argentino*, June 7, 6.

Enchautegui, Maria. 2008. *Por debajo de la mesa: Una mirada a los trabajadores informales de Puerto Rico*. San Juan, PR: Center for the New Economy.

Enchautegui, Maria, and Richard Freeman. 2006. "Why Don't More Puerto Rican Men Work? The Rich Uncle (Sam) Hypothesis." In *Restoring Growth in Puerto Rico: Overview and Policy Options*, edited by Susan Collins, Barry Bosworth and Miguel Soto-Class. Washington, DC: Center for the New Economy and Brookings Institution Press.

"Equity in Cultural Funding." 2008. *El Diario/La Prensa*, May 20, 22.

Ertman, Martha, and Joan Williams, eds. 2005. *Rethinking Commodification: Cases and Readings in Law and Culture*. New York: NYU Press.

Fernandes, Sujatha. 2010. *Who Can Stop the Drums? Urban Social Movements in Chávez's Venezuela*. Durham: Duke University Press.

Fernández-Kelly, Patricia. 2006. Introduction to *Out of the Shadows: Political Action and Informal Economy in Latin America*, edited by Patricia Fernández-Kelly and Jon Shefner, 1–22. University Park: Pennsylvania State University Press.

Ferro, Silvia Lilian. 2010. "Los dueños de la tierra." *Página 12*, June 6, 7.

Florida, Richard. 2002. *The Rise of the Creative Class: And How It's Transforming Work, Leisure, Community and Everyday Life*. New York: Basic Books.

Freeman, Carla. 2000. *High Tech and High Heels in the Global Economy: Women, Work, and Pink-Collar Identities in the Caribbean*. Durham: Duke University Press.

———. 2001. "Is Local: Global as Feminine: Masculine? Rethinking the Gender of Globalization." *Signs* 26 (4): 1007–1037.

Freidenberg, Judith. 2009. "Understanding the U.S. as a Foreign Country: The Life Course of Expatriate Populations." Paper presented at the annual meeting of the American Anthropological Association, December 3.

Frye Burnham, Linda. 2008. "Community Arts 2008: The Year of the Great Leap." Community Arts Network.

Fusco, Coco. 1995. *English Is Broken Here: Notes on Cultural Fusion in the Americas*. New York: New Press.

Gallego, Mariano. 2008. "Tango, nación e identidad." In *Emergencias: Cultura, música y politica*, edited by Mariano Ugarte, 75–85. Buenos Aires: Centro Cultural de la Cooperación.

Garcia Canclini, Nestor. 1993. *Transforming Modernity: Popular Culture in Mexico*. Austin: University of Texas Press.

———. 2005. "Todos Tienen Cultura: Quiénes Pueden Desarrollarla?" Presentation for the Seminar on Culture and Development at the Interamerican Bank, Washington, DC, February 24.

Garramuño, Florencia. 2004 "Primitivist Iconographies: Tango and Samba, Images of the Nation." In *Images of Power: Iconography, Culture, and the State in Latin America*, edited by Jens Anderman and William Rowe, 127–144. London: Berghahn Books.

Giarracca, Norma. 2007. "Tragedy of Development: Disputes over Natural Resources in Argentina." *Sociedad* (Buenos Aires) 3:1–14.

Gigante, Lucienne. 2000. "Meet Me at the Movies." *Caribbean Business*, March 1. http://puertorico-herald.org/issues/vol4n10/CBMovies-en.html.

"Goings On about Town." 2007. "Jack Hallberg/Miguel Luciano." *New Yorker*, January 8.

González, Francis Xavier, and Martha Hermilla. 2008. "Bienvenidos a la tercera edición de Isla Estilo." *Isla Estilo*, December 8, 2.

González, Juan. 2001. *Harvest of Empire: A History of Latinos in America*. New York: Penguin.

González, Rita. 2003. "Archiving the Latino Arts before It's Too Late." UCLA Chicano Studies Research Center. http://www.chicano.ucla.edu/press/siteart/LPIB_06April2003.pdf.

Goss, Jon. 1993. "The 'Magic of the Mall': An Analysis of Form, Function, and Meaning in the Contemporary Retail Built Environment." *Annals of the Association of American Geographers* 83 (1): 18–47.

Govan, Michael. 2008. Foreword to *Phantom Sightings*. Exhibition catalogue. Los Angeles County Museum of Art. 11.

Greenberg, Miriam. 2008. *Branding New York: How a City in Crisis Was Sold to the World*. New York: Routledge.

Gregory, Steve. 2007. *The Devil behind the Mirror: Globalization and Politics in the Dominican Republic*. Berkeley: University of California Press.

Grimes, Kimberly M., and B. Lynne Milgram. 2000. *Artisans and Cooperatives: Developing Alternate Trade for the Global Economy*. Tucson: University of Arizona Press.

Grimson, Alejandro. 2005. "Fronteras, neoliberalismo y protestas en Buenos Aires." In *Ciudades translocales: Espacios, flujo, representación—Perspectivas desde las Américas*, edited by Rossana Reguillo and Marcial Godoy-Anativia, 237–254. Guadalajara, Mexico: ITESO.

Grimson, Alejandro, M. Cecilia Ferraudi Curto, and Ramiro Segura. 2009. *La vida política en los barrios populares de Buenos Aires*. Buenos Aires: Prometeo.

Grimson, Alejandro, and Gabriel Kessler. 2005. *On Argentina and the Southern Cone: Neoliberalism and National Imaginations*. New York: Routledge.

Grosfoguel, Ramón. 2003. *Colonial Subjects: Puerto Ricans in a Global Perspective*. Berkeley: University of California Press.

Guano, Emanuela. 2002. "Spectacles of Modernity: Transnational Imagination and Local Hegemonies in Neoliberal Buenos Aires." *Cultural Anthropology* 17 (2): 181–209.

Hale, Charles R. 2006. *Más Que un Indio: Racial Ambivalence and Neoliberal Multiculturalism in Guatemala*. Santa Fe, NM: School of American Research Press.

Halter, Marilyn. 2002. *Shopping for Identity: The Marketing of Ethnicity*. New York: Schocken Books.

Handler, Richard. 1988. *Nationalism and the Politics of Culture in Quebec*. Madison: University of Wisconsin Press.

Hannerz, Ulf. 1996. *Transnational Connections: Culture, People, Places*. London: Routledge.

Harvey, David. 2007. "Neoliberalism as Creative Destruction." *Annals of the American Academy of Political and Social Science* 610 (March): 21–44.

Hines, Barbara. 2010. "The Right to Migrate as a Human Right: The Current Argentine Immigration Law." *Cornell International Law Journal* 43:471–511.

Holo, Selma, and Mari-Tere Alvarez. 2009. *Beyond the Turnstile: Making the Case for Museums and Sustainable Values*. Lanham, MD: AltaMira.

Homero Villa, Raul. 2000. *Barrio-Logos: Space and Place in Urban Chicano Literature and Culture*. Austin: University of Texas Press.

Hutter, Michael, and David Throsby, ed. 2007. *Beyond Price: Value in Culture, Economics, and the Arts*. New York: Cambridge University Press.

Inadi (Instituto Nacional contra la Discriminación, la Xenofobia y el Racismo). 2006. "Mapa de la discriminación." http://www.inadi.gov.ar/inadiweb/index.php ?view=article&catid=43:catinvestigacion&id =148:investigacion-&option=com_content&Itemid=22.

Irazábal, Clara. 2011. "Ethnoscapes." In *Companion to Urban Design*, edited by Tridib Banerjee and Anastasia Loukaitou-Sideris, 562–573. New York: Routledge.

Itzigsohn, José. 2006. "Neoliberalism, Markets, and Informal Grassroots Economies." In *Out of the Shadows: Political Action and Informal Economy in Latin America*, edited by Patricia Fernández-Kelly and Jon Shefner, 81–96. University Park: Pennsylvania State University Press.

Jackson, Maria Rosario. 2008. "Toward Diversity That Works: Building Communities through Arts and Culture." In *Twenty-First-Century Color Lines: Multiracial Change in Contemporary America*, edited by Andrew Grant-Thomas and Gary Orfield, 220–234. Philadelphia: Temple University Press.

———. 2009. "Shifting Expectations: An Urban Planner's Reflections on Evaluation of Community-Based Arts." Animating Democracy: A Program of Americans for the Arts. http://www.americansforthearts.org/animatingdemocracy/pdf/reading_room/shifting_expectations.pdf.

Jonaitis, Aldona, and Janet Catherine Berlo. 2008. "'Indian Country' on the National Mall: The Mainstream Press versus the National Museum of the American Indian." In *The National Museum of the American Indian: Critical Conversations*, edited by Amy Lonetree and Amanda J. Cobb, 208–240. Lincoln: University of Nebraska Press.

Judd, Dennis, and Susan Fainstein. 1999. *The Tourist City*. New Haven: Yale University Press.

Karp, Ivan, and Steven Lavine, eds. 1991. *Exhibiting Cultures: The Poetics and Politics of Museum Display*. Washington, DC: Smithsonian Institution Press.

Kennicott, Philip. 2010. "How Can the American Latino Museum Best Answer the Call of the Mall?" *Washington Post*, July 25, E6.

Kessler, Richard. 2009. *Testimony of Richard Kessler from the Center for Arts Education to the Joint Meeting of the Committees*. New York State Senate Committee on Cultural Affairs, Tourism, Parks, and Recreation and Assembly Committee on Tourism, Arts, and Sports Development. Albany, February 3.

Lacarrieu, Monica. 2008. "Tensiones entre los procesos de recualificación cultural urbana y la gestión de la diversidad cultural." *Revista de la Biblioteca Nacional* 7 (Spring): 242–253.

Lawson, Celeste M. 2009. *Testimony of Celeste M. Lawson, Executive Director of the Arts Council in Buffalo & Erie County to the Joint Meeting of the Committees*. New York State Senate Committee on Cultural Affairs, Tourism, Parks, and Recreation and Assembly Committee on Tourism, Arts, and Sports Development. Albany, February 3.

LeBrón, Marisol. 2010. "Mano Dura: Policing, Capital and Social Transformation in Contemporary Puerto Rico." Ph.D. diss. proposal, American Studies, New York University.

Lee, Denny. 2008. "Argentine Nights." *New York Times*, March 16.

Lee, Felicia. 2008. "Looking for Equity in Arts Financing." *New York Times*, July 24.

Lewis, Justin, and Toby Miller, eds. 2002. *Critical Cultural Policy Reader*. Malden, MA: Wiley-Blackwell.

Liechty, Mark. 2002. *Suitably Modern: Making Middle-Class Culture in a New Consumer Society*. Princeton: Princeton University Press.

Londoño, Johana. 2011. "An Aesthetic Belonging: The Latinization of Space, Urban Design, and the Limits of Representation." Ph.D. diss., New York University.

Lonely Planet Buenos Aires: City Guide. 2008. Oakland, CA: Lonely Planet.

Lonetree, Amy, and Amanda J. Cobb, eds. 2008. *The National Museum of the American Indian: Critical Conversations.* Lincoln: University of Nebraska Press.

López, Maria Milagros. 1994. "Post-work Selves and Entitlement 'Attitudes' in Peripheral Postindustrial Puerto Rico." *Social Text* 38:111–133.

Madison, Greg. 2009. *The End of Belonging: Untold Stories of Leaving Home and the Psychology of Global Relocation.* CreateSpace.

Mandell, Jonathan. 2005. "Arts Funding 101." *Gotham Gazette*, July. http://www.gothamgazette.com/article/arts/20050719/1/1485.

———. 2007. "Arts Funding, Transformed." *Gotham Gazette*, January. http://www.gothamgazette.com/article/arts/20070131/1/2091.

Marcus, George, and Fred Myers. 1995. *The Traffic in Culture: Refiguring Art and Anthropology.* Berkeley: University of California Press.

Markussen, Ann. 2009. "The Economics of Arts, Artists, and Culture: Making a Better Case." *GIA Reader* (Grantmakers in the Arts) 20 (3): 18–20.

Martínez, Conrado. 2009. "La próxima víctima de la hiper-regulación económica: La medicina prepaga." Bureau de Salud, August 7. http://bureaudesalud.com/v2/la-proxima-victima-de-la-hiper-regulacion-economica-la-medicina-prepaga.

Massey, Doreen. 1994. *Space, Place, and Gender.* Minneapolis: University of Minnesota Press.

Maxwell, Richard, ed. 2001. *Culture Works: The Political Economy of Culture.* Minneapolis: University of Minnesota Press.

McCarthy, Ellen. 2010. "Online Dating Assistants Help the Lonely and Busy." *Washington Post*, June 1. http://www.washingtonpost.com/wp-dyn/content/article/2010/05/31/AR2010053103127.html.

McClure, Tammy. 2010. "Buenos Aires: Birth of a Phenomenon." *Tango Zapa* 1 (1): 20–27.

McGuigan, Jim. 2010. "Creative Labor, Cultural Work and Individualisation." *International Journal of Cultural Policy* 16 (3): 323–335.

Méndez Berry, Elizabeth. 2010a. "National Conversation #2: Organizations." Report by the National Association of Latino Arts and Culture. http://www.nalac.org/images/eboletin/2010/organizations.pdf.

———. 2010b. "National Conversation #3: Aesthetics." Report by the National Association of Latino Arts and Culture. http://www.nalac.org/images/eboletin/2010/aesthetics.pdf.

Miller, Daniel. 1995. *Acknowledging Consumption: A Review of New Studies.* London: Routledge.

———. 1998. *A Theory of Shopping.* Ithaca: Cornell University Press.

Miller, Toby, Nitin Govil, John McMurria, Ting Wang, and Richard Maxwell. 2008. *Global Hollywood 2.* London: British Film Institute.

Morel, Hernán. 2009. "El giro patrimonial del tango: Políticas oficiales, turismo y campeonatos de baile en la Ciudad de Buenos Aires." *Cuadernos de Antropología Social* 30:155–172.

Moreno Vega, Marta, and Cheryll Greene. 1993. *Voices from the Battlefront: Achieving Cultural Equity.* Trenton, NJ: Africa World Press.

Morley, David, and Kuan-Hsing Chen, eds. 1996. *Stuart Hall: Critical Dialogues in Cultural Studies.* London: Routledge.

Morrissey, Marietta. 2006. "The Making of a Colonial Welfare State." *Latin American Perspectives* 33 (1): 23–41.

Muriente-Pastrana, Aurora. 2008. "Sorprendido el pueblo." *Primera Hora*, January 10, 7.

NALAC (National Association of Latino Arts and Culture). 2009. "NALAC 2009–2010 Organization and Artist Economic Survey Analysis." http://www.nalac.org/pdfs/NALAC_Economic_Survey.pdf.

Nash, June. 1993. *Crafts in the World Market: The Impact of Global Exchange on Middle American Artisan.* Albany: SUNY Press.

———. 2000. "Postscript: To Market, to Market." In *Artisans and Cooperatives: Developing Alternate Trade for the Global Economy*, edited by Kimberly M. Grimes and B. Lynne Milgram, 175–180. Tucson: University of Arizona Press.

National Endowment for the Arts. 2007. "How the United States Funds the Arts." http://www.arts.gov/pub/how.pdf.

New York Foundation for the Arts. 2001. "Culture Counts: Strategies for a More Vibrant Cultural Life for New York City." http://www.nyfa.org/level5.asp?id=55&fid=5&sid=9&tid=22&foid=8.

Noriega, Chon. 1999. "On Museum Row: Aesthetics and the Politics of Exhibition." *Daedalus* 128:57–82.

Nouzeilles, Gabriela, and Graciela Montaldo. 2002. "General Introduction." In *The Argentina Reader: History, Culture, and Politics*, edited by Gabriela Nouzeilles and Graciela Montaldo, 1–14. Durham: Duke University Press.

Novitz, Deby. 2010. "The Secret Society." *TangoSpam* (blog), June 6. http://tango-spam.typepad.com/tangospam_la_vida_con_deb/2010/06/the-secret-society.html.

O'Dougherty, Maureen. 2002. *Consumption Intensified: The Politics of Middle-Class Daily Life in Brazil.* Durham: Duke University Press.

———. 2006. "Public Relations, Private Security: Managing Youth and Race at the Mall of America." *Society and Space* 24 (1): 131–154.

OIC (Observatorio de Industrias Culturales de la Ciudad de Buenos Aires). 2007. "Tango en la economía de la ciudad de Buenos Aires." Subsecretaría de Industrias Culturales, Ministerio de Producción, Buenos Aires.

———. 2009. "Anuario 2009: Industrias creativas de la Ciudad de Buneos Aires." http://oic.mdebuenosaires.gov.ar/contenido/objetos/AnuarioOIC2009.pdf.

Ong, Aihwa. 1999. *Flexible Citizenship: The Cultural Logics of Transnationality.* Durham: Duke University Press.

———. 2006. *Neoliberalism as Exception: Mutations in Citizenship and Sovereignty.* Durham: Duke University Press.

Ortíz, Laura. 1992. *Al filo de la navaja: Los márgenes en Puerto Rico.* Rio Piedras, PR: Centro de Investigaciones Sociales.

Ortíz-Negrón, Laura. 2007. "Space out of Place: Consumer Culture in Puerto Rico." In *None of the Above: Puerto Ricans in a Global Perspective*, edited by Frances Negrón Muntaner. New York: Palgrave.

Ortíz-Negrón, Laura, and Carlos Guilbe López. 2005. *Arcadas de las estaciones, 20–21: Visiones sobre los centros comerciales en Puerto Rico.* Video. San Juan: University of Puerto Rico, Centro de Investigaciones Sociales.

Oszlak, Oscar. 1991. "Merecer la ciudad: Los pobres y el derecho al espacio urbano." Colección CEDES-HUMANITAS, Estudios CEDES.

Palmer, Marina. 2006. *Kiss and Tango: Diary of a Dancehall Seductress*. New York: Harper.

Paredez, Deborah. 2009. *Selenidad: Selena, Latinos, and the Performance of Memory*. Durham: Duke University Press.

Parra-Blessing, Gabriel. 2007. "Resistance Is Futile." *Caribbean Business*, March 8.

Paz, Luis. 2007. "Desalojo porteño for export." *Página 12*, January 7.

Peck, Jamie. 2005. "Struggling with the Creative Class." *International Journal of Urban and Regional Research* 29 (4): 740–770.

Peck, Jamie, Nik Theodore, and Neil Brenner. 2010. "Postneoliberalism and Its Malcontents." *Antipode* 41:94–116.

Pérez, Gina. 2010. "Hispanic Values, Military Values: Gender, Culture, and the Militarization of Latina/o Youth." In *Beyond El Barrio: Everyday Life in Latino/a America*, edited by Gina M. Pérez, Frank A. Guridy, and Adrian Burgos, Jr., 168–186. New York: NYU Press.

"Pese a que está prohibido, siguen cobrándoles de más a los turistas." 2008. *Clarín*, September 28. http://edant.clarin.com/diario/2008/09/28/um/m-01770020.htm.

Pierce Erikson, Patricia. 2008. "The National Museum of the American Indian and the Politics of Knowledge-Making in a National Space." In *The National Museum of the American Indian: Critical Conversations*, edited by Amy Lonetree and Amanda J. Cobb, 43–83. Lincoln: University of Nebraska Press.

Pittz, Will, and Rinku Sen. 2004. "Short Changed: Foundation Giving and Communities of Color." Oakland, CA: Applied Research Center.

Poder Ciudadano. 2007. "Accesso al Documento Nacional de Identidad y derechos básicos en la Ciudad Autónoma de Buenos Aires y Provincia de Buenos Aires." http://www.poderciudadano.org.ar/up_downloads/temas/96_1.pdf?PHPSESSID=c bfa3d9c5df6c33475ce79ea69816bc6.

Politi, Daniel. 2009. "Buenos Aires: A City's Power and Promise." *Smithsonian Magazine*, June.

Portes, Alejandro, Manuel Castells, and Lauren Benton. 1989. *The Informal Economy: Studies in Advanced and Less Developed Countries*. Baltimore: John Hopkins University Press.

Prevot Schapira, Marie-France. 2002. "Buenos Aires en los años '90: Metropolización y desigualdades." *Revista Eure* 28 (85): 31–50.

Ragsdale, Diane. 2009. Interview with David Throsby and review of *Beyond Price: Value in Culture, Economics, and the Arts*. *GIA Reader* (Grantmakers in the Arts) 20 (3).

Ramírez, Mari Carmen. 1992. "Beyond 'The Fantastic': Framing Identity in U.S. Exhibitions of Latin American Art." *Art Journal* 51 (4): 60–68.

Ramirez, Yasmin. 2005a. "Nuyorican Vanguards: Political Actions/Poetics Visions: A History of Puerto Rican Artists in New York, 1964–1984." Ph.D. diss., Graduate Center, City University of New York.

———. 2005b. "Nuyorican Visionary: Jorge Soto and the Evolution of an Afro-Taino Aesthetic at Taller Boricua." *Centro: Journal of the Center for Puerto Rican Studies* 18 (2): 22–41.

———. 2010. "The Creative Class of Color in New York." *GIA Reader* (Grantmakers in the Arts) 20 (3): 34–36.

Ramos, Carmen. 2010. "Smithsonian American Art Museum Collection of Latino Art." Presentation at Latino Art Now. Los Angeles, November 11–14.

Raymond, Oksana. 2010. "Tango as a World Heritage." *Tango Zapa* 1 (1): 95–96.

Reguillo, Rossana, and Marcial Godoy-Anativia, eds. 2005. *Ciudades translocales: Espacio, flujo, representación—Perspectivas desde las Américas.* Guadalajara, Mexico: ITESO.

Reich, Robert. 1992. *The Work of Nations: Preparing Ourselves for 21st Century Capitalism.* New York: Vintage.

———. 2007. "Is Harvard Really a Charity?" *Los Angeles Times*, October 1.

Rivera, Raquel. 2011. "Latino/a Imaginary: El Angulo Boricua." *80 Grados*, March 4. http://www.80grados.net/2011/03/latinoa-imaginary-el-angulo-boricua.

Rivera, Raquel, Wayne Marshall, and Deborah Pacini Hárnandez, eds. 2009. *Reggaeton.* Durham: Duke University Press.

Rivera-Galindo, Carlos, and Jose I. Alameda. 2002. "La quiebra de los detallistas locales frente a revolución global del comercio al detal: El caso de Puerto Rico." Congreso empresarial PYMES del desarollo empresarial. Universidad Interamericana de Puerto Rico. March 12.

Rodríguez, Carlos. 2009. "La guerra de los desalojos silenciosos." *Página 12*, May 4. http://www.Página12.com.ar/diario/elpais/1-124317-2009-05-04.html.

Rodríguez, Clara. 1997. *Latin Looks: Images of Latinas and Latinos in the U.S. Media.* Boulder, CO: Westview.

Roediger, David. 1999. *The Wages of Whiteness: Race and the Making of the American Working Class.* New York: Verso.

Roman-Velázquez, Patria. 2008. "Contesting the Night as a Space for Consumption in Old San Juan, Puerto Rico." In *Consuming the Entrepreneurial City*, edited by Ann Cronin and Kevin Hetherington, 201–220. New York: Routledge.

Rosa, Taina. 2006. "DDR Not Scared of Economic Woes in Puerto Rico." *Caribbean Business* 34 (24): 40.

Ross, Andrew. 2009. *Nice Work If You Can Get It: Life and Labor in Precarious Times.* New York: NYU Press.

Ryan, Frances. 2009. "Dismal Roller-Coaster Ride in Retail Shows Glimmers of Hope for Future." *Caribbean Business* 37 (1).

Ryan, Frances, and Jose Carmona. 2007. "Birth of a New Investment Era." *Caribbean Business* 35 (34): 1, 20–24.

Sassen, Saskia. 1999. *Globalization and Its Discontents: Essays on the New Mobility of People and Money.* New York: New Press.

Savigliano, Marta E. 1995. *Tango and the Political Economy of Passion.* Boulder, CO: Westview.

Scott, James. 1992. *Domination and the Arts of Resistance: Hidden Transcripts.* New Haven: Yale University Press.

Segal, David. 2009. "Our Love Affair with Shopping Malls Is on the Rocks." *New York Times*, January 9.

Seiler, Cotten. 2008. *Republic of Drivers: A Cultural History of Automobility in America.* Chicago: University of Chicago Press.

Shaked, Nizan. 2008. *"Phantom Sightings*: Art after the Chicano Movement." *American Quarterly* 60 (4): 1057.

Shever, Elana. 2008. "Neoliberal Associations: Property, Company, and Family in the Argentine Oil Fields." *American Ethnologist* 35 (4): 701–716.

Shoer Roth, Daniel. 2010. "Museo Latino: Un derecho ganado." *El Nuevo Herald*, February 28.

SInCA (Sistema de Información Cultural de la Argentina). 2010. "Presupuesto destinado a la cultura, 2001–2007." http://sinca.cultura.gov.ar/sic/gestion/presupuesto/index.php.

Smithsonian Institution. 1994. "Willful Neglect: The Smithsonian Institution and U.S. Latinos." Report of the Smithsonian Institution Task Force on Latino Issues. Washington, DC.

———. 2009. National Museum of African American History and Culture. "Overview History of the Museum." http://nmaahc.si.edu/attachments/1227/nmaahc_milestones_and_benchmarks_2009.pdf.

Stolberg, Sheryl Gay. 2010. "Mr. Broadway Storms Capitol Hill." *New York Times*, April 7.

Svampa, Maristella. 2005. *La sociedad excluyente: La Argentina bajo el signo del neoliberalismo*. Buenos Aires: Taurus.

———. 2008. "The End of Kirchnerism." *New Left Review* 53:79–95.

Svampa, Maristella, and Mirta Antonelli, eds. 2005. *Minería transnacional narrativas del desarrollo y resistencias sociales*. Buenos Aires: Editorial Bilbao.

Taylor, Julie. 1998. *Paper Tangos*. Durham: Duke University Press.

Taylor, Kate. 2010. "Blue Skies and Blue-Chip Sales at Art Basel Miami." *New York Times*, December 4. http://www.nytimes.com/2010/12/04/arts/design/04artbasel.html.

———. 2011. "The Thorny Path to a National Black Museum." *New York Times*, January 23.

Thompson, Krista. 2009. "The Sound of Light: Reflections on Art History in the Visual Culture of Hip Hop." *Art Bulletin*, December, 481–505.

Thompson, Robert Farris. 2005. *Tango: The Art History of Love*. New York: Pantheon.

"Trouble on Welfare Island." 2006. *Economist*, May 27.

Tu, Thuy Linh Nguyen. 2011. *The Beautiful Generation: Asian Americans and the Cultural Economy of Fashion*. Durham: Duke University Press.

Uchitelle, Louis. 2010. "American Dream Is Elusive for New Generation." *New York Times*, July 6. http://www.nytimes.com/2010/07/07/business/economy/07generation.html?_r=1&hp.

Ulysse, Gina. 2007. *Downtown Ladies: Informal Commercial Importers, a Haitian Anthropologist, and Self-Making in Jamaica*. Chicago: University of Chicago Press.

Underhill, Paco. 2005. *Call of the Mall: The Geography of Shopping*. New York: Simon and Schuster.

Valentín-Escobar, Wilson. 2010. "Bodega Surrealism and the Emergence of Latin@ Artivists in New York City, 1976–Present." Ph.D. diss., University of Michigan.

Vanketash, Sudhir Alladi. 2006. *Off the Books: The Underground Economy of the Urban Poor*. Cambridge: Harvard University Press.

Vargas, Miriam. 1991 *Artesanos y artesanias en el Puerto Rico de hoy*. San Juan: Centro de Estudios Avanzados.

Veblen, Thorstein. 1994. *The Theory of the Leisure Class*. New York: Penguin Books.

Veiga, Gustavo. 2009. "La patota del desalojo." *Página 12*, March 8. http://www.
Página12.com.ar/diario/elpais/1-121178-2009-03-08.html.

Velthius, Olav. 2005. *Talking Prices: Symbolic Meaning of Prices on the Market for Contemporary Art*. Princeton: Princeton University Press.

Viladrich, Anahí. 2005. "Tango Immigrants in New York City: The Value of Social Reciprocities." *Journal of Contemporary Ethnography* 34 (5): 533–559.

Whyte, Murray. 2009. "Why Richard Florida's Honeymoon Is Over." *Toronto Star*, June 27. http://www.thestar.com/article/656837.

Wilson, Ara. 2002. *The Intimate Economies of Bangkok: Tomboys, Tycoons, and Avon Ladies in the Global City*. Durham: Duke University Press.

Ybarra-Frausto, Tomas. 1991. "The Chicano Movement/The Movement of Chicano Art." In *Exhibiting Cultures: The Poetics and Politics of Museum Display*, edited by Ivan Karp and Steven Lavine. Washington, DC: Smithsonian Books.

Yúdice, George. 2003. *The Expediency of Culture: The Uses of Culture in the Global Era*. Durham: Duke University Press.

Zelizer, Viviana. 2007. *The Purchase of Intimacy*. Princeton: Princeton University Press.

Zukin, Sharon. 1993. *Landscapes of Power: From Detroit to Disney*. Berkeley: University of California Press.

———. 2004a. "Consumers and Consumption." *Annual Review of Sociology* 30:173–197.

———. 2004b. *Point of Purchase: How Shopping Changed American Culture*. New York: Routledge.

———. 2010. *Naked City: The Death and Life of Authentic Urban Places*. New York: Oxford University Press.

Index

Numbers in italics refer to illustrations.

and Latino culture, 114, 116–117, 134; community-involvement focus, 115, 127; consumer culture, disenchantments of, 117–118; *Coqui Kiddie Ride,* 127; *Cracker Juan,* 117, *118*; critical reception, 123, 127–129; CUE Art Foundation, 121, 128; evaluation of, 7; exhibition settings, 128; hip hop motifs, 124; Hot Wheels, 115–116, *117*; "Infinite Island" exhibit (2007), 119, 128; "Kréyol Factory" exhibit (2009), 119; *La Mano Poderosa Racetrack,* 115–116, *117*, 124; Latinos' right to public space, 125–127; *Learning to Love (Latinos),* 126–127; Maccarone Gallery, 126; *Manga-Manga,* 121, 128; in Miami, 115, 116; Newark Museum, 127; Nuyorican tradition, 130–131, 134; *Pimp My Piragua,* 119, 124–125, *126*, 127, 128; *Plátano Pride,* 119–120, 121, *122*, 128; postidentity positions in the arts, 123; public performances accompanying pieces, 124–125; public television, 128; Puerto Rican folkloric icons, 118–119; *Pure Plantainum* series, 119, *120*, 128; Queens Museum, 127; Taller Boricua, 114–115, 121; Volunteer Lawyers for the Arts (VLA), 126

Macri, Mauricio, 8, 151, 152, 168
Manga-Manga (Luciano), 121, 128
Medina, Onellys, *57*
Menem, Carlos, 140
middle classes: Argentinean, 159, 181, 184–188; Buenos Aires, 186; neoliberalism, 159; tango tourism, 158, 161–162
Miller, Susana, 141, 149, 158
Miller Valley Elementary School (Prescott, Arizona), 126–127
Milonga del Gardel de Medellín, 149
Milonga del Otro Lado (Milonga of the Other Side), 149

Milonga La Discépolo, 152
Milonga Niño Bien, 141
milongas (tango dance venues), 141–152, 156–160; behavioral codes, 158; couples-oriented milongas, 150; dance-related services and shops, 141–143; female tourists at, 148; integrity of tango as a distinctive form, 149–150; locals, 147; milonga circuit, 141–143, 144, 156–160; "Personista milonga," 151–152; Porteño dancers, 147; *profesionales* at, 159; taxi dancers, 135, 147–148; tourists, 145
mobility, 15–17; of capital, 16; creative industries, 16; culture, 1–2, 5, 8; flexibility through, 17; neoliberalism, 15; physical mobility, 16; social mobility, 16
modernity, 22, 23, 49
Mothers of Plaza de Mayo, 170, *171, 172*
multiculturalism, 6, 132
Muñoz, Henry, 95, 100
Museum of Contemporary African Diaspora Arts, 84–85
Museum of the Moving Image, 83
museums: curatorial practices, 129–130, 132–134; ethnic-specific, 113; exhibition in minority museums, 129–130; "Hispanic art boom," 112; Latinos and, 97, 105–106, 107, 132. *See also individual museums*

National Association of Latino Arts and Culture, 81
National Association of Latino Arts and Culture (NALAC), 106–107, 112
National Endowment for the Arts (NEA), 2–3, 76, 88
national identity: Argentina, 136, 183; Argentina's DNI (Documento Nacional de Identidad), 161, 168, 184; consumption, 22; National Museum of the American Latino (NMAL), 99; Puerto Rico, 22, 54; shopping malls, 2; tango, 136

About the Author

ARLENE DÁVILA is Professor of Anthropology and American Studies at NYU. Her previous books include *Latino Spin: Public Image and the Whitewashing of Race* (NYU Press, 2008), *Barrio Dreams: Puerto Ricans, Latinos, and the Neoliberal City, Latinos Inc.: Marketing and the Making of a People*, and *Sponsored Identities: Cultural Politics in Puerto Rico*.